Contents

Preface

Artists and Artisans is a book in the multi-volume series, *Work Throughout History*. Work shapes the lives of all human beings; yet surprisingly little has been written about the history of the many fascinating and diverse types of occupations men and women pursue. The books in the *Work Throughout History* series explore humanity's most interesting, important, and influential occupations. They explain how and why these occupations came into being in the major cultures of the world, how they evolved over the centuries, especially with changing technology, and how society's view of the occupation has changed. Throughout, we focus on what it was like to do a particular kind of work—for example, to be a farmer, glassblower, midwife, banker, building contractor, actor, astrologer, or weaver—in centuries past and right up to today.

Because many occupations have been closely related to one another, we have included at the end of each article references to other overlapping occupations. In preparing this series, we have drawn on a wide range of general works on social, economic, and occupational history, including many on everyday life throughout history. We consulted far too many such wide-ranging works to list them all here; but at the end of each volume is a list of suggestions for further reading, should readers want to learn more about any of the occupations included in the volume.

Many researchers and writers worked on the preparation of this series. For *Artists and Artisans*, the primary researcher-writer was Thomas A. Crippen; some articles were contributed by David G. Merrill. Our thanks go to them for their fine work; to our expert typists, Shirley Fenn, Nancy Fishelberg, and Mary Racette; to our most helpful editors at Facts On File, first Kate Kelly and then James Warren, and their assistant Claire Johnston; to our excellent developmental editor, Vicki Tyler; and to our publisher, Edward Knappman, who first suggested the *Work Throughout History* series and has given us gracious support during the long years of its preparation.

Irene M. Franck
David M. Brownstone

Introduction

The distinction between art and craft is a modern one. For most of history the artist and the artisan—that is, the skilled producer of handwork—were one and the same person. Though traditionally artisans have produced work to serve specific purposes, in recent centuries some have made objects more for their own pleasure and satisfaction, thereby becoming more artist than artisan.

The oldest arts and crafts are probably painting and sculpture. Tens of thousands of years ago, long before the last Ice Age, human beings were painting caves and carving objects, apparently for religious or ritual purposes. *Painters* and *sculptors* continued to be closely associated with religion over the centuries—as the glories of Renaissance Italy and Buddhist Asia attest

—as well as providing monuments and portrait records for the rich and noble. Only in the modern age, since the Renaissance flowering of artists like Leonardo Da Vinci and Michelangelo, have many artists focused primarily on creating art from their own inner visions, rather than producing work to order for wealthy patrons.

Potters, too, have an ancient history. By 6000 B.C., they were making vessels and other objects for everyday and ritual use in the lands of the Near East. The craft was so widespread, and the baked clay so well preserved in that dry climate, that fragments of pottery are often the main items to survive from ancient cultures, providing much useful information to modern archaeologists who seek to learn how early peoples lived. Even when producing objects for practical use, many potters—like those of ancient Greece or later China—produced fine art as well. In modern times, when most pottery is produced by machine, many individuals have adopted pottery as a hobby, seeking the satisfaction of working with clay both as an art and a fine craft.

The craft of glassblowing had a somewhat similar history, though a shorter one. At some time before 1500 B.C. the people of the Near East learned how to make glass; by 100 B.C. they had progressed from making solid glass objects to blowing glass, creating beautiful, often brightly colored containers. The secrets of *glassblowers* were closely guarded and, in some places, lost for long periods of time. During the Middle Ages, European princes and nobles delighted in what was for them the artistic hobby of glassblowing, much as their modern counterparts do today, when most glass objects are made in factories.

Surprisingly, furnituremaking has a much shorter history than many other crafts. Until modern times in the Western world, most people have lived in largely bare rooms, with just a few pieces of furniture, and those generally very simple. Only in the centuries following the Renaissance did Europeans begin to fill their rooms with elaborately fashioned beds, chairs, tables, and bric-a-

brac of all sorts. For a few centuries, before modern factories came to the fore, *furniture makers* were highly regarded as both artists and craftspeople.

More important for most of history were the *musical instrument makers*, who needed the skills to do fine work in a wide variety of materials, including wood and metals. Because music, like painting and sculpture, often served both religious and political purposes, these skilled artisans were highly regarded in most societies. Even today, when so much is made by machine, handcrafted musical instruments are prized, and their makers much respected.

The most skillful workers in precious metals, as well as gems, are the *jewelers*. Over the centuries, they have fashioned ornaments like necklaces and bracelets as well as whole sets of gold and silver tableware and utensils—some as much for display as for use. Because their working materials—gems and precious metals—are so valued, jewelers have sometimes acted as unofficial bankers to communities; that is true even in modern times, in periods of war and revolution, when normal currency has lost its value.

With their special skills, jewelers have sometimes been called upon to do many other kinds of fine work with metals. In the early days of printing, for example, they made the metal type; Johann Gutenberg himself was a goldsmith by trade. Jewelers often made the parts for early clocks and later, when the works could be made smaller, watches. As demand grew for these items, specialist *clockmakers* began to produce them. But today, when clocks and watches are increasingly factory-made, the old relationship has reasserted itself. Clocks and watches are generally sold in stores run by jewelers who more often sell or repair, rather than make, fine ornaments.

Closely related to both jewelers and clockmakers is another worker in fine metals: the *locksmith*. Although wooden locks were made as early as 2000 B.C., they could not match the security of metal ones, which became

common during Roman times. In the Middle Ages, when locks were a luxury, locksmiths often doubled as blacksmiths, doing rougher metalwork as well. And when clocks were first being built in Europe, before specialist clockmakers emerged, locksmiths often made the elaborate mechanisms and maintained them over the years.

Still other artists and artisans worked with books. In the centuries before and just after the discovery of printing in Europe, handwritten books were often works of art. The finest of them were written, not by workaday scribes, but by *calligraphers*, for whom writing itself was an art form. *Illustrators* specialized in painting elaborate and beautiful pictures to illustrate the texts. *Bookbinders* housed the books in fine leather cases, sometimes inlaid with gold, silver, or precious stones. Once books began to be printed wholesale on the new printing presses, these crafts fell into decline; but today, like so many other crafts, they have been revived as arts by individuals who wish to keep the old skills, and the beauty they produced, alive.

Bridging the world between painting and print-on-paper is the *photographer*. A product of modern technology, the photographer's craft was not born until the 19th century, when images were first captured on chemically treated plates. While many photographers have continued to work at photography as a craft, many others have made of it an art form. These have rivaled painters and sculptors in their claim to be artists, expressing an inner vision. Like many of their fellow artists and artisans, they continue to combine utility and beauty in their work.

Bookbinders

Bookbinders combine leaves or sheets into individual volumes. They began to practice their art in the early Christian era as books began to replace papyrus rolls as the chief form of text in the West. The early Christians were the first to popularize the *codex* (the book form of manuscript), and medieval monks developed binding into an elaborate art form. Moslem bookbinders began the practice of *tooling* bindings—that is, stamping or impressing designs into the binding, which were then often filled in with gold, silver, and precious stones. The Persians, who were foremost among the bookbinders of the Islamic world, also lacquered their bindings to preserve them and make them more attractive. In China and India bookbinding was never an important industry, and even today most books from those parts of the world generally have only simple, thin covers.

1

Binding became a distinct profession when printing was invented. Many of the earliest *binders* were *goldsmiths* or *jewelers* who did not specialize in binding. Aldus Manutius was one of the first printers to offer bound editions for sale from his Aldine Press in Venice. He hired specialists in binding to work in his printing house; other printers soon followed this example of hiring binders. Most binders, however, were itinerants; that is, they traveled from city to city in search of work. Since only a minority of books received elaborately decorated bindings, work was not plentiful and many a binder lived simply and worked for low wages.

Binders in the earlier Middle Ages used wood for bindings, but toward the 16th century most covers came to be made of leather. During the Reformation, various kinds of ornamental *stamping* were generally used as decoration. Gold and jewel tooling remained important

Early bookbinders sewed the leaves together and then enclosed them within a binding, often gilded. (By Jost Amman, from The Book of Trades)

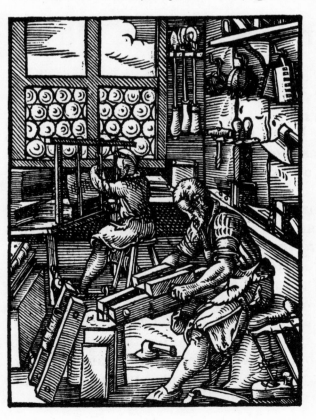

skills for the binder, but only the very wealthy requested these special bindings. One problem was that most of the gold and jewels would eventually be stolen, thus leaving the books less attractive than if they had been stamped. Martin Luther's bust and figure were commonly stamped onto leather binders during this time. Binders did not work the spine of the binding itself since books were generally either piled flat or shelved with the spine toward the wall. The first decorated spines date back to the 17th century.

Many binders were employed by royalty. Niels Poulsen was a well-known Danish court binder as early as 1559. The French courts were especially noted for their expert binders, who were well-paid and granted the privileges of nobles. Napoleon's two favorite binders were among his highest esteemed officials. It was the court binders of France who set many trends in the trade, such as the fancy lace-work binding that became typical of 18th-century bindings throughout Europe.

The largest number of binders, though, were those who worked for printers as part of their staff. Their jobs were usually more tedious than artistic. They busied themselves with making stamps either by pressing or—by the 17th century—rolling impressions on leather. At the same time, cheaper, plainer bindings became much more common with widespread circulation of books among the general population. Such bindings were made of calfskin or compressed cardboard. Often the binder made the cardboard out of old sheets of texts that were overstocked or had errors in them. Portions of many otherwise unknown texts have been recovered by taking apart the old cardboard bindings of popular standard books. By the end of the 18th century bookbinding was becoming less and less artistic, and the few skilled craftspeople who remained worked as court binders. Private work in binding was scarce. One of the most skilled binders of the day—Roger Payne of England—produced many beautiful works but lived most of his life in poverty.

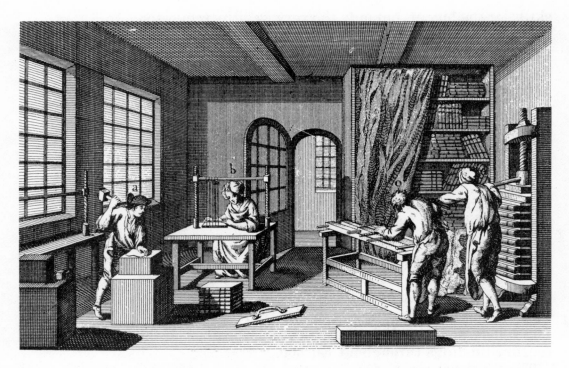

Workers in a bookbindery at the various stages of their craft. (From Diderot's Encyclopedia, *late 18th century)*

Early in the 19th century the English began the mechanization of binding in order to keep pace with the rate of book printings. Clothbound books appeared, and it was not long after that machine *casing-in* had replaced hand binding. In 1832 an *embossing* press was invented in England. This was significant because it permitted the machine decoration of cloth covers, so that inexpensive bindings that resembled stamped leather could be produced. Thus, cheap cloth books —machine-bound and embossed—flooded the English and American markets.

The remaining history of the bookbinder is lost in the industrialization of a once elaborate handicraft. In the 1920s, Pierre Legrain led a movement to revitalize the abandoned art, which met with great enthusiasm in Western Europe and the United States. Hand-binding continues to be a profession, mostly occupied with the artistic features of bindery, or the economical use of hand-binding for single copies of rare books or historical manuscripts. For the most part, however, people engaged in contemporary bookbinding are factory

workers who operate machines rather than hand tools. And in the most modern printing plants printing and binding are completed in a single process.

For related occupations in this volume, *Artists and Artisans*, see the following:
 Calligraphers
 Illustrators
 Jewelers

For related occupations in other volumes of the series, see the following:
in *Communicators*:
 Authors
 Editors
 Printers
 Publishers and Booksellers
 Scribes
in *Scholars and Priests*:
 Monks and Nuns

Calligraphers

As an artistic method of producing written letters, calligraphy was a part of the *scribe's* occupation dating back to the time when the Greeks developed a Phoenician-derived style of alphabet in about the ninth century B.C. The extent to which scribes were also calligraphers in Greek and Roman times would determine greatly their value to employers or to clients. And the practice of calligraphy—the production of beautiful writing—continued to some extent through medieval times. However, there was no distinct occupation of specialized *calligraphers* until just shortly before the invention of print.

As books became more fashionable during the Renaissance, scribes were busied in their production. Since royalty and wealthy aristocrats formed a large por-

tion of the new public eager for books, the quality of production was often more important than the speed. A class of *scrittorii* arose during this time as distinct from the regular *copistii*, who were simply scribes engaged in copying texts quickly and cheaply. The scrittorii were professional calligraphers who labored at producing beautiful and artistic manuscripts for royal and noble collections. The best paid and most highly regarded of the professional scribes, they enjoyed a high ranking in court societies, particularly in Italy. They were obliged to have a good knowledge of Greek, since they were usually employed in the copying of Classical Greek works. Scrittorii often worked as members of large staffs which included copistii as well.

With the invention of print, writing forms became simplified and stylized. Books began to look alike, rather than reflecting the individual style of a calligrapher. But the occupation of *scrittori* did not evaporate instantly. During the production of the *incunabula* (the first printed books, 1440-1500 A.D.), calligraphers remained busy, supplying the wealthy and elite members of society, who preferred the artistic manuscript over the simpler, less visually appealing, mass-produced book that was marketed to more ordinary folk. Many a noble, like Frederick of Urbino, "would have been ashamed to own a printed book." Eventually, however, printing surpassed hand copying as the accepted way of producing multiple copies of a book. The calligrapher was soon out of business, except for occasional special purposes, such as preparation of handwriting manuals, especially popular in the 16th century, for use in grammar schools.

Calligraphy was strong in the East. Islamic peoples have revered the art of calligraphy for many centuries, and between the eighth and tenth centuries A.D., many copies of the *Koran* were produced by expert calligraphers. Depiction of living creatures, including humans, is discouraged by the Moslem faith, though the prohibition was often ignored in parts of the Islamic world, such as Persia and India. So in stricter, more

orthodox regions, calligraphers have been the chief artists of Islam, decorating mosques and fabrics as well as books. In China and Japan, the large number and fluidity of characters in the written language has kept alive the profession of calligraphy that had virtually died out in the West. To this day Eastern calligraphers work closely with *printers* and *typesetters*, and often these professions are only thinly separated.

Toward the end of the 19th century there was a revival of Western interest in calligraphy as an art form. This revival began in Germany and Britain, soon passing to America. Most professional calligraphers are now graphic artists who display their works in art galleries

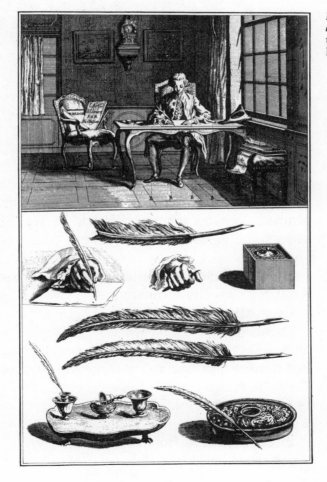

For the calligraphers, quills and ink are the tools for producing beautiful writing. (From Diderot's Encyclopedia, *late 18th century)*

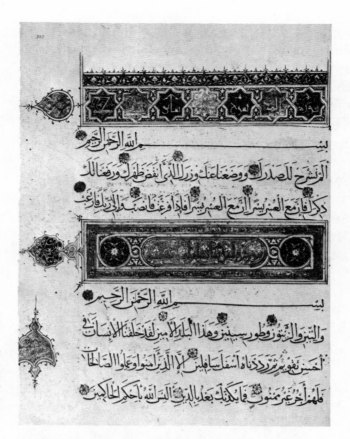

Because the Moslem religion forbade depiction of living creatures, calligraphy and geometric decorations developed into a major form for Islamic artists. (From a 14th-century Iraqi Koran, MS. Or. 1009 f. 303 v., British Library)

and museums. They are usually freelancers, and sometimes are hired to compose public signs, posters, and placards. Some also find work in teaching the art to others.

For related occupations in this volume, *Artists and Artisans*, see the following:
Illustrators
Painters

For related occupations in other volumes of the series, see the following:
in *Communicators*:
Printers
Publishers and Booksellers
Scribes

Clockmakers

The clockmaking profession has a relatively brief history. The first fully mechanical time-telling devices appeared in Europe only during the 14th century; these were followed by clocks and watches increasingly similar to those in use today. Before then, people had relied on quite a variety of primitive time-telling devices. We know little of the artisans who manufactured these; only the learned people who invented modern time pieces are remembered by history.

Before people ever imagined that time could be measured, they saw that the sun and the moon each traveled its own predictable course across the sky. Once people noticed these predictable changes they had reliable guides to charting time. The earliest time-tellers were scholars who made a science of following the

movements in the sky. In Chinese legend the earliest rulers of the land were credited with mapping out the paths of the stars. It is known that, at about the same time—between 3000 and 2000 B.C.—the temple priests of Egypt and Babylon in the Near East had also begun to record the movements of the sun, moon, and stars.

When humans began to make their own time-telling devices, these were simply ways of reading the sky more precisely. The people of the ancient Near East set up posts of uniform height; as the sun rose, a post's shadow would lengthen alongside a measured scale of intervals. This arrangement was called a *gnomon*; something like it is mentioned in the Bible's Book of Kings. When the sun's movements changed with the season, so did the measurement of time. This resulted in a convention of the ancient world that historians call "temporary hours"; the number of divisions in a day remained the same, but their length altered in proportion to the length of the day. With a sun clock, of course, the length of a day was the time between sunrise and sunset. As the days got longer in summer, the units of time got longer too. As the days got shorter, the units of time got shorter.

Other instruments were also developed to measure time, ones that did not use the sun. The first *water-clock*, called the *jala-yantra*, was invented by the people of India around 300 B.C. The familiar *sandglass*—what we call an *hourglass*—could be found in all the countries that bordered the Mediterranean. Other devices used flames that burned for a set length of time. Of course, none of these early "clocks" could be supplied with enough sand, water, or oil to keep track of an entire day. They measured only a given amount of time, no more than a few hours at the most.

Longer intervals were still charted by the sun. A Chaldean priest named Berossos is said to have invented the first *hemicycle*—better known to us as a *sundial*—in the second century B.C. A simple disk with a raised fin stood on a pedestal; as the fin's shadow lengthened it touched a series of marked points on an arc, measuring

time. Compact and simple, the sundial became a fixture of the ancient world. Even the Romans, in those days still quite distant from the high culture of the eastern Mediterranean, were soon using it. A character in *The Boetian*, a play from the first century B.C., noted that when he was a boy people knew it was time to eat when they were hungry; now, he complained, "The city is full of sundials, but we see almost everybody crawl around half dead with hunger." As both leisure and intelligence were required for the development of time-measuring devices, in the ancient world the *priesthood* had the greatest opportunity to devise such inventions. From the decline of Rome and into Europe's Dark Ages, the Christian priesthood continued to foster invention. Among priestly inventors were St. George, Archdeacon Pacificus of Verona, and Pope Sylvester II. A monarch also dabbled in this area: In the ninth century A.D., England's Alfred the Great made candles that were measured to burn down in four hours; they were in lanterns so that drafts would not affect their flames.

The clocks of Asia were far more sophisticated. Through most of the Middle Ages, Europeans could not match the Arabs or the Chinese in fashioning time-telling devices. The nobles and monarchs of the East owned clocks that could be startling in their lavishness and complexity. In 800 A.D., to celebrate the coronation of Charlemagne as Emperor of the West, the Shah of Iran presented him with a water-clock inlaid with precious stones. Medieval Europe had nothing to match that. In southern England, villagers could tell time only by the local church's simple sundial. Each dial was hand-carved by the local *mason*, and each was of a different size, design, and shape.

China, in particular, produced a succession of very ingenious clocks, driven in a wide variety of ways over the centuries. An eighth-century A.D. Chinese clockmaker apparently even discovered the principle of the *escapement*, a wheel-and-anchor device that regulates movement, essential to later Western clocks. Long

thought to have been developed first in 13th-century Europe, this idea may in fact have originated in China and percolated across to Europe during the time of Marco Polo. But clocks as we know them did not become widespread in China until modern times. Until then Chinese clocks were massive affairs designed more for astronomical and calendrical calculations than for telling hours and minutes. As a result, no separate clockmaking craft developed. A 17th-century Japanese work by Ihara Saikaku put the situation quite clearly:

> The clock was invented in China. Year after year a man thought about it, with mechanisms ticking by his side day and night, and when he left the task unfinished, his son took over in a leisurely way, and after him, the grandson. At long last, after three lifetimes, the invention was completed and became a boon to all mankind. But this is hardly the way to make a successful living...

The history may be faulty, but the conclusion is not.

Modern clockmaking began in Europe. The first fully mechanical clock, one that worked only by its own gears

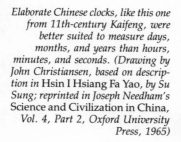

Elaborate Chinese clocks, like this one from 11th-century Kaifeng, were better suited to measure days, months, and years than hours, minutes, and seconds. (Drawing by John Christiansen, based on description in Hsin I Hsiang Fa Yao, *by Su Sung; reprinted in Joseph Needham's* Science and Civilization in China, *Vol. 4, Part 2, Oxford University Press, 1965)*

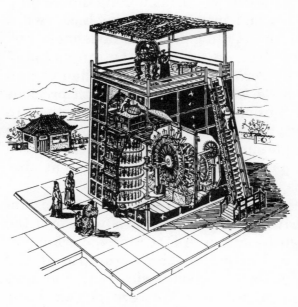

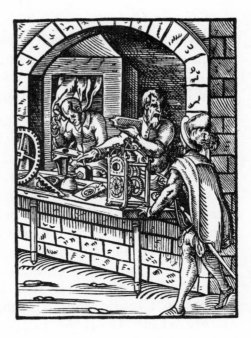

Early clockmakers made hourglasses as well as cases for their timepieces and sometimes did other fine metalwork besides. (By Jost Amman, from The Book of Trades, *late 16th century)*

and weights, was invented in Italy during the 14th century. How the Europeans came to invent this very complicated device before the Chinese or Arabs we do not know. They did, however, and the artisans who went on to copy and develop this invention are the people we think of as *clockmakers* and *watchmakers*.

The first of these clocks was built in 1335, in Milan, one of the wealthiest cities in northern Italy. Soon other cities in Italy, France, and England followed suit. Building one of these clocks was most often a municipal affair: Only a generous noble, the church, or a whole town of commoners could afford it. Some clocks were paid for with money set aside for that purpose accumulated from the legacies of citizens.

The people of the time did not have the technology for fashioning intricate, small-scale systems of gears. The workings of each clock were so large that it took an entire room to contain them. *Blacksmiths* forged the pieces and then assembled them in the top chamber of a tower (hence the name *turret clocks*). One clock served for an entire town.

These early clocks had no face or hands. The workings simply acted as a cue for the public *watchman:* When their weights set off an alarm, he would shout out the time to the people below. Accuracy was not impressive; clocks could be expected to be off by half an hour a day.

Once a town had bought one of these clocks, it would be a long while before a second one was needed, and the clockworks were so massive that they could not readily be carted to other markets. As a result, few, if any, tried to make a living from clockmaking in these early times; it was a sideline of skilled craftspeople engaged principally in other work. In 1419, for example, the Cathedral of St. Pierre, at Geneva, Switzerland, hired Etienne de Vuy, a blacksmith, to act as caretaker—the actual title was *rector*—of its clock. He was later succeeded by the *locksmith* Claude Noyon, another artisan skilled at metalworking. Until the 17th century, blacksmiths and locksmiths were still being called upon to construct many of the vast public clocks of Europe.

But inventors continued their work and changes began to be made. Giovanni Dondi, physician to the Holy Roman Emperor Charles IV, was known as "Master John of the Clock" for his creation: a clock kept in motion by one weight and small enough to be set on a stand. People considered it a wonder. In 1389, a contemporary wrote: "The subtil skill of the said Master John enabled him to make with his own hands the said clock all of brass and copper, without the help of any and he did nothing else for sixteen years."

In the next century, *chamber clocks* appeared which told time on a dial and could be kept in one's room. The German locksmith Peter Henlein improved the clock's interior with the addition of the spring. The devices were complex and only royalty and aristocrats could afford them, but the clocks were being bought. Wherever there were communities of *locksmiths, armorers, blacksmiths,* and *swordsmiths,* some turned to clockmaking. Many of the early chamber clocks came from towns like Augsburg

and Nuremberg in Germany, surrounded by forests providing plentiful wood for forges.

The makers of these new clocks slowly emerged as specialized artisans. As they kept the materials and habits of their earlier trades, they first constructed clocks from iron. But in the last decades of the 15th century, iron clocks were replaced by handsome and more reliable ones made of brass, a metal that could be shaped into finer and more precise gears. The clockmakers of Paris began their own guild; the clockmakers of Nuremberg followed suit in 1565, leaving the guild of blacksmiths. The trade grew quickly. The Paris guild had only seven signatures on its initial application to the king; by the end of the century, the guild set 77 as the number of masters who could practice in the city. By that time, Parisian clockmakers already had rivals in Blois, a city in central France, where a guild of clockmakers was established in 1597.

The clock was a curiosity that people were anxious to own; it was a special favorite of rulers. Even in England, where the craft had not yet been mastered, Henry VIII and then his daughter, Elizabeth I, collected galleries of timepieces. In France, the court maintained a three-man office of "Clockmakers to the King." These men, freed from their guild by royal patronage, spent the rest of their careers in making whatever kind of clock their new master wanted. Elizabeth I also had her own clockmakers: the first died in 1590, and for his successor the job was converted into a court post with the title "Royal Clockmaker."

Once confined to towers, clocks could now hang comfortably in a room in a private home. Craftspeople worked exclusively at making clocks, and their skills became more finely honed. Midway through the 16th century, artisans in Germany and France had found ways to make a clock's interior gears even smaller. These gears were designed to make a clock that could be carried about by its owner. The works of these first *watches* required cases four to five inches across and

three inches deep. They did not fit easily into pockets, so men hung them by chains from their belts. Engravings of the day show that some nobles could not be bothered with that, employing instead a servant who would follow his master about, holding the watch in his hands.

These new watches soon surpassed clocks in popularity; watches were fashioned and bought as examples of extreme wealth. In France, they came in cases made of bronze (sometimes gilded) or even gold or silver. In Germany, craftspeople made watches that resembled books, tulips, crouching dogs, and even skulls. A rarity, watches were meant to startle the eye. One, made in Strasbourg, was a silver globe with the continents of the world etched upon it.

Clockmaking changed with each new discovery in the trade. Clockmakers were different from most craftspeople in that they sold technology as well as used it. Each time an inventor found a new way to simplify a clock's mass of gears and weights, clocks became smaller and less expensive—and their market broadened. In 1656 the Dutch astronomer Christian Huygens found that pendulums could most simply and accurately regulate a clock's inner workings. Some of the clocks that resulted from this new technology rested on stands, their long pendulums protected by a case. Today these are called *grandfather clocks*. Others were small enough to fit on the mantel. Well-to-do merchants and tradespeople found these more accurate but relatively less expensive clocks an attractive way to demonstrate their prosperity. The clockmaker treated all as items for display: *mantel clocks* even had decorated backplates, which were visible when the clock was set before a mirror. In homes, clocks were often accorded a special place in the gallery, where the most valuable items of the house were set out for show.

The growth of the clockmaking trade led to the development of shops in which several people worked together. A plate from the 17th century depicts the men of a clock shop at work. The illustration shows a cluttered establishment: a forge is in the rear near the open door; in

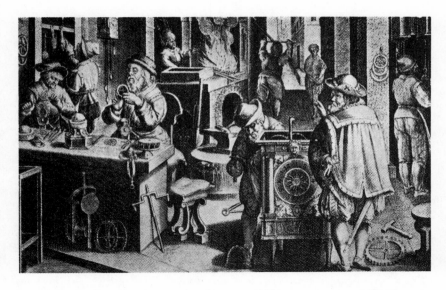

In the days when clocks were collectors' items, the clockmaker's shop was a busy place. (Authors' archives)

the foreground is a worktable as well as a scattering of cogs and gears on the floor. Of the seven men working, it is hard to tell if anyone is in charge. One man forges metal, while another works the bellows. Two other men seem to be inspecting pendulums and finished clocks; these men, like the two at the forge, wear thick leather aprons and peaked caps. In the foreground, two men file metal pieces at the worktable; a third stands apart as he chisels a clock's decorative casework.

In France the trade—given new life by Huygens' discovery—flourished not only in Paris and Blois, but also in Grenoble, La Rochelle, Dijon, Rouen, Sedan, Lyon, and Autun. In Germany it did not survive the Thirty Years' War, a period of chaos that left the country ruined through the 17th century. But other nations were developing their own clockmaking industries.

English blacksmiths of the 16th century had found the domestic market for clocks filled by specialists from abroad. But while the Europeans on the Continent fought the Thirty Years' War, British crafts grew independently. In 1622, the clockmakers of London petitioned Charles I to expel their foreign competitors. The king refused. In 1630, the Worshipful Company of Clockmakers was formed, its members drawn from the

blacksmiths', jewelers', and locksmiths' guilds. The early members of the company were not the most exalted of craftspeople; their guild could not afford an assembly hall, so meetings were convened in a tavern.

The clockmakers had planned to work together as an interest group to influence the king and his court, but they also found it convenient to regulate the trade among themselves. While rulers often proved resistant, the craftspeople benefited from adhering to the same rules. The guild put a limit on the number of apprentices a shop could employ; this made the profession more secure by preventing any one person from taking another's share of the market. But the guild also set standards of workmanship that its members had to meet. This improved the quality of British clocks until they matched the best on the Continent. By the end of the 17th century, the trade that had vanished in Germany was well established in England.

Thomas Tompion was looked upon by English clockmakers as the most enterprising and imaginative of their number. He worked hard, making 650 clocks and 5,500 watches in the course of his career. This tells something about output during the time, as well as about the relative popularity of clocks and watches. A Tompion mantel clock with a case made from tortoiseshell sold for 40 pounds (approximately $500 today). The best of Tompion's gold watches cost 70 pounds (about $866). A grandfather clock by any reputable London craftsman, if it was carved well, using good wood as well as handsome gilt, would cost the equivalent of $700.

English fittings were well formed but not meant to capture the eye. Watches were deliberately plain; the Puritan manner was adopted midway through the 17th century during the religious rule of Oliver Cromwell. Clockmakers concentrated on the timepiece's interior, and their workmanship set the standard for Europe. Their method of work was also copied. Teams of artisans filed and shaped the clock's pieces; each person was trained to fashion a single gear, often turning out noth-

ing but this piece all through his lifetime. The actual clockmaker became the person who, after overseeing the creation of the pieces, then assembled them. This was like fitting together one three-dimensional jigsaw puzzle after another. This was the real craftsperson of the team, a worker who had to use both mind and hands. This system of work allowed clocks to be made faster and yet to be constructed more carefully: For a long while it gave English clockmakers the lion's share of an international market that once they had not even been able to compete for.

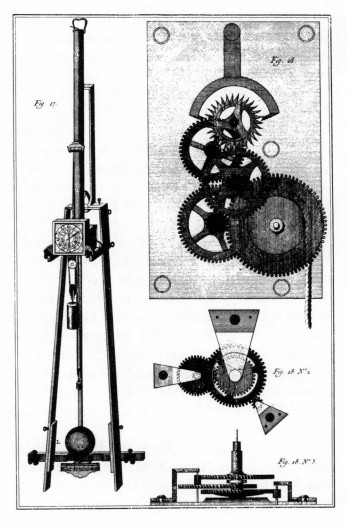

Clockmakers had to be extraordinarily precise. These are mechanisms for measuring seconds in a large standing clock. (From Diderot's Encyclopedia, *late 18th century)*

In the 18th century a home with any pretension to comfort or affluence boasted a clock and the most successful clockmakers were rewarded with admiration and wealth. Even in the last years of the 17th century, the clockmaker Thomas Tompion had become rich through the patronage of King William III. The Knibbs and Dents, families of clockmakers, became pillars of society in the 18th century. John Knibb, for example, became a privileged citizen of the city of Oxford; he also served as its bailiff and its mayor.

The patrons of a talented clockmaker kept coming back to him for more and better work. In France, Abraham-Louis Brequet founded a firm that, as the House of Brequet, still serves fashionable clients. By the 18th century the rich, especially on the Continent, were becoming more extravagant. Louis XVI of France decided that the three royal clockmakers were not enough. He needed two more to follow him on his travels about France. Clockmakers found new ways to delight their customers. When John Arnold managed to make a watch contained in a ring, George III rewarded him with 500 pounds (about $6,250). Clockmakers also invented the *music box*, a novelty that told time by producing a melody on the hour.

All this while, European clockmakers had dominated the trade. Dutch traders brought watches to East Asia in the 16th century. But for hundreds of years only a handful of clocks were made in China. Early in the 17th century, however, the Japanese began making their own clocks, with some special adjustments. Since in Japan "temporary hours" were used, the clockmakers designed replaceable dials, one for each season. When in the 1630s, Japan's rulers closed the nation to foreign trade, competition with the craftspeople of Europe was deferred until modern times.

Closer to Europe, Turkey's Ottoman Empire, which then ruled the Near East, imported many clocks and watches but made none. The Turkish nobles had a good deal of money, and their trade supported circles of

clockmakers in London and Austria who worked for no other market. The Europeans carefully inscribed the clock faces with the Islamic calendar and system of hours.

Nor did clockmaking flourish in the Western hemisphere. Any clocks found in South America had been imported. For a long while this was also true of England's colonies in North America. Records of the 16th-century settlements and villages make no mention of telling time. In 1629, the people of New England drew up a request for British supplies, one that included all "such needful things as every planter doth or ought to provide." Clocks were not on the list. As far as we can tell from town records, turret clocks were first seen in America after 1650.

A few clockmakers did arrive from England along with other immigrants, but the trade offered little opportunity. The Colonies had little money, so the clockmakers would advertise for scrap metal from which they could make inexpensive clocks. Most of them could find no tools other than a drill, a file, and a hammer. These artisans worked in much the same manner as the blacksmiths and locksmiths of Europe had three centuries before. The craft was a sideline; a clockmaker finished only occasional commissions, all for the rich, with each project taking months. Any clockmaker who had connections with England was likely to advertise the fact. Some of them also imported clocks form Europe, work that could be sold for much more than anything American.

While clocks were rare, watches were regarded as an almost impossible luxury. In the late 18th century, Thomas Harland owned a Connecticut factory that made forty clocks and only two watches. Luther Goddard tried for decades to sell his watches; even when Americans did begin to buy watches, he could not make them cheaply enough to compete with the ones shipped from Europe. In the end he quit to become a gospel-preacher. This was not surprising. The secrets of clock technology were too complicated to easily cross long distances. Even in

England, the only spring-driven clocks were made in London; the craftspeople in the provincial cities never learned how to make springs and had to use weights instead. Only chance allowed the secrets to circulate.

During the 17th century, Switzerland came to rival Britain as a center of the clockmaking trade. In the next century, Swiss clockmakers surpassed the British in workmanship and profits, holding their preeminence until the present day. According to the Swiss, all this came about through something of an accident.

The founder of the Swiss clock industry is said to have been Daniel Jean Richard; there is a statue of him in Switzerland's capital, Geneva. The son of a blacksmith, he grew up in a Swiss mountain village. One day, while Richard was still a boy, an Englishman who had broken his watch passed through town and asked if Richard's father could fix it. The blacksmith could do nothing. Richard saw the watch and, by some great persuasive power, managed to get permission to try his hand. He fixed the watch and set its making and operation in his mind. He spent the next year piecing together a watch of his own; it ran. One boy on his own had absorbed the science of English clockmaking. He worked hard through his life, and his knowledge made him rich. Richard had five sons; all were intelligent and dedicated workers, and all became clockmakers. The craft had come to Switzerland to stay.

The Swiss clockmakers were clever people. They found ways to produce more than their English counterparts had ever thought of. Switzerland was rural: most of its people lived and worked on farms. When winter came, they retreated to their cottages and waited for spring, living on what had been saved from the previous year's crops. The Swiss clockmakers trained these people, adopting the English system and then stretching it to take in more workers than it ever had before. One person would learn how to file one piece of the clock and did just that for the rest of his life. Anyone could be an artisan of this sort, and hordes of workers were available each

winter. A clockmaker could hire whole families, paying them by the piece. This was a preindustrial revolution; the Swiss output hinted at that which would result when machines replaced workers.

The Americans introduced that innovation. In 1800 a man name Eli Terry, formerly an apprentice to an immigrant English clockmaker, diverted the course of Niagara Brook, a Connecticut stream, to produce water power for the engines that ran the lathes and drills for his factory. His was the first automated clock factory. It offered the only real competition to England's exports; each "movement" (set of works) and dial produced cost $4. Local *carpenters* built the cases. He and his partners had to go out and sell what they made, carrying their goods with them as they traveled through the northeastern states.

The Connecticut clockmakers of these years knew their trade and were willing to take risks in marketing what they had made. They achieved success. Many people in the United States could now afford goods that a few decades before had been beyond their reach. As plain, well-made work was in demand, that was what the clockmakers decided to offer. In 1814 Eli Terry patented a clock that was made completely from wood, from its gears to its case. It sold for $14 and made him a rich man.

He had competition from the Jerome brothers, Chauncey and Noble. In 1828 Chauncey Jerome issued a mantel clock that, though remarkably ugly, was cheaper than any that had been made before. His sales surpassed Terry's. In 1837, when business suffered from a depression, his brother, Noble Jerome, introduced a still cheaper clock made of brass. This revived the trade. A million of the clocks were bought each year—a remarkable number, given early America's small population.

Clockmakers in England paid little attention to the new industrial developments. The Swiss Pierre Frederick Ingold invented some machines that could replace human labor. He moved to London and founded

the British Watch Company—it failed in two years. Next he moved to the United States, where his efforts met with success. As late as the 1870s, one of England's most successful clockmakers, Samuel Smith, still worked by hand, making only a dozen clocks a year. English clockmakers were content with the prosperity and respect they enjoyed. Belonging to a small and proud circle, they did work that they knew to be good and never thought of making more and cheaper clocks to sell to more and more people. When Benjamin-Louis Vulliamy, Queen Victoria's clockmaker, decided to increase his output, he had to send his clock cases to Switzerland to be fitted with movements.

After the fire of Westminster in 1834, a new house for Parliament had to be built. Its tower was to contain the clock now called "Big Ben" (originally that was the nickname for the bell that had tolled the hour). The tower's architect stipulated that the clock should be highly accurate, and the best clockmakers of the country competed to come up with the perfect design. One of them, Edmund Beckett, was made a nobleman for his work.

In 1842 a shipment of Chauncey Jerome's clocks arrived in England, the first of the American factory-made clocks to be exported. Some found their way to Germany where, within the decade, Johannes Burk had founded a clock factory in Schwenningen. He had competition from the Junghans family, one of whom had brought back technical secrets after serving as a factory worker in America. The familiar cuckoo clock, hand-carved in Germany's Black Forest since the late 17th century, was produced in the new factories, and the clock became popular all over the world.

The history of clockmaking has since been marked by a rush to incorporate new technical developments. In 1840, a Scottish clockmaker demonstrated the first electric clock. Succeeding generations of clockmakers have outdone each other in producing clocks of great power

and accuracy that can measure time down to thousandths of a second and beyond.

Modern technology allows millions of clocks and watches to be made. It also allows them to be made better than they could be before. Clock companies still employ skilled people to design not only clocks and watches, but also the tools with which these are made. Although machines have replaced the hand-work, the brain-work of the clockmaker has remained. Superior clockmaking requires great delicacy and precision; machines can now supply this. Now entire populations can be supplied with goods that before were reserved to the few, and the new goods are—at the price—more accurate and more reliable than the old, though not necessarily the work of art produced by the finest individual craftsperson.

A sign of how the trade has changed is the present-day popularity of watches. Once they were too expensive for the mass market. Even while millions of clocks sold, American watch firms had to struggle to stay in business. It was not until 1892 that R.H. Ingersoll of Boston made a cheap, reliable watch that sold; it was, as his firm called it, "The Watch That Made the Dollar Famous." In this century, twice as many watches as clocks have been sold around the world. Being able to tell the time of day is something people take for granted.

In the 20th century, America and Switzerland have dominated the trade in clocks and watches, with Japan recently joining them and England struggling to keep up. Today, Switzerland makes almost half of the world's clocks and watches, an annual output of 69,500,000 out of the world total of 152,000,000. Switzerland's makers are employed by corporations, all of which have organized themselves under the Swiss Federation of the Association of Watch Manufacturers. By exacting a tax on the export permits it grants its members, the Federation funds an agency that enforces standards of quality. Its examination is close: There are three grades for jewelry, six for mainsprings, and so on.

America trails Switzerland, making 31,750,00 clocks and watches each year. The much smaller nation of Japan matches this figure. Seiko of Japan rivals the Swiss firms in the intelligence and care of its operation (Seiko watches are the third best-selling brand in Switzerland). Mass production of this convenience has reached even England. The descendants of Samuel Smith, the craftsman who a century ago made a dozen watches a year, own and operate factories that produce an alarm clock every two and half seconds. These numbers pose a threat to the traditional watchmaker. Many of the new mass-produced watches are powered by quartz crystals, which are replacing the metal gears that have been the heart of watches and clocks for centuries.

For related occupations in this volume, *Artists and Artisans*, see the following:
 Furniture Makers
 Jewelers
 Locksmiths

For related occupations in other volumes of the series, see the following:
in *Builders*:
 Carpenters
 Masons
in *Communicators*:
 Messengers and Couriers
in *Helpers and Aides*:
 Private Guards and Detectives
in *Leaders and Lawyers*:
 Police and other Law Enforcement Officials
in *Manufacturers and Miners*:
 Metalsmiths
 Weapon Makers
in *Scientists and Technologists*:
 Astrologers
 Astronomers

Furniture Makers

Furniture seems so basic a necessity one would think that in every culture of the world there would be craftspeople dedicated to making nothing else. Surprisingly, this is often not so. Through most of the world's history, most people have lived in sparsely furnished rooms, their few pieces of furniture regarded only as conveniences not requiring the craft of skilled artisans. Only in Europe, and then just in the last few centuries, was furniture produced in large quantities by special workers.

Furniture was scarce in even the wealthiest civilizations. The chambers of China and Japan are still relatively stark, compared to those of the West. Furniture has existed in these nations for several thousands of years: wardrobes, beds, chairs, chests, a variety of small

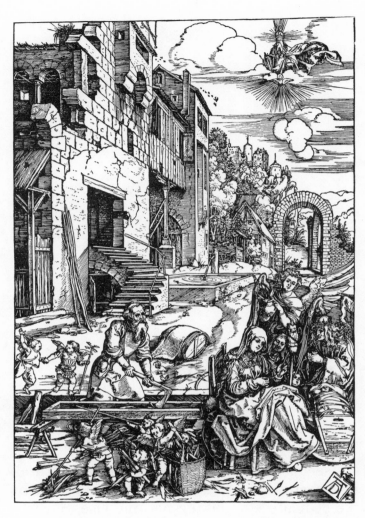

En route to Egypt with his family, Joseph plies his trade as a carpenter. (By Albrecht Dürer, early 16th century)

tables. But these pieces are generally small and often confined to the edges of an area. The beauty of a Japanese room is supposed to lie in its architectural proportions, uncluttered by accessories. In all China's voluminous writings on art, literature that has accumulated for 2,000 years, furniture and its makers rate hardly a mention; few writers considered a person who made furniture to be an artist.

For 4,500 years, from the time of the ancient civilizations to Europe's Renaissance, furniture was equally scarce in the West. Most often, furniture was made by *carpenters*, whose trade was woodworking in

general. We know something of the carpenter's tools used in Egypt in 1500 B.C. They included chisels (one of them specially shaped to make narrow mortise joints, in which a plug and cavity are fitted together to join two pieces of wood), axes, adzes (used to plane wood and make its surface smooth), hammers, awls (for puncturing small holes in wood), straight-edges, mitre-blocks (used for measuring angles to prepare for cutting a joint), and flanged squares (for fashioning an outcropping ridge along a work's rim, to ensure that angles were correct). It is a long list of tools, and one that has changed little; more than 2,000 years later, the furniture specialists of Europe used much the same types of instruments, but designed for finer work.

The specialist in furniture first appeared in Greece, working a small but steady trade and being largely ignored by his society. Furniture workshops were small, and scattered everywhere; no city or region ever monopolized the craft by displaying special excellence. One workshop owner employed 20 workers—but we know of him only because he was the father of the great orator Demosthenes. When Plato, for the sake of an argument, wanted to select an entirely unexceptional artisan, he chose the *couch maker*.

As in the East, furniture of the ancient West stayed spare and simple, though sometimes skillful in design. In Egypt, Greece, and Rome the list is much the same: couches, stools, chests, boxes, tables, chairs, and beds. The Greeks made chairs that were imposing and high-backed, and used them for ceremony; the Romans reserved their chairs as special seats for women and the old, though someone who had won special respect would sometimes be seated in a place of honor. By today's standards, rooms of the time would seem empty. When Rome's wealthy citizens, the richest of the Mediterranean, began to pour out their money, their pieces of furniture became more lavish but remained few.

Rome fell in the fifth century A.D., and with it went European civilization. In the succeeding Dark Ages, life

quickly became harder, more dangerous, and more exacting. Even the royal families of Europe slept as many of today's poor do—two, three, or four to a bed. The one piece of furniture still made and sold in any number was the simple chest. It was especially popular because it could serve many useful purposes: chair, table, desk, even bed. Most important, it offered security: In those turbulent times, persons with property were inclined to lock it up.

The Dark Ages were relieved somewhat during the ninth century, but without a return of affluence to Europe. Nobles would gather personal collections of furniture, much like wardrobes of clothing, taking them on travels from one estate to next, leaving each castle bare until their return. Even near the end of the 13th century, a prosperous city dweller in Italy, where the richest commoners in Europe lived, did not own much furniture—perhaps a bed, a table, and one or more chests.

The Catholic Church preserved carpentry skills through the Dark Ages, among the many crafts to have flourished in this haven of wealth, security, and learning. Monasteries ran carpentry shops where apprentices could be trained. From the sixth to the fifteenth centuries, most benches and stools in Europe were built to furnish church buildings.

Carpentry did not remain the exclusive province of the church. Over the centuries, apprentices brought their skills to the outside world, and gradually a few found that they could make their living by practicing their craft. In the 12th century, these carpenters joined together in guilds to regulate and protect their trade through cooperation among themselves. These groups soon won the recognition of Europe's rulers. In 1254, the Provost of Paris, appointed by the throne of France, gave official sanction to the city's carpentry guild when he listed its by-laws in *The Book of Trades*. The guild of Florence stipulated that any one piece of work had to use the same kind of wood throughout. Only certain kinds of

decoration were allowed; sealing the parts with glue was never allowed. Until 1384, making a chest above the usual size meant paying a fine.

Furniture could be made on a *lathe*: The carpenter shaped a piece of wood by revolving it against a turning blade. Every piece for a stool or chair—circular columns for the legs and a disc for the seat—could be made this way. Because of this technique the name *turners* was applied to carpenters who practiced it from the ninth to the sixteenth centuries. Other carpenters made their living building the frames of houses, but then used whatever wood was left over from a project to make rough furniture, most often *coffers* (strong boxes). In medieval England carpenters were called *cofrers*. To fashion chairs, the cofrers used the same tools with which they cut beams. A cofrer took an axe to hew out some planks, then fastened them together with nails and iron bands, the result being considerably less graceful than a barrel.

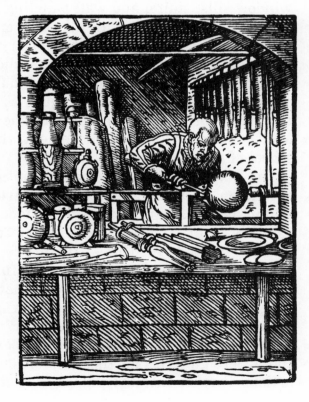

Turners were skilled at making all kinds of delicate and fine crafted items out of wood. (By Jost Amman, from The Book of Trades, *late 16th century)*

By the last centuries of the Middle Ages carpenters were refining their skills. As relative prosperity returned to Europe, desks and cupboards were added to the standard types of furniture: chair, bed, and chest. The old practice of *paneling* was also revived. Planed panels of wood fitted together could produce far lighter and finer furniture than that made by hewing planks. The people who did this delicate work practiced skills unknown to general carpenters, and reinvented an array of tools similar to those of ancient artisans. These new artisans were called *joiners*—so named for no other reason than that they joined wood parts. Joinery developed as a separate specialty; the joiners of Paris, for example, left the carpenters to form their own guild in 1371. These artisans still worked on other projects, but their furniture-making work involved skills that set them apart from other carpenters. Their job extended to preparing all kinds of interior woodwork—doorways, window sills, stairs, and wall paneling.

The craft prospered with all other crafts as Europe's Renaissance began in the 14th century. In these years, when all other crafts won respect, so did furniture making. Artists might make furniture, and furniture makers could aspire to be artists. Hugues Sambin of France began his working life as a carpenter; he finished it as the leader of a small artistic movement, the "Burgundian" school of woodcarvers.

The Europeans began to make furniture with as much attention as they gave to other artistic works. In Renaissance Italy, the people who made chairs were just as likely to carve statues; it simply depended on what the patron wanted. At times, furniture was treated as statuary. Venice's most eminent furniture maker, Andrea Brustolon, fashioned work that everyone found very beautiful, but which almost no one could put to practical use. The noble palaces of 17th-century Rome were planned with vast reception rooms at the front; these were galleries for the work of renowned furniture artists. Farther into the palace were found the private

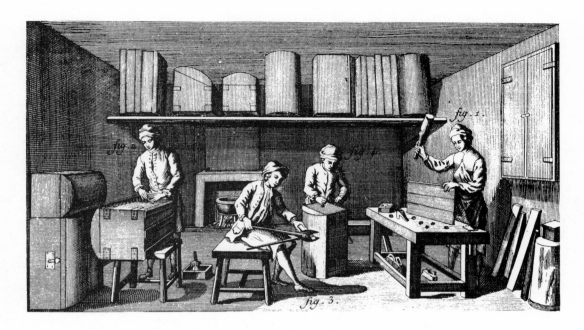

rooms: smaller, more intimate rooms with furniture by carpenters and joiners.

The nobles of this time began to accumulate furniture, and it is this piling-up that has made the craft's history in the West so different than in the rest of the world. Florence under the ruling Medici family founded a state factory for furniture art, a system of workshops known as the Galleries. A respected artist ran the complex, designing furniture; each lieutenant saw that his workers faithfully executed their part of the design. A furniture maker from the Netherlands was taken on for his special expertise in 1667—at a rate of pay equal to that accorded Europe's most successful portrait painters.

This is when the work of furniture making divided into a family of crafts. One person could no longer make a fine piece of furniture; the number of details required a team, and each member of the team needed specific skills. In the Galleries, a *turner* made parts on a lathe and a *cabinetmaker* assembled them. Then came the decoration of the piece, which took as much effort as the construction. The work went on to a *veneerer*, a *marquetrer* (who applied the inlaid ivory and other materials), a *carver*, an

Chests, cases, and trunks were the main items produced by furniture makers for many centuries. (From Diderot's Encyclopedia, *late 18th century)*

upholsterer, and finally someone to paint on the finish. Then the work was considered complete.

The finest furniture had been made in Italy, in the south of Europe. But money most often draws talent, and furniture makers, like other craftspeople in demand, soon found that they were welcome everywhere. As its practitioners scattered, the craft became something of an international community, as the sons and daughters of carvers, cabinetmakers, and other such artisans married and formed a great "extended family" across Europe.

The most money was in France, and that is where the furniture-making community came to be centered. Midway through the 17th century, France was the wealthiest nation in Europe. Rich French nobles were busy rebuilding their homes after years of civil war. Italian furniture makers did not miss the opportunity; they traveled to Paris. To escape the city's guilds, the newcomers settled in the Faubourg St.-Antoine, a district owned by an order of nuns and traditionally, though not geographically, separate from the capital.

The French were willing to spend money for fine furniture. Louis XIV wanted to make a lavish display of material splendor; his nobility competed with him, often bankrupting themselves in this contest of luxury. Pieces of furniture were numerous and visible, and so played an important part in the competition. The king won an unsurpassable lead, however, by establishing his own furniture factory. The Gobelins workshop had been operating since 1622, but in 1667 Louis gave it more money and more workers, and renamed it the Royal Manufactory of Furniture for the Crown. The Manufactory had to produce work so fine that it would find buyers all over Europe. Money had drawn talent to France, and now that talent would also draw more money. The throne followed the example of the Medici Galleries in Florence. Charles Le Brun, an architect and the king's First Painter, oversaw the work with a team of lieutenants. No guilds had authority in the king's workshops; the artisans simply followed the orders sent down by their

supervisors. They worked for the best wages in the trade and the state educated their children. The complex continued at full strength for 18 years: Louis spent as much on wars as on luxuries, and 1686 military demands forced sharp cuts in the Gobelins' budget. But the tradition of luxurious furniture was established in France, and it never left; after Louis' death, 1,325 seats were counted in the palace of Versailles.

In the 17th century craftspeople made more furniture than ever before to satisfy the demands of the rich. Those who could afford to do so amassed quantities of furniture. Sofas were added to rooms that before held only chairs and tables; then patrons began buying new kinds of sofas. The furniture makers sold bulky plush armchairs and even more bulky chairs meant for sleeping. Furniture was intended to be visible evidence of wealth.

In less sophisticated times, the carpenter who made a bed also designed it. No longer, however, could one person conceive and execute a piece of fashionable furniture. Customers' concerns went beyond the usefulness of a piece of furniture. It now had to show a special elegance.

Some cabinetmakers specialized in marquetry, the decorative inlay of wood, ivory, and other materials. (From Diderot's Encyclopedia, *late 18th century)*

In the Gobelins, the king could hire artists for their lifetimes and have them design his chairs and tables. But who would design the furniture made outside of the king's factories?

The question was an important one because of the attention paid to furniture; almost anyone whose work had to do with the interior of a house wanted a say in how its furnishings would look. Before, what furniture there was had been placed in conventional patterns along the walls of a room. The same set of patterns, changing for each room, could be found in the home of every family rich enough to afford furnishings. Now these patterns began to shift, as people began to design the interiors of their homes. Over the coming centuries, furniture would come to be arranged ever more freely, resulting in the individualized interiors of today. Since the rich were the first—by many years—to be affected, there arose a group of people who tried to make a profession of planning the arrangement of their interiors, including furniture. The first *interior decorators* made their appearance.

Chairs, with their finely curved pieces and plush upholstery, became widely fashionable only in modern times. (From Diderot's Encyclopedia, *late 18th century)*

Who these interior decorators would be was an open question. *Architects* had come up with a new discipline when they planned a building's construction and the look of its exterior. They also had to plan for the wants and needs of the people who would live in the building. As one wrote in 1624: "Well building hath three Conditions—Commoditie, Firmness and Delight." Commoditie (comfort) was placed first. This meant planning interiors. Architects of private mansions often chose to design what furniture would go inside it. Charles Le Brun and Jean Berain drew up the architectural plans for Louis XIV's palace at Versailles, and they also designed its furniture. Berain's pupil, Daniel Marot, brought the practice to Holland and England, where he insisted upon matching patterns for all of the accessories in a room. Most architects sketched out just the few pieces of furniture that would first catch the eye and give the room its effect. The furniture makers would then make the rest of the room's furnishings to match. Sometimes architects, or people who took that title, made their living as *furniture designers*. Through the 17th century they published books of furniture designs for anyone to copy. These people never worked on a building, but they understood what a practicing architect had to look for in furniture. Their books could guide builders or give ideas directly to the furniture makers.

Once a house was built and furnished, its architect went on to another project. But rich families sought new opportunities to demonstrate their wealth. No suite of furniture was intended to be permanent. When the old goods went and new ones had to be found, no one thought of consulting an architect, a person whose chief work was putting up buildings.

Some *upholsterers* fashioned covers and wall hangings in the furniture shops. Others who belonged to the craft practiced a more complicated line of business. In the Middle Ages, they had bought and sold clothing at second-hand. Now they were far beyond that. Upholsterers supplied fabrics; and since wall hangings

and curtains in those days did much more to furnish a home than they do now, the upholsterers formed ideas, just as the architects did, of what the interior of a house should be like. While an architect may have built a mansion and then left, upholsterers entered noble homes and learned their ways. Upholsterers became experts on the most fashionable ways for the rich to spend their money; once they had a say in how that money was spent, they could direct the furniture trade. Their opinions dictated what material silk merchants sold and what styles cabinetmakers would take up. In 1741, an Englishman described the upholsterer as a "Connoisseur in every article that belongs to a House." In effect, upholsterers became interior decorators. As such, they decided what the furniture they arranged would look like, and so became involved in furniture making.

Intimates of the rich could win this much influence because wealth was still the first qualification for owning furniture. Furniture making had become a craft and then something of an art, even an unusually fortunate one. The work of the 18th-century furniture makers surpassed that of their predecessors. These people made more furniture and sold their work for more money than their colleagues of an earlier time had ever thought of doing. A few decades after his death, Louis XIV's 1,325 chairs were considered sparse by royal standards. A nobleman could choose chairs built to serve almost any purpose that came to mind—the *F/voyeuse*, or "onlooker," for example, provided a rail with padding for comfortable inspection of a card game over the players' shoulders. The fabrics that upholsterers used—like silk from the other side of the world—cost more than most people in Europe could ever dream of having.

Furniture remained a privilege and a luxury, plentiful (when matched against the quantity found in the rest of the world) only because Europe's nobles insisted on indulging themselves with it. In the 1520s, when the furniture makers were creating a separate craft, a farm worker might own a table, but he was far less likely to

own a stool. Most people in England, according to a man remembering the time, slept upon "straw pallets or rough mats covered only with a sheet." By the 18th century the people of England had become the most prosperous in Europe. Many furniture makers were at work, and many in England earned great profits. But in Cowdray, a noble English mansion, the servants slept on pallets that were laid out at night then rolled up in the morning. More people than before had furniture of some sort, but many still had none.

Through the last decades of the 17th century, the furniture-making crafts began to spread slowly north. In 1685 France's rulers revoked the Edict of Nantes, a royal order of tolerance for Protestants; the resulting loss of religious freedom gave many able craftspeople a commanding reason to leave France. While the wars of Louis XIV had ruined parts of the French economy, England's wealth had continued to grow. Even London's Great Fire of 1666 did not cripple the nation; the rebuilding of the capital provided decades of work for artisans with the right skills. So furniture makers were drawn to England. Many upholsterers working in England during this time were French, like John Poitevin and Philip Guibert; cabinetmakers were more likely to be Dutch, like Cornelius Gole and Gerreit Jensen.

Native English artisans learned from these skilled immigrants, worked hard, came to hold their own, and soon had made an enviable name for themselves. John Evelyn wrote in 1696, with pride and possibly surprise, of "that late Reformation and Improvement" by which the craftsmen of England "Paragon, if not exceed even the most exquisite of other countries . . . Joyners, Cabinetmakers and the like, . . . from very vulgar and pitiful Artists, are now come to produce work as . . . admirable . . . as any we meet with abroad."

As England's wealth grew, ambitious entrepreneurs and professionals became rich; in turn the most skilled of the craftspeople who served these newly rich could also acquire wealth. In 1768, for example, one Mr. Seddon,

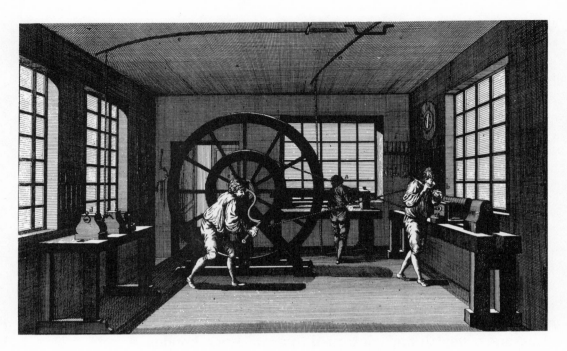

As furniture making moved into the modern age, lathes like this one were increasingly used by turners. (From Diderot's Encyclopedia, *late 18th century)*

owner of a furniture-making company, lost 20,000 pounds (about $250,000 today) in a fire. With wealth also came prestige. The London newspapers of the period referred to the "eminent" William Hallet, cabinetmaker.

The English cabinetmakers worked for themselves. The king owned no factories, though he did employ a personal cabinetmaker who held the post of Great Wardrobe and received an annual salary of 25,000 pounds (about $312,500). Making fashionable furniture meant employing a team of workers, and the more workers a workshop had the more money it could earn in a boom market. A cabinetmaker might begin his career bent over his workbench and end it managing a small-scale Gobelins.

These successful artisans, still called cabinetmakers, understood every step involved in making furniture, but they also became something like present-day manufacturers. A German lady visiting Seddon's furniture company in 1786 reported that it employed 400 men "on any work connected with the makings of household furniture—joiners, carvers, gilders, mirror-workers,

upholsterers . . ." The building that housed them had six wings. One department "contains nothing but chairs, sofas, and tools of every description," while in others could be found "writing-tables, cupboards, chests-of-drawers, charmingly old-fashioned desks . . . in all manner of wood and patterns." Of course, Seddon and Company also provided wall-hangings and carpets, "in short, anything one might desire to furnish a house . . ."

The people who made furniture now ran the trade. Since there was a great market for their work, cabinetmakers no longer worked solely on custom-made pieces ordered in advance; they now worked on their own projects and sold their work retail—that is, to anyone who wished to buy it. The cabinetmaker now had a claim to the patronage of the rich, matching that of the upholsterers. In fact, the two trades seem to have merged in many areas. In 1811 an Englishman remarked that "in almost all places the business of the cabinet-maker is united to that of the upholsterer . . ." Thomas Chippendale, the most famous of England's furniture makers, did not just sell furniture; he took responsibility for the interior decoration of his client's home. Once the furniture had been bought, his employees were on call to clean and fix it as needed. Chippendale workers made and installed everything that went into a house, down to the wallpaper and a mahogany cage for a pet monkey.

Since even the best furniture could now be made for retail sale, it was only a matter of time before some people started earning their livings by simply *selling* furniture, rather than making it. In London, furniture sellers and tapestry sellers took over a street called Broker's Row. In Paris, they settled along the Faubourg St.-Honoré. The English storekeepers also called themselves cabinetmakers; by then the name meant merchant almost as much as it did artisan. At first the furniture they sold came secondhand from people who had tired of it. But after a while these stores could buy new furniture from its makers, and even hire their own artisans. Now the rich were not the only ones who could afford furniture.

Thomas Chippendale's *The Gentleman and Cabinet-Maker's Director*, published in 1754, noted that it contained designs "suited to the Fancy and Circumstances of Persons in all Degrees of Life."

Professional furniture makers could be found in even the less prosperous regions of the West. Philadelphia, one of the chief cities of England's North American colonies, made a small amount of furniture that could match the best of the mother country. In 1775 Boston had 150 furniture makers and Newport had 50. Inspiration for designs came from England, however. A foreigner visiting Philadelphia wrote home: "Household goods may be had here as cheap and as well made from English patterns." "Price-books" written overseas told cabinetmakers what to charge customers and what to pay workers. Chippendale's *Director* provided designs, though these had to be modified—chairs were narrower and taller than in England, to suit the more cramped American homes. American furniture makers worked most often with native pine. Haircloth and dyed leather replaced silk in American upholstery, as did cotton printed with patterns. Except for silver, materials for expensive decoration had to be imported from Europe.

Only furniture makers in America's largest cities could afford to specialize. Most worked in their own shops. Duncan Phyfe employed 100 workers, but his firm was, until the second half of the 19th century, comparatively immense. In the cities, the different branches of the trade were not represented by their own guilds; workers specialized only because division of labor met the demands of a growing market. All furniture makers entered the craft the same way, serving as apprentices from age 15 to 21, then going from shop to shop until they could set up their own businesses. Furniture makers did much of their work as storefront tinkers. In 1801, Samuel Ashton of Philadelphia made 120 pieces of furniture and repaired 70. One interesting point about American furniture makers of this time is that they won respect not simply for being artists, as in Europe, but for being *useful*

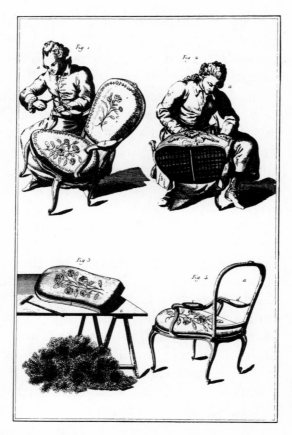

Working hand in hand with makers of fine furniture were upholsterers who covered the finished pieces with fabric. (From Diderot's Encyclopedia, *late 18th century)*

artists. The furniture-maker made fine things that one could put to good use.

Through the 19th century, the history of furniture making in Europe and America merges. Like other artisans, furniture makers found themselves working for a mass market that extended throughout Europe and America. The prosperity that created this market was produced largely by the machine age, and the market itself could be satisfied only by machines.

As the century began, the finest of English cabinetmakers could be found not only in London, but also in Lancaster, Liverpool, Leeds, and Edinburgh. The Frenchman Jacob-Desmalter made $350,000 worth of furniture every year. Furniture had become something that everyone owned. In the novel *Cousin Bette*, French writer Honoré de Balzac, who had an eye for the details of

everyday life, described a down-at-the-heels lower-middle-class apartment in Paris, which included two bedroom sets, a sofa, chairs for living room and dining rooms, dressers, a side table, a dining room table, and knick-knacks for a mantelpiece. Furniture was no longer just plentiful; it now crowded rooms, especially those of the affluent. The English slang "what-not", coined at this time, described a piece of furniture whose use was not apparent.

In the 19th century, the important furniture makers might simply design a piece and leave its production to legions of workers. Some simply owned and managed their companies and hired others to do the designing. Coil-springs gave seats comfort that had been unknown before. Metal parts, like brass bed rails, competed with wood. American factories produced many kinds of iron benches for the garden, molded to resemble logs, rustic bridges, rose tendrils, and anything else they thought their customers might buy. The new technology of the trade allowed the imagination to run free. Americans thought up a line of "gadget furniture" for invalids, equipped with mechanical claws worked by levers. Machines could make furniture from coal, from antler horn, from papier-maché—and so, for a time, they did.

But industrialization had its disadvantages. Before the machine age, furniture making had come to be considered an art, and some people insisted on keeping it one. The Englishman William Morris created work painstakingly by hand, much of it very fine, but one factory in full production could turn out dozens, hundreds, or thousands of pieces while such a lone craftsman was working on a single piece. Others tried to infiltrate industry. Members of the Art Furniture movement hired themselves out as *designers*, deciding that what the factories would do should at least be done well. Finally, a few of the industrialists made furniture that was first-rate and like nothing that had come before. Germany's Michael Thonet manufactured "bentwood furniture," with frames made of narrow, steam-curved

sections of wood. The product was simple and lightweight, and its sinuous arcs appealed to a variety of people—from artists to American pioneers.

But most of the new furniture never did become popular. In 1904, an English architect wrote: "It is indeed difficult at the present time to buy a piece of modern furniture with which it would be a pleasure to live." Much of the factory-made work was shoddy, and much of the artists' furniture was made for their colleagues to admire rather than to make anyone comfortable and happy. Through the 19th century, and even up to today, many customers lost confidence in the designers of modern furniture. Until the last few decades, the possession of work that was distinctively new seemed almost eccentric.

Partly as a result of this rejection of the new, the trade in antiques became a healthy one from its start in the 19th century. Evidence of it existed in the previous century in

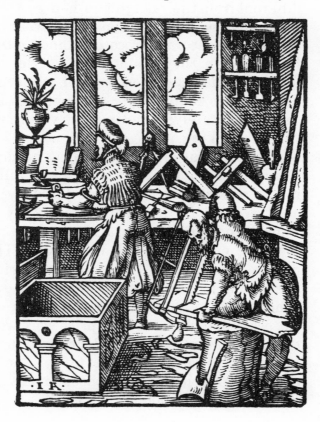

These Nuremberg joiners are making a variety of furniture with elegant moldings. (By Jost Amman, from The Book of Trades, *late 16th century)*

secondhand furniture sold along Broker's Row, as well as in the "charmingly old-fashioned desk" that the German visitor saw being made at Seddon and Company. But it became a powerful fashion when George IV, who ruled England from 1820-1830, collected a great store of French furniture from the previous two centuries. Specialist retailers—*antique dealers*—made a profession of running emporiums for the rich, collecting, appraising, and restoring valuable works, as well as advising their clients. This work still goes on, conducted by talented and dedicated experts, and still returns respectable profits.

Since very few people could afford genuine antiques, the furniture industry supplied copies. The rage for reproductions began in the 1830s. Many families moving into London's new middle-class suburbs wanted their houses to have style and distinction, but not to look too different from their neighbors' houses. One style satisfied everyone, and the suburban villas were furnished in the elaborately decorated rococo manner of the 17th century. Furniture in the "Louis Seize" style, modeled on the furniture that had been popular while Louis XVI ruled France, also found buyers. Sometimes the pieces were copied accurately; sometimes they were just meant to be "French looking."

A certain pattern of decorating became universal in Europe and the United States. In an affluent home, the rooms regarded as masculine territory (study, library, and dining room) were generally furnished in Renaissance or Classical fashion, or in the grim Gothic manner of the late Middle Ages. The rest of the house—regarded as the woman's territory—was done most often in the elaborate Rococo style. A few styles from times gone by suited both the upper and the middle classes. What changed with price were workmanship and the faithfulness of design. Reproductions stayed popular into the 20th century. Half of today's "antiques" are said, by one authority, to have been made in England and France between 1900 and 1930.

Through the 19th century and into the 20th much work continued to be done by laborers; a hybrid of machine work and craftsmanship survived. In a district of furniture makers, one shop owning machines that performed the most repetitive parts of furniture making would rent their use to artisans who came to the store. In this way, an unofficial factory of independent hand workers evolved, with the equipment in the one store as its industrial plant.

Few furniture factories today employ more than 100 people. Much of the work is done by machines, although the more delicate work, such as fitting fabric over a seat's springs, still must be done by hand.

After industrialization, manufactured furniture declined to a sometimes tasteful mediocrity. Lately, however, there has been some improvement. Factories produce work that can be comfortable and unobtrusive, as well as more startling goods that are higher in price and whose styles come and go with the fashion. *Interior decorators*—who in the 20th century appeared as professional advisers, clearing out the over-stuffed rooms of Edwardian England—now select and arrange the furniture primarily for affluent families. But for the majority of the population, furniture is a readily available convenience that is kept clean but does not command much attention.

For related occupations in this volume, *Artists and Artisans*, see the following:
 Clockmakers

For related occupations in other volumes of the series, see the following:
in *Builders*:
 Architects and Contractors
 Carpenters

Glassblowers

The people who work with glass have traditionally been among the most respected and important of skilled artisans. Glass has been used to make both household goods and sophisticated art objects, and for centuries the *glassblower* has been the chief creator of glass.

Making glass and fashioning objects from it are usually part of the same process. Glass is created from a combination of ingredients, the most important being silica, found in the form of sand. The ingredients have to be mixed in the right proportions and then melted together under extremely high temperatures. The newly created glass is worked upon while it is still hot and soft. Turning molten material into a finished product requires skill and coordination on the part of an entire team of workers. Until the introduction of machines during the

Industrial Revolution, this was the only way glass could be made.

Egypt and Mesopotamia seem to have been the earliest homes of glassmaking. Information is sketchy, but by 1600 B.C. glass was being used for the manufacture of small beads; by 1550 to 1500 B.C., large numbers of more sophisticated cups and bowls were being made. The Egyptians were skillful users of glass for decoration, and their work resulted in some stunning artifacts that still survive today. The funeral mask of the 14th-century B.C. Pharaoh Tutankhamen, for example, admired by modern-day museum crowds the world over, was inlaid with beautifully worked cut glass. The Egyptian glassworkers seem to have been independent tradespeople who sold their work to a small market, one rich enough to afford novel and decorative items. Glass amulets and perfume containers have been found in the tombs of ancient Egyptian nobles.

After 1000 B.C., glassmaking techniques were established throughout the eastern Mediterranean and in Persia. Early techniques were cumbersome. A chief method was "coring." Glass was set to harden around a core that would then have to be scraped out. This took time, and since few pieces could be produced, prices were high.

It was not until the last century before Christ, some time after 100 B.C., that *glassblowing* was devised. This method of working glass was much simpler and quicker than any that had come before. It forever changed the glass trade, allowing both the cheaper production of common household objects, and the creation of luxury items that steadily gained in delicacy and artistry. For almost 2,000 years the glassblower would be the chief maker of glass. It is a measure of our ignorance of ancient life that no one knows by whom or where this new method was invented. It arose somewhere in the eastern Mediterranean region, perhaps in Syria; after a few decades, it had become the only method for making glass in the region.

The techniques of glassblowing changed little for centuries, although knowledge of the craft was lost for a time in many parts of Europe. (From Diderot's Encyclopedia, *late 18th century)*

The way glassblowers work has not changed essentially in any century or any country: A team of workers prepares the glass mixture and fixes a lump of molten material to one end of a blowpipe; the glassblower, the chief of the team, then shapes the glass. This can be done either by blowing the glass into a mold, or by "free-blowing." First the lump of glass is rolled into an approximation of the desired form; then the glassblower uses lung power and a set of tools to give the glass final shape.

In the same century that glassblowing developed, the Mediterranean world was dominated by Rome. Under the early empire, prosperity and peaceful trade created

new buyers for glass, and the glassblowers responded to that market. It has been estimated that more glass was made in the first century A.D. than in the thousand years that came before it. Glass was a practical necessity of Roman life, serving to store food, to hold medicines, and to set the table of a prosperous family.

The glassblower was a privileged person whose services were much in demand. At first Rome had to depend upon exports from Alexandria and Syria. But glassblowers were not tied to one place; they knew they could make a living anywhere in the empire. In A.D. 14 the Emperor Tiberius summoned a group of glassblowers to settle in Rome. They found the city so receptive that soon glassblowers became leading artisans, with a section of the city claimed as their own (a common practice among Rome's skilled workers). Glassblowers also established themselves in the Roman provinces in France, along the northern Adriatic coast, and in Britain and Spain. All they needed was easy access to sand and forests to provide fuel; they knew there would be people willing to buy their goods.

Little is known of how Roman glassblowers conducted their trade. While they produced only ordinary objects for most of the population, glassblowers acquired new skills permitting them to create the sort of decorative objects that only the rich could afford. It is said that almost every one of the techniques used in contemporary creative glassblowing was known to the Roman workers. The *Portland Vase*, named after one of the aristocrats who owned it in later centuries, is a Roman work thought to have been commissioned by the Emperor Augustus in the first century B.C. The vase, which can still be seen in the British Museum, is a two-handled jug of black glass covered by a thick second layer of white glass; the white glass has been cut away to create a scene depicted in detailed sculptural relief.

As glassblowers prospered, they found themselves attracting the special attention of tax collectors. In A.D. 220, the Emperor Alexander Severus needed money and

settled upon glass as an industry healthy enough to supply it. He levied a new revenue tax on glassblowers. This tax was a sign of the glassblowers' prosperity, but it was also one of the many small symptoms of the empire's decline. As trade declined and wars returned, Rome's rulers had to look harder for money. The glassblower also felt the pinch; glass was a favorite material for people with ready money, but when money was tight, glass became a luxury. Equally important, the glassblowers depended upon safe transportation for their products to reach their markets unbroken at a reasonable price. When the Western Roman Empire fell, every craft and trade suffered, but glassblowing completely disappeared in Western Europe.

After that, glassblowers once again were found only in the East. In Japan and China, glassmaking had been known since about 1000 B.C; Indian glass artifacts have been found that date back 500 years before that. But these countries' glassworkers created only beads, amulets, and other personal adornments—sometimes very beautiful, but limited in range. Glassblowers worked only near the Mediterranean, in Persia and in the Eastern Roman Empire's Asian territories that survived the fall of Rome in the West. The status and methods of the glassblower seem to have continued much the same as before; the craft survived and even flourished when the entire Near East was captured by the Islamic Arabs in the seventh century. New invasions from Central Asia later devastated Islamic civilization, but, even then, rulers recognized that glassblowers were valuable artisans. When Tamerlane sacked Syria in 1420, one of the prizes he sent back to Samarkand was a detachment of men skilled in glassblowing.

In Western Europe, the craft was lost through most of the Middle Ages. When it was rediscovered, glassblowing seemed something so new as not to be a trade at all. In France during the 10th and 11th centuries, the few who learned how to create glass were feudal lords; traditional crafts were considered inappropriate for people of

their status, but the throne did not consider glassmaking a craft. For centuries, aristocrats owned and even ran glassmaking operations. In the 12th and 13th centuries French religious wars brought refugees to England, among them workers skilled in glassmaking. Sussex and Surrey, with forests for the furnaces and sand nearby, began producing the first glass that England had seen in centuries. As in France, aristocrats provided the money and materials, hoping to earn new revenue through trade.

Glass windows in many medieval churches are made of *stained glass*—tiny panes, each one a special color, arranged into devotional scenes, often of great beauty. Stained glass seems to have been widespread in the 12th and 13th centuries. A central workshop may even have trained apprentices in the art—at least, church and cathedral windows completed in different decades are remarkably similar and their work done at the same high level of skill. Like most builders of the day, *stained glass artists* probably wandered from project to project. Their best and most plentiful products are found in France and England. Some of their craft traditions survived into the 20th century.

Theophilus, an 11th-century monk who wrote about crafts, recorded that he mixed his colors with wine and urine. He made his brushes from the hair of cats and the manes of asses. In the 14th century stained glass artists were more sophisticated; their colors were named after gems, and are still famous for brilliance. White was called *crystal*, blue *sapphire*, red *ruby*, and so on. The color red was actually produced by a skin of molten ruby being laid over the still-forming glass. Colors were not painted on; the glass itself had to be tinted while it was still being made.

Stained glass workers in medieval times drew out a series of plans while they thought a project through. Some of the plans—charcoal lines on white-washed table tops—survive. First came a sketch of the scene to be rendered, something like a *cartoon*. The artist then had

to calculate what segments of glass would compose this scene, and draw out a plan of their outlines; this scheme was called the *cutlines*.

Stained glass work declined after the 15th century. The Reformation brought forth a breed of worshipers who preferred simply decorated churches. In addition the invention of colored enamels made it a simple matter to paint glass whatever color one wanted. The colors were crude, but cheap to make and apply; skilled labor was no longer necessary. And once skill had left the craft, the craft itself largely disappeared, though it has been revived somewhat in modern times.

During most of the Middle Ages, glassmaking as a skilled craft was in Europe confined to one city: Venice, Italy. Trade with the East had made Venice one of the wealthiest cities in Europe. It had the money to create its own skilled industry and an interest in creating valuable exports. Rather than import glass from the East, Venice

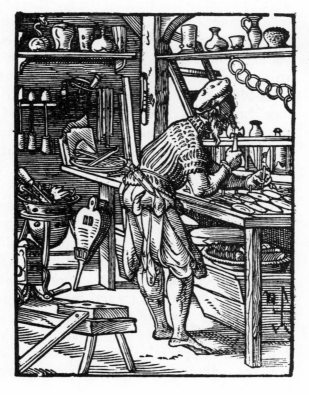

Venetian techniques for making drinking glasses were copied throughout Europe. (By Jost Amman, from The Book of Trades, *late 16th century)*

imported several glassblowers and began making glass in the mid-13th century.

Glassblowers once again became respected as skilled and valuable artisans. But because they had learned their skills under the auspices of the city's rulers, the Council of Ten, the glassblowers were considered commodities to be kept under careful watch. The Council wanted its new industry to stay unique; glassblowing techniques were an official secret. Glassblowers were forbidden by law from working for foreign nations. Glass products were stamped with the seal of Venice and sold through the city government, which also oversaw technical developments in the craft, granting monopolies for the production of new kinds of glass.

In 1291, the city moved its glassblowers to the nearby island of Murano, where they worked in isolation. The glassblower's prestige was magnified by some rather extravagant legends. As salamanders were thought to be able to exist in the hottest fires, some people claimed that salamanders lived in glasshouse furnaces, directing the glassblowers in their work. Another less fantastic story reflected how far the Council of Ten would go in protecting its secrets. According to the story, a fugitive glassblower escaped Murano and fled the country. On foot, he traveled across Italy and the length of France, until one day he reached the gates of Paris, still closed at dawn. When the gates opened that morning, the city guards found him dead; the Venetian Council had sent an assassin to track the man down.

But the glassblowers found their position comfortable. By 1268, they had organized themselves as a guild, taking part in an annual procession of craftspeople through the city. Venice, as a trading city, was devoted to the makers of its most valuable exports, so it is not surprising that a proclamation issued by the Council in the 1450s refers to the work of the glassblowers as "the glory and ornament of the city." In 1376 glassblowers were made burghers, a special class whose daughters could marry into the aristocracy. This new privilege was a measure, no

doubt, not simply of the glassblowers' prestige but also of their wealth: Sons of the nobility, as so often happens, may have been looking for profitable marriages.

In 1271, the guild negotiated with the government a set of regulations called the *Capitolane*. These tell us something of how a medieval glasshouse worked. The furnace was kept going constantly, and the operation was staffed by two shifts of workers, each working 12 hours a day. Glass was made from January through August; the rest of the year was spent in repairing equipment and finding raw materials. At this early stage, the Venetian glassblowers made only useful, everyday objects; the *Capitolane* mentions beakers, wine bottles, and glass weights.

Work in a glasshouse was divided among teams. *Gaffers* were the elite, the people who actually blew and shaped the glass. Beneath them were the *apprentices*, and then the *boys*. One large furnace heated the glass; smaller ones, called *glory holes*, were used by the individual teams to keep the glass soft while containers were given final shape. Lower-level workers looked after the furnaces and materials; the glassblower created the piece itself. But even he did not fashion his own work. The more elaborate productions were made by groups of glassblowers; each one finished a piece that would then be assembled with the others. The manager of the glasshouse, the chief glassblower, had his own smaller furnace, which he used to work out new designs his teams would later follow. As the market expanded, Venetian glass factories developed a systematic division of labor that resembled that of modern-day industries.

We know little of how someone went about becoming a glassblower in Venice. The best source of information is a set of regulations dating from 1783, for a glasshouse run by Venetian expatriates in Stockholm, Sweden. At that time a candidate had to be male and at least 15 years old. For his first five years in the glasshouse he performed menial work while a gaffer instructed him in the craft. He was allowed to use the glasshouse furnaces six hours a

week for his own efforts. After becoming an apprentice, he prepared a trial piece designed to show his skill; if the glassblowers of the workshop approved, he was accepted into their ranks.

By the 15th century, Venetian glass was known for its exceptional beauty. Gradually, however, the craft spread, and glasshouses outside Venice developed and prospered as well, taking up the market for simple wares. A picture from this time survives, showing a glasshouse in Bohemia, a region of present day Czechoslovakia, where the craft flourished. Because of the heat, work was done out of doors; the picture shows a roof supported by stilts as the only shelter. The roof is made of slats, so that sections could be removed to affect the movement of heat and air. One man with a blowpipe wears protective clothing: two layers of heavy stockings cover his legs, a damp cloth is wrapped about his hair, and his left side, turned toward the furnace, is covered by a thick cloak.

In France, families of glassblowers tried to keep the craft among themselves. Since a glasshouse required teamwork, it made sense to keep things in the family; it also made sense to cut down on the competition. One region confined the right to blow glass to legitimate male children of the Henvezel, Thietry, Thisac, and Biseval families, forbidding them from teaching others "on the peril of the damnation of their souls. . ." The families of glassblowers, though no longer so exalted as they had been a few centuries before, were looked on as belonging to an outlying branch of the French nobility. Even if they leased their land rather than owned it, *les gentilhommes verriers* ("the gentlemen glassmakers") were exempt from taxation. In Bohemia, one family, the leading glassblowers of the region, prospered enough to be made nobles by a special act of the Holy Roman Emperor in 1592.

In the 16th century, Venice's glassblowers began to disperse. The city's power and wealth had declined, and the Council could no longer firmly control its subjects. The Venetian glassblowers' skills, still unmatched at

that time, were appreciated in the growing cities of northern Europe. Venetian glassblowers traveled in groups of up to six, so that together they could work as a complete glasshouse team. By the end of the century, glassmakers from Venice were earning livings in Austria, Bohemia, France, and further north, in England, Holland, and even Sweden.

The invention of the printing press and Europe's spectacular rise in population made glassblowing a far less exclusive craft than it had been before. Books could reveal the secrets of making simple glass, although the highest craftsmanship was still out of reach for most. At the time, more people than ever before had money with which to buy glass. The Venetians and their imitators, producing luxury goods, continued to work near the cities. But from the 15th century on, glasshouses were set up in the forests of northern Europe, away from the cities. Far from centers of fashion, they turned out simple bottles and other practical wares, rapidly expanding in the 17th and 18th centuries.

A site would be established, with large numbers of workers brought in and housed in tenements. The glassblowers lived with other glass workers, although the chief glassblower, who usually worked his way up, would generally have his own house, often a modest manor. These glasshouses sometimes grew into permanent villages, each community with its own rules. The glasshouse master ruled unchallenged; he negotiated all business deals, set regulations, and acted as judge for his fellows. Generations of families would work for the same glasshouse, producing the same bottles. Only the influence of Venice, slowly filtered through the cities, brought attempts to experiment. Otherwise the rhythm of life at the glasshouse stayed undisturbed.

As Europe's glass industry grew, England gradually took the lead. Attempts by the Crown to control the craft were ended with the Civil War of 1640, and England's technical progress soon brought it dominance of the glass

market. The English devised a more attractive kind of glass called *lead glass* which gave a sheen that made elaborate workmanship unnecessary. By 1696, 88 glasshouses operated in England, providing goods for both the aristocracy and the middle classes. Of these, 37 made only bottles, 19 made flat glass for windows, and 22 made "flint and ordinary" tableware. From the start of the 17th century, English glassmakers had used coal as the fuel for their fires in order to preserve timber for England's navies. Using coal allowed the English to maintain glasshouses as large as those in German forests.

The most highly skilled glassblowers still kept a respectable place in society. In 1754 a Norwegian spy was locked in Newgate prison for luring away English glassblowers; he escaped and led off some renegade glassblowers who enjoyed very comfortable lives in Norway. The designs created by a glasshouse were not commissioned by clients. Instead, the operator of the glasshouse set his own designs, and then sold as many as he thought people would buy. But the workers below him could not always count on security and independence. Except for the most accomplished, workers in the English glasshouses lived on low wages in tenements that quickly became slums.

The European powers in America tried to equip their colonists with glass but their efforts were not always successful. Spanish glasshouses failed in Latin America. In 1621, Captain William Norton brought four Italian glassblowers with him to an English colony in Virginia, but the only work they could find was making beads for the Indians, and after a few years they became dissatisfied enough to leave. It was not until the 18th century, when something like a settled European civilization had grown up in America, that glass became a desired commodity. In America, however, it was local businesspeople rather than the government or aristocracy, who set up operations with their own money. Caspar Wistar, who previously had manufactured brass

buttons, brought four German glassblowers to New Jersey in 1739, with a promise of a share of profits. His glasshouse, which turned out bottles, was similar to the forest houses of northern Europe; the workers lived together in the midst of their fuel, subsisting on the community's own cattle and crops.

In America there was no way to keep valuable expertise secret. Competitors arose, and workers left to sell their knowledge elsewhere. Where there was money to be made, people always found new ways to produce whatever was valuable. The prestige of the craft, already threatened in the new Europe, began to diminish even further. Improved furnaces made it possible to prepare vast quantities of glass at one time. In 1826, a machine was introduced that could press hot glass into rows of molds, producing quantities of a product that sometimes looked complicated enough to have been made by a painstaking craftsman. In 1845, one factory employed 800 people, and sold $600,000 worth of glass. By the late 19th century, a glassblower in one New Jersey factory was paid $60 a week, 10 times the usual wage for unskilled labor. This placed him in the elite of the working class, but the working class did not occupy an enviable position in the America of that day. The owner of a New Jersey factory was considered something of a saint because he let his workers rest every Sunday, whether there was hot glass in the furnace or not.

Glassworkers no longer felt they had a stake in keeping things the way they were. In earlier times, a person who worked in glass had spent years learning a trade that could someday bring him comfort and respect. Now he either assisted machines or knew that his job was about to be taken over by them. The Sandwich factory of Cape Cod, the most successful mass producer of glass in the United States, saw its employees organize themselves into the Flint Glass Workers Union. An attempted wage cut in 1883 brought a strike that closed the factory. In Minotola, New Jersey, one factory that employed blowers as late as 1901 attempted to install

bottle-making machines. The glassblowers, told that they would be kept on as factory hands, organized themselves and struck in defense of their craft. The glassblowers wanted to continue at their old work, but neither side would give way; in the end, the strikers burned down their factory.

Machines were needed to make glass for the mass commercial market, a job that had become too big for human hands. The making of hand-blown glass became a pastime limited to artists. For the most part, these people were males from the middle or upper classes, with patrons and clients drawn from among the wealthy. In America, Louis Tiffany, a successful painter, went on to found a thriving business in luxury glass items. When an artist who worked with glass became fashionable, he found many people willing to pay for elegance. In France, Emile Gallé had a workshop that turned out routine productions in his style, while he concentrated on creating individual masterpieces. René Lalique created the vogue for Art Deco glass, mass-producing his pieces on a power press. Glass factories, trying to capture the small but rewarding market of the rich, might even hire artists to lend creativity to their products. In Sweden, the Orrefors and Kosta glassworks each put artists on their payroll to design work; in the 1930s, America's Steuben glass offered artists generous rewards for new ideas.

Such opportunities are exceptional, however. For the most part, people work glass as a pastime. Like all the arts, glassblowing finds a special haven in museums and universities. For example, glassblower Harvey Littleton first began working with glass in his own garage, on a grant from the University of Wisconsin. Since 1957, he has tried to educate Americans about glassblowing as a technique and an art form, writing books and teaching classes, as well as exhibiting his own work.

Up until modern times the glassblower was at the center of all glass production; even glass windows were formed from blown glass that was cut and allowed to flatten. That is one reason why early windows were so

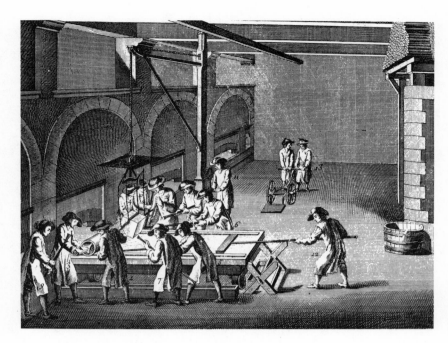

The techniques for making mirrors and large windows were perfected only in modern times. (From Diderot's Encyclopedia, late 18th century)

small, so distorted, and so few in number. Before modern times few flat pieces of glass were produced that exceeded five feet in diameter. The "window revolution," which in modern times has produced picture windows and window walls, was made possible only by the development of machinery that rolled sheets of glass out of the furnace. It is no wonder that the Crystal Palace—a delicate structure made of sheets of glass held in place by a network of iron struts—so astonished Victorian London.

Mirrors underwent a similar transformation. Sheets of glass coated with metal have been made at least since the time of Christ; the techniques survived the fall of Rome in Europe, although mirrors were limited in size by their method of production. In Venice, always a center of glassmaking, *mirror makers* formed their own guild in 1564. The modern method of mirror-making developed with the help of French and German specialists, and it, too, has been transformed by factory production.

Some specialists also worked to produce optical glass. In about the 14th century, both in Europe and in China,

glassmakers began to produce magnifying lenses. These were placed in frames and sold by wandering peddlers who traveled about the land with their cases; customers would try on various pairs of spectacles and choose the one that seemed to suit them best. A 15th-century painting of St. Jerome featured a pair of eyeglasses, and he became adopted as the patron saint of the *spectacle-maker*'s guild. Benjamin Franklin later developed bifocals, which included lenses for both farsightedness and nearsightedness in the same pair of glasses. The development of high-quality optical glass, in which German scientists led the way, was an important part of the development of reliable scientific instruments, such as microscopes and telescopes, which were always limited by the quality of the lenses used in them.

As lens making became more scientific, related specialties developed. Working from a prescription provided by an *ophthalmologist* or *optometrist*, the *ophthalmic laboratory technician* grinds the lenses for an individual's eyeglasses—or in modern times, often contact lenses. The *optician* actually fits the customer with the glasses, making sure the lenses are placed into the frames appropriately for the shape of the individual's

With the ability to grind lenses to precise specifications, the occupation of the spectacles-maker arose. (By Jost Amman, from The Book of Trades, *late 16th century)*

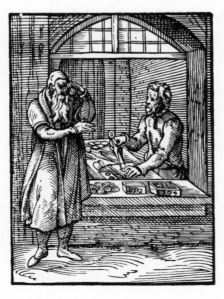

Optometrists like this one rely on modern technology for precisely produced optical lenses. (American Optometric Association)

eyes and face. Both opticians and ophthalmic laboratory technicians undergo technical training as well as apprenticeship for their work.

Recently, glassblowing, along with many other crafts, has enjoyed a revival, finding practitioners among the young of the middle class. These new glassblowers do not practice the craft for financial reasons, but for personal ones. From being one of society's most exclusive and lucrative crafts, glassblowing has become a recreation for people who want to express themselves.

For related occupations in this volume, *Artists and Artisans*, see the following:
 Painters

For related occupations in other volumes of the series, see the following:
in *Healers*:
 Physicians and Surgeons
in *Scientists and Technologists*:
 Chemists
 Scientific Instrument Makers

Illustrators

Some artists have always specialized in decorating or illustrating written materials. Among Egyptian and Babylonian scribes from ancient times, some were adept at illustrating papyrus rolls and tablets. These illustrations usually had religious and magical significance and were most commonly found in works like the Egyptian *Book of the Dead* or in contracts, documents, and chronicles that needed the special protection of the gods.

Illumination—the artistic decoration of manuscripts—became popular in the days of ancient Rome, and reached its height during the Middle Ages. The work was usually done by professional *scribes* or by monks, working as scribes, and does not appear to have been a separate profession until the Renaissance.

Nonetheless, the professional scribe who was an *illuminator* was certainly most highly regarded, because beautiful books could be sold more easily and at a higher price than those containing text only.

Byzantine illuminators of the early Middle Ages were renowned for their fine and elaborate work on biblical themes and subjects. In later centuries, Islamic illuminators established their own traditions of illustration. In Europe, the finest illuminators were the Italians, who in the Renaissance period founded schools for their art in Italy, France, and England.

The art of miniature painting became the secular pursuit of many a professional, where previously it had been a religious form employed by monks in the copying of the Bible. But even these worldly professionals found that the best market for their work was the church, for whom they illuminated prayer books for parishioners. Since the interest of the professional illuminator was

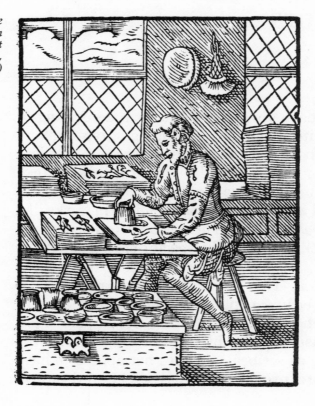

Illuminators colored and gilded the pictures in early books, whether on paper or parchment. (By Jost Amman, from The Book of Trades, *late 16th century)*

more in art than in religion, prayer books like the English *Book of Hours* soon became repositories for secular paintings of battles, landscapes, and peasant life which had little or no reference to the *codices* (manuscript volumes) which contained them. A group of highly regarded Flemish illuminators of the 15th century moved to Paris and produced some of the most realistic painting of their day in the form of book illumination. Some non-religious literature written in the vernacular—that is, in the everyday languages of the people, rather than in Latin—thereafter was also grandly illuminated by professional guilds.

Illuminators often worked in the same company as *scribes*, *calligraphers*, *rubricators* (people who applied red to titles, headings, and some initialed letters), and *bookbinders*; in practice, these activities were often performed by the same person. Ironically, the profession reached its height in the 15th century, after the development of the printing press. Since printed books came out so much faster and cheaper than hand-produced ones, scribes and illuminators accentuated the advantages of hand-made works, chiefly beauty in the form of calligraphy and illumination. Early printed books were often regarded as crude and ugly; in many such books, spaces were left for calligraphers and illuminators to fill in with pictures and designs. This practice did not last long and illuminators found less and less work as the decades wore on. Easel painting was becoming popular at the same time, however, and by the early 16th century most illuminators had become *painters* working on canvas rather than in books.

Illustrators took up the job of providing pictures for Europe's printed books in the beginning of the 16th century. Earlier *block books* had been the first to be illustrated on a mass-produced scale. In block printing, both the text and the illustration were engraved on wood blocks which could be used for rapid reproduction. This technique was developed in China, where all the operations were performed by one person, the *printer*. In

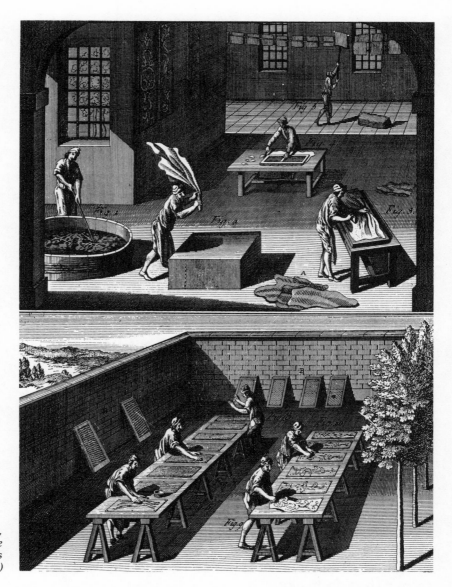

Early books were heavily decorated, both on the inside and, as here, on the leather binding. (From Diderot's Encyclopedia, *late 18th century)*

East Asia, printers would continue to engrave both text and illustration for block printing into modern times. But in Europe the operations soon became separated. There, only pictures were engraved, while text was printed separately on the press. Illustrators, then, did all their work as wood carvings which could be used on an entire page of a book. This was known as *letterpress* illustrating, and it usually involved an illustrator as well as an

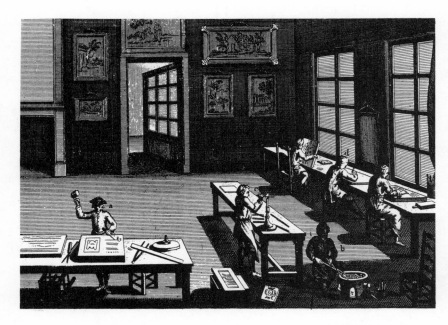

With the rise of printing, illustrators were much in demand to produce wood cuts and metal engravings. (From Diderot's Encyclopedia, *late 18th century)*

engraver, who cut away the background from the picture or design, thus leaving it raised.

Copperplate engraving began to replace the wood-block technique in the 17th century, and the finest of these illustrations were produced in the following century. An artist would usually make the picture, and then an engraver would transform the picture into copper impressions which were to be filled with ink and then pressed onto sheets of paper. But professional guilds of wood and metal-block engravers still played a minor role in the illustration of books, until, by the 19th century, there was renewed activity in their vocation, stemming largely from new techniques invented by Thomas Bewick in England.

Yet another new technique—photography—evolved in the 19th century; it enabled printers to mass-produce illustrations more easily and soon diminished the role of the engraver in the process. A special kind of engraving on stone, known as *lithography*, came into wide use at this time. The craft was simplified by the use of photographic techniques that eventually allowed the *lithographer* to transfer illustrated images onto film for easier printing.

The illustration of books today is handled primarily by artists who specialize in such works. Some illustrators work as freelance artists, but a great many are employed by large publishing firms. They are involved in cover designs as well as in illustrating whole pages in books and magazines. (Some authors, especially those of children's books, are also their own illustrators or *photographers*.) Some photographers are also kept on staff to provide pictures for books.

Picture researchers are modern specialists who find illustrations of all kinds—both old and new—from outside sources to accompany published texts.

For related occupations in this volume, *Artists and Artisans*, see the following:
Bookbinders
Calligraphers
Painters
Photographers

For related occupations in other volumes of the series, see the following:
in *Communicators*:
Printers
Scribes

Jewelers

Jewelers—artisans who work with precious materials —have generally been employed by the wealthy and powerful of society. Gold, silver, and gems are some of the materials most valued by humans, and the upper levels of society can often reserve such goods for themselves. Where jewelers have developed a level of skill to match their materials, they have been the most exclusive of all artisans. This has afforded them a measure of comfort and prestige.

Golden ornaments and drinking vessels dating from ancient Egypt and Ur (where Iraq is today) show techniques that were already advanced; indeed, the work involved in making jewelry is said to have remained much the same from that day to this. The craft requires meticulous attention to detail; once the technol-

ogy for melting and alloying materials was found, everything depended upon the hands and imagination of the individual.

Most of the surviving work from ancient times is of gold and silver, with precious stones sometimes used as embellishment. Even afterwards, *goldsmiths* remained the best-known practitioners of the jeweler's trade. From the start, goldsmiths have made practical objects, though with a high degree of skill and care. The Egyptian tombs contained as many platters and goblets as they did necklaces or bracelets. Kings, nobles, and priests valued the prestige these gave as highly as the splendor supplied by personal adornment.

In Egypt, the pharaoh owned not only all precious materials, but also all the artisans who could work with such goods. Gold mined by prisoners in Nubia, south of Egypt, would be sent to the pharaoh's treasurer and then doled out through a system of slave workshops. People with metalworking skills were valued slaves and,

This Hindu jeweler is working heat-softened metal to produce fine jewelry. (From India, by Fannie Roper Feudge, 1895)

despite their confinement, were at least better off than most of the population.

The desire for gold was universal. The monarchs of kingdoms close to Egypt pleaded that more gold be released for their own use. The Etruscans of northern Italy were as fond of gold as the Egyptians; it is thought that most of their goldworking skill filtered to them through Egypt's neighbor, Phoenicia. Gradually gold became part of international life. By the sixth century B.C. the Greeks were leading goldsmiths, even though they had little gold of their own. Much of their work was with imported materials and was made for foreign clients. Their network of clients reached from Etruria to Armenia; the Greek colony of Colchis, on the Black Sea, even maintained a healthy trade in commissioned work with their nomadic neighbors to the north, the Scythians.

Greek artisans showed skill and ingenuity that set them apart from workers in other countries, and they evidently applied different standards to what they made for buyers from other nations and what they made for Greeks. All their work was handsome, but work that would be bought and appreciated by a Greek was more painstakingly detailed. A gold wreath would have each individual leaf beaten and shaped until it looked as if it might have been plucked from a tree.

Goldsmiths in Greece were not slaves, but independent tradespeople, accorded great prestige. Goldsmiths worked to keep their business in the family, passing skills and equipment on to their children and serving the same noble families for centuries. Goldsmiths' commissions came from men and wealthy associations, for Greek women were discouraged from adorning themselves. Nobles and monarchs of the many small kingdoms were good customers as were government institutions and temples.

As the supply of gold slowly grew, so did its use. In the sixth century B.C., Croesus, a king in Asia Minor legendary for his hoard of precious metal, released some of his gold as coinage. Gold coins were something new,

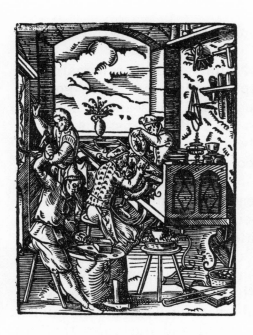

Goldsmiths like these often functioned as informal bankers, before the modern development of widespread banking systems. (By Jost Amman, from The Book of Trades, *late 16th century)*

and they gave the goldsmiths added importance. The logical place to store coins was with the goldsmith, who was transformed into an early type of *banker*.

The Greek world competed with Persia, its eastern neighbor, for the available supplies of gold. The competition ended in 331 B.C. when Alexander, inheriting the overlordship of Greece from his father, overturned Persia's empire. Along with his armies he brought gold prospectors. Mediterranean markets were soon flooded with Persian treasures.

Alexander's generals and their descendants ruled Greece, Egypt, and the Near East for the next few centuries. In this Hellenistic Age, the trade of the jewelers flourished. Women now could wear jewelry, and they spent a good deal on self-decoration. Merchants earned large fortunes, which they were willing to spend. Because of Persia's riches, there was enough gold to satisfy their desire for jewelry. Every large city had its quarter for goldsmiths and silversmiths, and the craft's elite attached itself to royal courts.

After Rome's rise, the Greeks became the new empire's leading jewelers. Rome had never had much gold. The

Roman historian Pliny claimed that in 390 B.C. the population of the city owned no more than 830 pounds of gold among them; gems were equally scarce. For a long time Rome was considered a rough, backward place by its neighbors. Even with the conquest of wealthier regions, the Romans used their new riches to pay their armies of occupation. In the third century B.C., the Senate even passed a law forbidding women to wear more than half an ounce of jewelry.

This changed when Rome at last conquered all of the Mediterranean countries. Though not an age of memorable craftsmanship, it did witness a great deal of gold consumption. Roman jewelers copied the Greeks; indeed the Roman jewelers often were Greeks, imported as slaves by the wealthy families of Rome. The richest nobles competed to find and own the best goldsmiths; even families that were prosperous, but not wealthy, might have a smith of their own. The Romans used their power and money to graft the Greek tradition of jewelry onto their own culture. Rich Romans bought as much as they could. Any Roman noble could set a banquet table with silver. Many went beyond that. In Petronius' *Satyricon*, Trimalchio, a character of repellent greed and ostentation, is used to parody the gold craze among Rome's newly rich.

Jewelers worked hard to keep up with their expanding market. Workshops grew; for greater speed, each artisan was set a specific task, which was carried out on piece after piece. Gradually some of these gold- and silversmiths set up shops of their own. Many of them were Greeks who had begun as slaves; few Roman workers learned the skills that were known to foreign-born ex-slaves. These free jewelers worked along the *Sacra Via* (Sacred Road) where there were enough of them for the satirist Martial to complain that the din of their hammers added to the city's noise.

Most Greco-Roman jewelers worked in the style of earlier centuries; pieces from the fifth and fourth centuries B.C. were especially prized, valued over work

done by contemporary jewelers. One Roman innovation, however, was in considering precious stones as important as gold. As the years passed, the Romans came to prefer size over workmanship in jewelry and the Greek manner thickened, as each piece was worked with more and more material. This was during the last years of the empire when a general decline affected all aspects of Roman life.

After Rome's collapse in the fifth century A.D. Europe declined in what are called the Dark Ages. In the Near East, however, the Islamic (Moslem) culture rose. We know little about the work produced during this time. Few examples have survived for archeologists to uncover, for the new dominant religions, Christianity and Islam, did not allow the burial of earthly goods with the dead.

In the Islamic countries of the Near East, jewelers were at first distrusted by the Arabs, who had recently emerged from the desert to found an empire. But the new rulers accepted some fashions from the cities they had conquered; one was a taste for fine craftwork done in gold and silver. A merchant might employ a goldsmith for trade, and the profits would make them both rich. Although Moslem law banned ornaments of precious metals, the famous eighth-century Caliph Harun al-Rashid is said to have employed many jewelers and smiths. Many of the goldsmiths were Jews, practicing a craft that gained them some acceptance in an alien society; those living along the North African coast later helped carry jewelry-making techniques back into Western Europe. In the 13th century, Arab coins had reached the West and reintroduced those more backward nations to gold currency.

After Rome's fall in the West, the Eastern Roman Empire remained with its capital at Constantinople (also called Byzantium, and now Istanbul). Its rulers set themselves apart from the population, calling for a reverence once reserved for gods. Jewelers were employed to deck them suitably for this role. Emperors, nobles, and priests weighted themselves with precious

objects. An idea of their riches can be gained from the legacy of the sixth-century Emperor Anastasius I: 320,000 pounds of gold. Other powerful figures also amassed riches; Constantinople was a city for jewelers.

Some jewelers also worked among the "barbarian" kingdoms of Western Europe. Times were harder there. Gold no longer reached the north and many artisans worked with red stones called garnets instead to decorate their new masters' helmets and sword hilts. In the south, the clasp, used for fastening cloaks and belts, became a favorite item of goldwork. This simple personal adornment carried such prestige that Charlemagne, who proclaimed himself the new Roman Emperor of the West in A.D. 800, made it a law that no commoner could wear jewels; in those poverty-stricken times, however, the edict served little practical purpose, since most commoners had trouble obtaining the necessities of life, let alone jewels.

Europeans respected the artisans who worked with precious materials. Many stories are told about the skill of

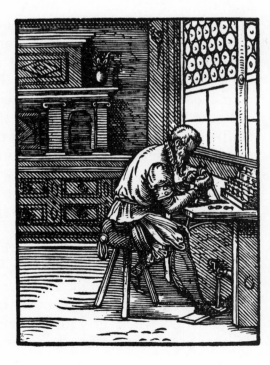

This jeweler is using a wheel to help him cut and polish gems. (By Jost Amman, from The Book of Trades, late 16th century)

one seventh-century goldsmith named Eligius: A king was said to have commissioned him to make a throne and, with the gold available, Eligius made two, both so beautiful that the king offered one to its maker as a reward. In later years Eligius was canonized. As St. Eloy, Rome's goldsmiths took him as their patron.

But jewelers could not support themselves and carry on their tradition alone. The Catholic Church was the only institution left with widespread power and respect; over the years, its leaders accumulated wealth and its monasteries provided the security necessary for preserving and refining many skills. Together, these made the church the best possible sponsor of skilled crafts, with jewelry among the most valued. At that time a mysterious discipline preserved from Classical times, the craft of making jewelry was learned by monastic scholars, often the most able and ambitious of the church's priesthood. In the 11th century, we find among jewelers men like Bishop Bernwald and Spearhavoci, the abbot of Abingdon, who fashioned the crown of England's Henry IV. The church was also a repository for the jeweler's products, with the nobility donating ornaments, and the church commissioning its own. Crosses, altars, pulpits, and even the binding of the Bible could all be very lavish. Much of the work that survives from those centuries was preserved by the church.

By the 11th and 12th centuries the craft was no longer confined to the church. In this period, *monks* who were goldsmiths began to take on apprentices from outside the clergy. At first, these did only whatever odd jobs the monks allowed them, but the amount of work slowly grew and as the non-clerical artisans proved their skill their numbers increased.

One book gives us an idea of what was expected from an able goldsmith. Theophilus, a monk, compiled a volume of instructions for all the medieval crafts. These changed little in technique over time, and scholars date Theophilus' work anywhere from the ninth to the thirteenth century. The monk recorded that a skilled

goldsmith could sculpt, shape his own models in wax, fix inlay, mount gems, smelt metals, and enamel. By the end of the 12th century goldsmiths outside the church had begun to organize their own secular guilds. One of the earliest mentions of a goldsmiths' guild was in England in 1180, when the group was fined, along with several others, for joining together without the king's permission. By 1267, the London goldsmiths' guild had at least 500 members; or at least that was the number said to have joined in a street fight against the *tailors*. (Casualties were tossed into the river.) The English guilds were not alone; about the same time, craftspeople in France founded the Goldsmiths' Company of Paris.

The new jewelers were soon subject to regulation. Working with such valuable materials sometimes tempted them to deceive their clients. The Byzantine (Eastern Roman) Empire had insisted that its jewelers have their precious metals assayed: in this examination, a small sample was chemically treated to find out how much was gold or silver and how much was alloy. If it came up to standard, the government stamped the metal. The guilds and governments of Western Europe took up this practice. In 1238, repeated complaints about the quality of precious metals led Henry III to choose six London goldsmiths to police their craft. Work that had been assayed and found acceptable was stamped with a leopard's head seal. France's king, Philip the Fair, issued similar orders in 1313, and Roman city laws of 1358 required the municipal government to appoint an expert who would test the goldsmiths' materials.

Guilds also operated to keep the jewelry trade honest. In 1462, English goldsmiths had been given the right to search any store, marketplace, or workshop where gold was made or sold. They used their powers, looking for goods made with alloy, or items set with glass instead of precious stones. By law, provincial work was to be sent to London for scrutiny, but transportation was so hazardous few jewelers risked sending their goods, and most felt justified in operating illegally.

The number of jewelers increased rapidly. The most successful were sought out by kings, for the jewelers' goods conferred prestige. Banquets of the time were made more festive by the *stepped buffet*, a sideboard laden with multiple shelves of striking vessels and tableware of precious metals. The aristocracy might manage to fill three shelves, though royal families sometimes had six-shelf buffets. In 1456, Philip the Good, the duke of Burgundy, celebrated the Feast of Knights of the Golden Fleece with three buffets, one of which was solely for display.

Many people also wanted personal jewelry, though its use was reserved for ceremonial occasions when the participants had to shine. At this time, both sexes decorated themselves with jewelry; it was only during the 17th century that gems came to be worn largely by women. As the jewelry trade revived, the nobility tried once again to restrict the privilege of owning gems; a 13th-century French law forbade the use of gold and precious stones by anyone except the priesthood and the

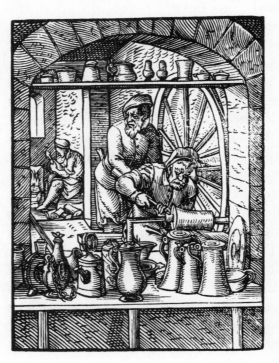

Among the proverbial candlestick makers were these pewterers, who also made plates, pitchers, and even keys. (By Jost Amman, from The Book of Trades, *late 16th century)*

aristocracy. But by the next century, jewelers could find customers among city governments, guilds, and other organizations that could afford to honor themselves.

A special degree of status was attached to the craft. The London goldsmiths, for example, were the first tradespeople to be granted a royal charter, becoming a corporate body in 1393. In England, some goldsmiths came to be counted among the country's most eminent citizens. One smith, Henry FitzAllyn, became the first mayor of London in 1189. In the 16th century, goldsmith Martin Bowes became London's first sheriff, then its lord mayor, later the kingdom's master of the mint, and finally the member of Parliament for London. He was also given a coveted place as an attendant at the coronation of Elizabeth I.

Jewelers were not confined to capital cities. An English law of 1423, for example, mentions goldsmiths' guilds in Coventry, Norwich, York, Lincoln, Newcastle-upon-Tyne, Bristow, and Salisbury. The craft traveled easily, for jewelers did not have to carry many tools. In an age of nobility, the rich and powerful were dispersed around the country. Wherever people had money to spend, they were willing to pay for jewelry, and jewelers practiced throughout the West, in Italy and Germany as well as in England and France.

The Italians and Germans did much of the outstanding work in these years, leading the craft during the 16th and 17th centuries. In Rome, the goldsmiths were specially favored, receiving commissions (specific orders) from the papal court. Goldsmiths could work outside of their guilds, which many never bothered to join, and were exempt from taxes.

The Germans did more to organize their jewelers. The guild set a rigorous course of training before one was recognized as a *master*. Once accepted, a candidate became too valuable to leave the city without permission from the city council. The guild also set a limit on the number of assistants a goldsmith could employ, ensuring that the market could never fall into one person's hands.

These enamelers are busily engaged in making "false pearls." (From Diderot's Encyclopedia, *late 18th century)*

Like the Romans before them, the German goldsmiths practiced an efficient division of labor, with up to 12 people turning out one piece. The jewelers copied one another, sometimes using a printed pattern book with designs they could follow. Jewelers might escape the guilds by obtaining royal commissions, but they were then totally dependent on their ruler. In addition, no goods could be sold outside the court unless they had been assayed and stamped by the guild members, who were extremely reluctant to give their hallmark (official stamp) to a rival.

German and Italian jewelers led the way in the growing artisic development that accompanied the Renaissance. The talent and discipline required in jewelry making made it a perfect incubator for artists. The jewelers' skills were extraordinary. A small gold locket made during the time might be inscribed with a battle scene depicted in miniaturized detail. Many artists of the Renaissance began their training as apprentices of goldsmiths; many others would work with precious materials after winning recognition as *painters* or *sculptors*.

One of the most famous goldsmiths of the Renaissance, Benvenuto Cellini, created many impressive, elaborate works. (He also left behind a boastful autobiography, which has helped preserve his name.) Recognizing the emerging difference between an artist and an artisan, Cellini insisted that he be treated as an artist. He wanted people to admire whatever he chose to make, but the record of his life is filled with descriptions of recurring quarrels with patrons. Cellini was a skillful man, one whose services were sought out by the king of France. But the goldsmith did not want to make what the king ordered. At last Cellini was discharged. His employer wrote: "I am quite overwhelmed, seeing all my particular wishes set aside, while you [Cellini] are bent on carrying out your own."

Up to this time, European jewelry had been made from whatever precious metals were found on the Continent or near the Mediterranean. But with the discovery of the Americas, a new source of gold swamped Europe. In the 16th century, Spain and Portugal conquered Central and South America. Mines from that region accounted

Some jewelers specialized in cutting designs or pictures into gems, as had been done for many thousands of years. (From Diderot's Encyclopedia, *late 18th century)*

for 61 percent of the world's gold in the 17th century; during the 18th century, this figure rose to 85 percent.

Native American civilizations had already mined and skillfully worked much of the New World's gold. The Aztecs and the Incas, for example, had immense stores of treasure. These the Europeans looted, melting down almost all gold jewelry. All we can discover of the Aztec tastes is that both men and women were partial to ornament, and that the men pierced their noses and upper lips to add extra decorations. The Incas are said to have worshipped gold as part of the sun. Commoners collected gold for tribute to the Great Inca, who—like Egypt's pharaoh—owned all gold and goldsmiths. Historians have estimated that 190 tons of gold were delivered to the Great Inca every year. Collected in Inca cities, the gold was ready to be seized by the new conquerors.

While this excess of gold caused severe inflation in Spain, that did not discourage other countries from reaching out over the seas to foreign nations suspected to be rich in gems and gold. None was richer than India, whose trade with Europe boomed in the 17th century. In contrast to their European counterparts, Indian jewelers generally worked with minuscule amounts of gold, using it primarily to set off the color of precious stones. These gems, sometimes of enormous size, inspired legends in Europe. The scarcity of gold may have made the Indian jewelers unscrupulous in getting their hands on such useful material; at least, a trade manual for medieval times discusses different methods of swindling gold from a client. Indians who could afford jewelry most often wanted a great deal of it. The craft prospered most under the Islamic Mughal (Mogul) dynasty in the 16th century; noble Indians of the time might wear six different kinds of hair ornament. While Indians continue to enjoy jewelry, very few can afford it, even today, and most jewelers still work for only a small number of clients producing custom-made jewelry.

Africa had its own gold-rich civilizations. Since the early Middle Ages gold from sub-Saharan Africa had

been shipped by caravan across the great desert to North Africa, from where it supplied jewelers in the Islamic world and Christian Europe as well. But Africa had its own fine jewelers in the Ashanti people of the West African Gold Coast. Like the Incas, the Ashanti revered gold as a gift from heaven. But they never suffered the fate of the South Americans; the Ashanti were reputed to be powerful warriors, and they were protected by a forbidding stretch of jungle. The Europeans kept their distance; it was not until 1874 that a British expedition was sent to capture the Ashanti capital. Until then, the Europeans stayed along the coastline, gaining what Ashanti wealth they could through trade. The Ashanti empire was a confederacy of tribes, each with its own chieftain. Their union, the spirit of the nation, was symbolized by the Golden Stool on which the overlord sat. Every year, the stool was carried by bearers atop its own throne, on a pilgrimage to the royal burial grounds. Once there, it was honored with ceremonies that included the sacrifice of slaves.

Each chieftain's court had its goldsmiths, who were the nation's only jewelers. Only members of the guild could work with gold, and positions were hereditary and highly desired. Although goldsmiths could work only for the chieftains, their work assured them a prosperous life. All Ashanti goldsmiths traced their lineage back to the same figure, Fusu Kwabi, who they thought had descended from heaven with gold. The goldsmiths made all their own equipment, for other artisans did not have the necessary delicacy. The smiths made scales cast in the shape of animals and men, sometimes portraying everyday scenes; such works are now highly prized by collectors.

Elsewhere, Europe's expansion soon took in all of North America. The jewelers of the North American colonies did not cater to an aristocracy; they were small tradespeople whose clients could keep them comfortable, though seldom rich. Money was scarce, and many of the settlers held austere views on personal behavior and adornment.

Silver, however, was inexpensive enough not to be restricted to the handful of prosperous colonials; it could be mined in the Colonies themselves, with North Carolina being the chief source during the 18th century.

In the 17th century, the first silversmiths settled in Boston; by the late 18th century, many smiths were working throughout the Northeast, the most famous being the patriot Paul Revere. The silversmiths made little jewelry, and certainly none that could be called gaudy; they specialized in fashioning handsome practical objects such as candlesticks, tableware, and tankards. Colonial silversmiths were noted for their frugality with which they used materials. They would stretch their aprons taut from the work bench to catch filings for remelting.

North American gold- and silversmiths did not form guilds. Each smith was an independent master, who demanded the most intelligent and eager apprentices. One apprentice's contract from early 18th-century Philadelphia survives. The apprentice served seven years and swore personal loyalty to "his Master." During that time, he could not marry, nor could he gamble, "haunt Alehouses, Taverns or playhouses," or even simply leave the house without first getting permission. The contract was meant to ensure an unshakable honesty; the jeweler did not want to let anyone near the precious silver who might conceivably steal it. While the terms were hard, they were not unusual for the time, and the career promised was far better than most people could hope for.

North American silversmiths often doubled as *import merchants*, supplementing their income by selling more expensive goods sent over from Europe. At first, the silver shops were scattered, being found wherever a smith might happen to live. By 1800, however, the number of smiths had grown large enough for cities to rows devoted to their shops. Silverwork also spread elsewhere in the New World. The craft was carried to Canada by Loyalist smiths who settled in Halifax after the American Revolution. These jewelers worked on a small scale, concentrating on rings, brooches, and lockets. They had no

guild, and smiths each made up a hallmark to stamp on their work.

The Native Americans of the Southwest were introduced to silverwork by the Spanish colonists, but the craft did not grow among them until the United States Army forcibly confined them to reservations. The Navajos picked up some techniques from their captors while being held in Fort Sumner in the decade following America's Civil War. On the reservations, they lived as small farmers, widely scattered one from the other, meeting occasionally at a crossroad trading post, where small items in copper and silver were sold: flasks, tweezers, belt buckles, rings, and buttons.

Navajo silverwork is known for its beauty and originality, but not for its volume. Most Navajos being poor, only a plentiful source of silver nearby made silverwork at all possible. Because buyers were scarce, a Navajo silverworker often practiced the craft as a demanding hobby, following a day spent with his livestock and crops. Eyestrain from working at night was an occupational hazard. No advanced tools found their way to the Southwestern deserts, and the silverworkers improvised equipment from cast-off farm implements

This group, possibly a family, is engaged in softening and beating gold to form fine jewelry. (From Diderot's Encyclopedia, *late 18th century)*

and what could be scavenged from the railroad lines. But the silversmith's expertise carried with it prestige; when the community met on some sacred occasion, the local silversmith was quite often the person chosen to lead the ceremonies.

In the late 19th and early 20th centuries, railroads brought to the Southwest tourists who wanted to buy Indian silverwork as souvenirs. The Navajo silversmiths no longer worked for their own argicultural community but for the larger market of industrial America. As a result, Navajo silversmiths came to work full-time; indeed, to meet the demand, many members of the tribe became silverworkers of one sort or another. The visitors were not selective about what they bought, however, and the silverwork steadily became cruder and more imitative.

This process is characteristic of the changes in jewelry making in the industrial age. First, there was a great increase in the quantity of work produced: From handwork for a small community, the Navajos jumped to serving an endless flow of visitors from all over the nation and the world. Second, the new silverwork was not expensive and was of lesser quality. The jewelry business had grown and its customers were no longer only the rich, although—as always—the people with the most money could still afford the best work.

By the 19th century the Industrial Revolution was creating a different working climate for jewelers. Steamships and new mining technology allowed people to venture further and dig deeper for precious stones and metals. Soon the search for the trade's raw materials took in the whole world, and new materials poured into Europe and America. Between 1850 and 1875, Australia and California produced more gold than had been seen in all the years since 1492. New lodes were soon found in Alaska, Canada's Yukon, and South Africa. People are still finding new ways of extracting what they want from the earth; in 1970 alone, 1,500,000 kilograms (about 3,300,000 pounds) of gold were produced. This is more than was discovered during the entire 17th century,

when Spain and Portugal drained South America of its gold.

In addition, new machines were used in production. Many of the people making jewelry became factory workers rather than artisans. In 1840, the British introduced *electroplating*, the coating of base metals with a thin surface of gold or silver; this allowed the easy production of uniform items. The middle class, and even some members of the working class, now had more money than before; they could buy electroplated tableware, a sign of gentility. Some of the new factories, like the Gorham Manufacturing Company of Rhode Island, made a point of giving their products the look of hand-made work. The new middle-class customers also bought personal jewelry, such as the Navajos' work. In the late 19th century, England even began the mass production of bracelets and necklaces intended only for the working class. These were stamped out by machines from sheets of thin metal, usually as a plain rectangle, inscribed with some appropriate message with a space left for the owner's name.

Wealth seems to be the best preservative of craft. The rich can still demand the finest work. But with more affluent people than ever before, compared to past centuries, even the upper classes of today form close to a mass market. Machines that made possible mass production of simple goods also allow the reproduction of quality work. Now even the most exclusive firms are more likely to sell retail items made elsewhere than commissioned works produced in-house. Today, many of the people called *jewelers* are actually store owners with special knowledge of the field who sell pieces rather than make them.

The work itself is likely to come from large firms. The most famous and successful of these were founded by the other variety of jewelers, the artisans and designers. The most famous firm of this kind was Fabergé's. Louis Fabergé, descended from a family of Huguenot refugees in St. Petersburg, Russia (a city now known as

Leningrad), took over his father's business at the age of 24. With his imagination and outstanding skill, he was soon recognized as a master in his field. Like jewelers centuries before, he worked for the rich; Russia's imperial family were his prime customers. But his market grew to be international; in France, Fabergé's work brought him membership in the Legion of Honor. He worked for the most exclusive customers, but his business grew to an unprecedented scale: by 1898, Fabergé employed 700 skilled workers and had opened branches throughout Russia, as well as in London.

Fabergé's rivals included Cartier of Paris, Garrard of London, and Tiffany of New York City. Like Fabergé, these jewelers were successful entrepreneurs as well as artisans. The people employed by their firms were the chief designers of new jewelry. Instead of fulfilling commissions, a workshop of jewelers developed its own

ideas, and then saw that they were reproduced a thousand times over in factories. In addition to these professional *jewelry designers*, some artists better known for their work in other media also designed jewelry. These include Alexander Calder, Man Ray, and Jean Cocteau. People bought this jewelry as they would buy any other work by the artist.

Throughout history, the people we know as jewelers have primarily been specialist metalsmiths, working precious metals such as bronze, copper, gold, silver, and platinum into fine works of art. Over the years, however, jewelers have come to work with a wide variety of materials—everything from precious stones such as diamonds, rubies, sapphires, and pearls to less conventional items such as tiger claws and feathers—and in modern times even plastic.

Because of their ability to do detailed and delicate work, jewelers have often been pressed into service for other purposes. Many jewelers, for example, have been the proverbial *candlestick-makers*, producing fine metal ornaments and functional items for all occasions. Others have doubled as *locksmiths* and as makers of the parts for early clocks and watches, before specialist *clockmakers* and *watchmakers* existed. In modern times, this old relationship has been revived, as watches—today usually factory-made, even expensive timepieces intended as much for ornament as function—are generally sold in jewelry shops. Jewelers also made much of the type for early printing; Johann Gutenburg was a goldsmith by trade before developing the modern printing process. Jewelers even provided *dentists* with custom-made wooden false teeth for their clients. Paul Revere, for example, often made dental plates.

While fine *metalsmiths* made the settings, other specialists often worked on the stones or other items that were to be displayed as jewelry. *Lapidaries* were specialists who worked with precious gems, both trading in the stones and preparing them for use in jewelry. The lapidary's trade is a very old one. At least 4,000 years

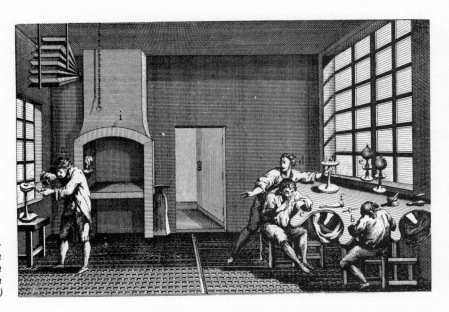

Much of the jeweler's work has involved mounting precious gems in settings of gold and silver. (From Diderot's Encyclopedia, *late 18th century)*

ago, traders were carrying amber from northern Europe to the Mediterranean; by at least 1500 B.C, amber was being brought to the Swiss Alps, where lapidaries were working the fossilized resin into ornaments. In the same period, jade was being brought from Central Asia into China, where jewelers transformed it into jewelry and highly prized ornaments of all sorts. The extremely delicate small-scale carving found on stamp seals—used in ancient times to mark the seal of a message so the receiver would know the contents were untouched—date back thousands of years before that in the Near East.

For most of history, the lapidary's work consisted mostly of buying gems, polishing them as they were rounding the face to be displayed, or carving designs on the stone; then the gems were either traded to other jewelers or placed into settings in the lapidary's own shop. The cutting of stones into facets was developed only in the 15th, 16th, and 17th centuries in Europe. The *gemcutters* who today produce the sparkling facets on diamonds and other precious stones are extremely skilled, highly prized, and well-paid artisans; they generally work in the gem centers of the world, notably Amsterdam and, especially since World War II, New York City. In the

Asian world, where gemcutting has been less favored, lapidaries have tended more toward carving and polishing stones, even into this century.

Some jewelers have also specialized in producing certain types of jewelry. A prime example is *cloisonné*, in which the metal surface of an object is covered with thin wires; into the pockets (*cloisons*) formed by the wires is poured a mixture of powdered enamel, which is then heated and fused with the metal to form brightly colored inlays. This complicated technique was known in the West as early as Mycenaean times, perhaps 4,000 years ago, and was especially popular in the Byzantine Empire during the 10th through 12th centuries A.D. The technique was brought to China—possibly by Arab merchants traveling along the Silk Road, but perhaps by a French silversmith who worked in the Mongol capital at Karakorum—in the 14th century and quickly became popular throughout East Asia. In China and later in Japan, some jewelers specialized in producing cloisonné objects; the most skilled artisans often worked in royal workshops at court.

The jewelry trade today accommodates many different markets. For the first time, large profits can be made from adorning people who are not rich, as well as those who are. Though the best and most interesting work is still done for the wealthy, the jewelers' wares find buyers from all levels of society around the world.

For related occupations in this volume, *Artists and Artisans*, see the following:
 Bookbinders
 Clockmakers
 Locksmiths

For related occupations in other volumes of the series, see the following:
in *Communicators*:
 Printers

in *Financiers and Traders*:
 Bankers and Financiers
 Merchants and Shopkeepers
in *Healers*
 Dentists
in *Manufacturers and Miners*
 Metalsmiths
 Miners and Quarriers

Locksmiths

The first lock known to history was in the royal palace of Nineveh, a biblical city in Mesopotamia. Made from wood, in the Egyptian style, the lock dates from some time around 2000 B.C. Egyptian artisans had perfected a lock composed of two upright casings, each with a hollow square at its center. A horizontal bolt slid into these spaces. The bolt itself had holes bored into its surface; when locked, pegs in the first casing slipped down into those holes, securing the hollow bolt. To release the lock, a rod with studs in the proper formation was slipped within the bolt and then pushed up until the pegs were forced out.

The same type of lock could be found far beyond Egypt and its neighbors; ancient peoples over much of the globe found the same answers to locking something shut. The

peg lock appeared in both Japan and the British Isles. In the 20th century, it is still being used in England's Cornwall peninsula, which had trade with the Near East perhaps a thousand years before the Roman Empire.

The Greeks invented the first lock worked by key and keyhole. Chroniclers claimed that these were in use before the Trojan War, a legendary conflict very remote in Greek history, probably around 1200 B.C. The locks, however, did not have a reputation for strength. They were still made of wood and could be shattered.

Roman *locksmiths* introduced metal locks. They worked with forges, and sold their expensive wares to some very wealthy customers. Locks were cast and carved as small-scale sculptures; keys could be worn as jewelry. The keys fit into the grooves of a bolt inside the lock. Metal ridges, called *wards*, guarded the lock against foreign keys; only the key shaped with the correct configuration of slots could slip past them. The shape of the keyhole stayed the same from lock to lock; the arrangement of wards within the lock was what mattered.

These locks were all built into the objects they served to secure. But locksmiths also made a removable lock called a *padlock*. This was found in both Rome and China; but no one knows in which country it was invented. The padlock amounted to a portable lock, and travelers used it to secure their cases; it may have been carried from one country to another by traders on the 5,000-mile Silk Road across Asia.

Rome fell in the sixth century A.D., and with it much of the locksmiths' craft in Europe. But fine locksmiths continued to operate in the East. A ninth-century Moslem writer talked admiringly of the "inviolable locks" that came from the Byzantine domains. In China in the same period, almost unbreakable safes and strongboxes were being used. But of the locksmiths who operated in the Eastern lands we know practically nothing.

The craft did not completely die out in Europe, however. In the ninth century, Alfred the Great of

England commissioned the first metal locks known to medieval Europe. The locks of the Middle Ages were opened by turning the key, rather than by simply pushing it as before. Turning is still the method most commonly used today. English locks were being made by the 12th century A.D. German workers carved, after the fashion of their Roman predecessors, elaborate set-pieces into the plates of door locks. Light was scarce in those times; the decorations guided the hand to the keyhole.

Like the *clockmakers*, locksmiths were looked on first of all as people who worked with iron; the skills needed to shape the material counted for more than those needed to make any specific object from the material. Before there were specialist clockmakers, locksmiths were often called upon to produce the parts for the town clock that was the centerpiece of many medieval communities. The 15th-century artisan Jörg Heusz combined two skills to be-

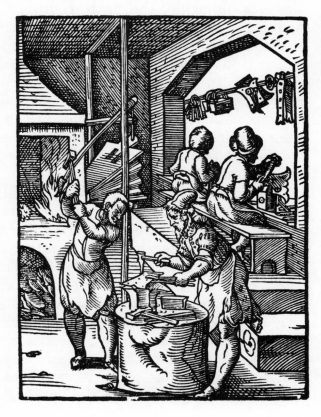

Early locksmiths made not only security devices, but also other objects requiring fine metalwork, such as parts for clocks. (By Jost Amman, from The Book of Trades, *late 16th century)*

come Master Clockmaker and Locksmith. Many locksmiths earned their livings as *blacksmiths*, making locks on the side. They generally settled near forests and mines, where they had metal to work and wood for the forges. Locksmiths often lived in their workshops, keeping finished locks on their kitchen shelves for sale.

Charles IV, Holy Roman Emperor and a leading prince of Germany, created the rank of *Master Locksmith* in 1411. The requirements demanded as much a talent for decoration as technical skill. But the making of locks had clearly been recognized as an honorable and respected craft; an artisan could take pride in excelling at it, even if his excellence sometimes took the form of sculptured nymphs, rather than new arrangements of wards.

Mathurin Jousse wrote the first book for locksmiths in 1627. He recommended that locksmiths make their own tools, believing that no other artisan could be trusted to understand what the craft required. Once having acquired skills and tools, locksmiths became highly valued experts, the best of whom traveled though Europe in the 16th and 17th centuries, welcomed by good wages wherever they settled. The locksmith Bartholomew Hoppert of Holland was expressly invited by the great of various nations, including Louis XIV of France, to join their service. English locksmiths were much aggrieved by the competition of talented foreigners who came to their country.

In England, a locksmith was still usually thought of as a sort of blacksmith. But even there the craft had shown signs of an independent life for many years. Wolverhampton became a locksmiths' center, and the standards of skill rose steadily. An English writer of 1686 reported that: "The greatest excellency of the blacksmiths' profession in this country lies in their making of locks for doors, wherein the artisans of Wolverhampton seem to be preferred to all others." For an English lock 2 pounds (roughly $24 now) was considered a reasonable price. A merchant from Portugal visiting Wolverhampton in 1732 praised the locksmiths

for their skill. He saw a lock equipped with timed chimes that cost 20 pounds. Wolverhampton's parish records listed 290 locksmiths in 1770.

In 1784 Joseph Bramah stopped making locks with wards, the type that had been used for almost 2,000 years. He substituted for them a bolt within the lock's own interior bolt, worked by a key shaped like a cylinder. This type of mechanism remains the ward key's chief competitor. English locksmiths adopted the "fly press" during the 1790s. It automatically shaped and then pierced plates for locks, speeding up work. Other presses stamped ingots into "key blanks"; the locksmiths then filed the keys to fit individual locks. This was the beginning of mass-production for the locksmith. But most of the trade still kept to old ways, buying up discarded horseshoes for their raw material.

America saw its first clockmaking factories in the early 19th century. These used much the same tools and materials as those needed to make locks; a few factories converted from one product to the other, as either market looked more promising. In Terryville, Connecticut, all lock companies together produced more than 500,000 locks in one year. The locks were sold wholesale to merchants, in lots of ten, fifty, and a hundred.

Eagel Lock company issued an 1862 catalog featuring 500 kinds of locks, with illustrations done with gold leaf. With their new prosperity, the owners and managers of lock factories received a good deal of prestige. Connecticut was a lockmakers' center: Voters elected lockmakers, as the local people of substance, to the legislature, and one, John C. Lewis, served as the speaker of the house.

A reporter who visited Eagel Company's factory in 1880 recorded that it housed 36 drills, operated by four workers; each drill punched holes into barrel (cylinder) keys, turning out 12,000 keys each day. The drills worked under water, both to cool them off and to somehow contain the clouds of metal filings they produced. Lock plates were cut for *dies*, something like

tailors' patterns; Eagel Company kept its collection of dies in a vault and put their value at $70,000.

Lock factories needed machines for grinding metal, shaping it, and pressing it. Most factories include a department for finishing work—japanning (painting it with a hard lacquer), bronzing, and so on. They employed numerous skilled locksmiths, along with *toolmaker*s, *machinist*s, and some apprenticed youths; as in many factories of the mid-19th century, large numbers of women, many of them quite young, were employed at menial jobs.

In the late 19th century, American locksmiths developed some new types of locks. Among these were the *pin-tumbler lock* developed by Linus Yale, Jr., of Connecticut; this employed a notched key to move pins of different lengths within the lock; when all were moved properly, the internal bolt could be released and the lock opened. This pin-tumbler lock became widespread throughout the world, and made the name and fortunes of the Yale Lock Company. In the 1920s, the Yale Lock Company plant in Stamford, Connecticut, spread over 28 acres; it was made up of 68 different buildings, and employed 6,000 people.

Linus Yale, Sr., developed the *combination lock*, refined by James Sargent of Rochester, New York. This now-common type of lock used a numbered dial, which was turned in a pre-set sequence, in order to release the internal bolt. But, since the "combination" could easily be extorted from the people who used the lock, Sargent later improved upon this by adding a timing mechanism; the lock could only be opened by the combination at preset times. Such *time locks* are now common in banks. All of these types of locks lent themselves to large-scale manufacture, as the size of the Yale Lock Company factory indicates.

Skilled handwork has kept its place in lockmaking, even as machines have become more and more important. In modern times, England's National Union of Lock and Metal Workers joined with the Lock and Latch

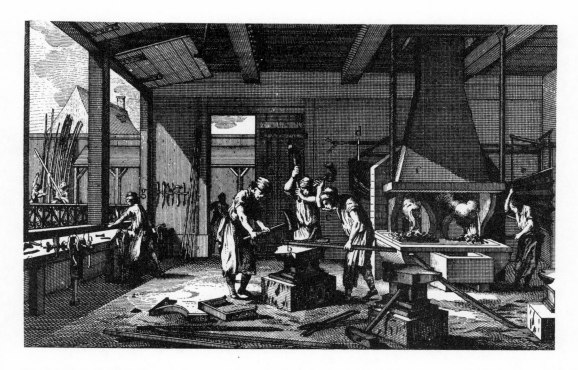

As security became increasingly important, locksmiths' shops grew ever larger. (From Diderot's Encyclopedia, *late 18th century)*

Manufacturers' Association in a Joint Industrial Council that set standards for four grades of factory worker; the top rank were still known as *locksmiths* and did skilled detail work. Some factories maintain a department which employs only such artisans; there, customers can order locks made to their own specifications.

In recent decades, locksmithing—like many other trades—has been much affected by modern technology. Locks and safes no longer suffice for many purposes, and locksmiths have combined their craft with various kinds of engineering expertise to produce elaborate security systems involving computers and other electronic devices designed to stop intruders or warn of their entry. The result is the age of the *security specialist.* Some of these modern specialists design protective systems for large institutions, such as banks, art museums, and military complexes; these security experts are usually employed by large firms engaged in devising and selling such systems. Other specialists—more often small business owners—focus on the growing market for

burglar alarm systems and security devices in private homes.

But many locksmiths still focus on basic locks and keys. While the locks themselves are generally made in large factories, these locksmiths supervise the installation of them in large buildings, or sell them direct to individual customers from retail shops. In truth, many of these locks are so effective that much of a modern locksmith's work is opening locks or safes when keys or combinations have been lost or the device damaged.

For related occupations in this volume, *Artists and Artisans*, see the following:
 Clockmakers
 Jewelers

For related occupations in other volumes of the series, see the following:
in *Communicators*:
 Printers
in *Manufacturers and Miners*:
 Metalsmiths

Musical Instrument Makers

Musical instruments have always had political, military, and religious significance in society. In the earliest recorded times, they were used to accompany military campaigns and religious ceremonies. In many parts of the world, even into modern times, musicians made their own instruments, or employed skilled artisans such as *carpenters* or *metalsmiths* to make instruments for them. Specialist *musical instrument makers* were common only in the Mediterranean world and in the West altogether, until modern times.

While little is known of ancient musical instrument makers and their precise activities, they were probably an elite group of craftspeople. The musical instrument was too important a device in ancient cultures to be turned over to a common worker. In Sumer, the arched harp was

a significant religious instrument, and workers assigned to make them for the royal court adhered to the highest standards of string-making. In Egypt, the angular harp was the favorite of the leisure and noble classes. While *tool* and *weapon makers* may also have made simple musical instruments, the art quickly advanced beyond simple clay bells and drums, whistles, rattles, and bone flutes. The tomb of Tutankhamen—the Egyptian pharaoh of the 14th century B.C.—included many magnificent bronze trumpets. In Judaism, musical instrument making served the needs of the temple; the prophet Moses took the time to discuss the craft in some detail in the Old Testament.

In Classical Greece and Rome, instruments became more associated with entertainment, although they continued to retain military and religious significance. The cithara, lyra, and flute-like aulos were the chief instruments of the day. Several writers of the time described their highly ornate decoration and even silver working, so that one may suppose that the metalsmiths and possibly *jewelers* had some hand in the trade. Performers, too, were known to be instrument makers. The Greek *singer* and *poet* Terpander, for instance, has been mentioned as the inventor of the lyra in about 700 B.C.

From the fall of the Roman Empire until the flowering of the Renaissance, instrument making seems not to have been a very important profession. Indeed, music became almost wholly religious in nature and format in the West. The voice was the chief musical "instrument," and most music was simple, austere, and unembellished. Manufactured instruments were rarely mentioned at this time, although the organ was beginning to be developed for use in church services. For the most part, the few musicians there were—mostly members of the clergy—designed and made their own instruments.

The Renaissance marked the rebirth of classical culture in the West. While the Roman Catholic Church continued to dominate developments in music, secular

entertainment was also making headway. While more and more complicated polyphonies (musical pieces with more than one melody) had been developed from the ninth century on in sacred music, it was not until the sixteenth century that these pieces became well organized, passionate, and sung with several equal voices. Nonetheless, the voice remained the main "instrument" of the day.

Still, musical instrument making began to attract attention. Several makers began writing on the subject and establishing it as a scientific enterprise as well as an artistic one. Arnold Schlick, a blind *organist*, wrote a book on organ-building in the 16th century. Martin Agricola, another expert on music during the Renaissance, wrote a popular treatise on instruments and the various techniques of building and playing them. Hans Gerla, a fine *lutenist*, wrote about lutes and viols—instruments that he manufactured as well as played.

The lute was the most popular Renaissance instrument other than voice. In fact, the term *luthier* (lute maker) gradually came to refer to the manufacturers of all stringed instruments. There were other instruments, of

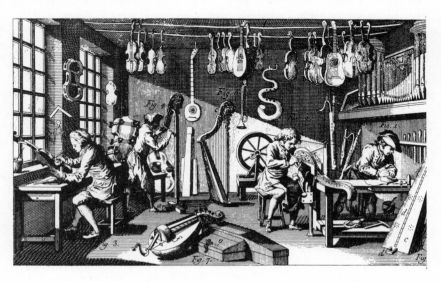

Among the best-known and most highly respected musical instrument makers were the luthiers, the makers of stringed instruments. (From Diderot's Encyclopedia, *late 18th century*)

course. Many were being experimented with for the first time; others were being improved and refined. There were wind, percussion, and even a few keyboard instruments, but there was really no great demand for any of them. Probably the greatest demand came from nobles and gentlemen, who collected them purely as art objects, in much the same way that art collectors gather paintings and sculptures.

Many fine craftspeople specialized in making instruments. They made very costly and very beautifully adorned instruments coated with ivory and set with silver, gold and precious stones; these were bought for status and displayed as conversation pieces. Masters in this trade left their inscription on their work as a sort of trademark.

After musicians had formed successful labor guilds, instrument makers followed suit. Some of the earliest corporations of instrument makers were formed by the *viol makers* of Antwerp in the latter 15th century and the *bell founders* in Malines. King Henry IV of France founded the *gilde des luthiers* in 1599. These and other guilds were highly exclusive, with memberships offered to only the finest and most prestigious craftspeople in the trade. They assured a certain standard of quality workmanship—though in protecting a few select masters, they may also have held back some of the creativity in the profession as a whole.

Still, a great deal of experimentation on new types of instruments continued, both inside and outside the formal trade organizations. Indeed, not all instrument makers were organized. A good number were pensioned and patronized by lords and kings. Jan van Steenken, for instance, received a pension from the duke of Burgundy from 1458 to 1467. He was bound by the terms of the arrangement to give the duke the first option to buy any instruments he made during that period. Many lords and kings were interested in such arrangements in order to procure the finest, most original pieces available for their treasured collections of musical instruments.

The Baroque period, roughly from 1600 to 1750, saw considerable development of musical instruments, particularly the bass instruments. Extravagant polyphonic music was typically backed up, during this era, by a steady background melody supplied by a bass. Hence, the period has been referred to as the era of the *basso continuo*. This form eventually gave rise to opera and the concerto. The musical instrument had finally achieved some prominence, taking an honored position beside the voice. The musical instrument industry entered one of the grandest times in its history.

It was Casparo da Salo of the famed "school of Brescia" instrument makers who was supposed to have designed the first violin in the 16th century. Many embellishments followed, notably those of the Amati family, and of Jacob Stainer and the Tyrolean school. *Violin makers* from the Netherlands, France, Austria and Germany crowded into Rome, where the industry was bustling. Some alterations were structural, while others were merely decorative or personal touches. Stainer violins, for example, were recognized by the distinct lion's head carved at the end of the neck.

For some time, the violin changed so quickly and dramatically that it could hardly be identified as a standard instrument—until the late 17th- and early 18th-century creations of Antonio Stradivari and his family at Cremona. Many in the industry marveled at the quality of sound achieved by the violin—"the Stradivarius" (named after its maker). Was it the specially prepared varnish? A special blend of fine woods? The mystery continues today. Like most master instrument makers, Stradivari had a trademark inscription designed to distinguish his pieces from others. Yet there were many cheap, mass-produced fake copies in circulation with the famous *Antonius Stradivarius faciebat Cremonae 17* inscription on them.

While many instrument makers continued to belong to professional guilds and associations, lack of sufficient

membership frequently caused them to join guilds for members of other occupational groups.

For instance, because there were so few *flute* and *recorder masters* in France during this period, those desiring guild membership had to join with the *chair-leg manufacturers*.

In the 18th century, *musicians*, *composers*, and *music copyists* assumed prominent positions in the profession. Jacques Hotteterre, for example, was both an instrument maker and player, as were many other members of his legendary family. It was quite common for people of leisure to take up instrument making, for it was widely viewed as an art, a science, and a suitable pastime for the gentry.

By the time of the classical period in music, from 1750 to about 1830—the age of Haydn, Mozart, and Beethoven—the majority of the grand instruments of the Baroque masters had been altered. The art of *ravalement* involved adding more keys to famous harpsichords dating back to the 17th century. Pascal Taskin—custodian of the instruments of the Royal Chapel in Paris and those of the King's chamber—was a master at this until his death in 1793. Some instrument makers of this time con-

Some highly skilled metalsmiths specialized in making musical instruments. (From Diderot's Encyclopedia, *late 18th century)*

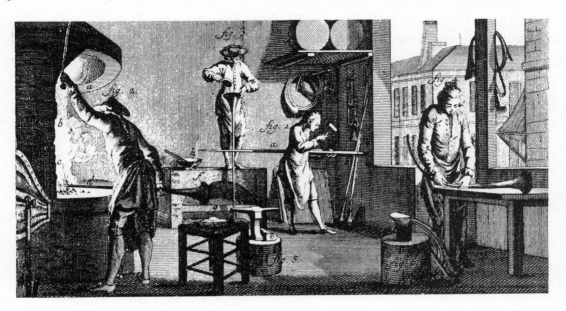

centrated on developing *clafecins de voyage*—small, portable instruments easily folded up and transported. This was a good business at a time when so many people were taking to the seas for adventure and colonization. Still other instrument makers of the classical period were diversifying their trades. They manufactured musical boxes, clocks, and toys as well as instruments. *Violin bow makers* developed a distinct and lucrative specialization during this era. But the greatest strides in the profession were taken by *keyboard masters*.

In the 19th century the piano became the center of the new movements in music. Unlike the *guitar makers*, who also held a prominent position in the instrument trade during this era, the *piano makers* were seldom individual masters. Large companies came to control the industry by the middle of the 19th century. The firm founded by Ignace Pleyel in Paris was a leader in the field, while the company of John Broadwood and that of the Erard Brothers dominated the scene in London. Piano making was based largely on handicraft, as were the traditional industries, yet as the century progressed standardization techniques and division of labor were introduced with considerable success.

The 20th century has seen instrument making continue in the direction that began with piano making. For the most part, it has been taken on by large companies making relatively cheap and standardized instruments for a mass market. Only a few master craftspeople continue to work in the field, and their products are considered works of art. The greatest opportunities in instrument making today lie in the field of electronic instruments. Instrument designers in this industry are *scientists* and *technicians* rather than craftspeople and musicians. The manufacturing process itself has become quite simple and routine. Perhaps the greatest demand for handwork in the field of musical instrument making is in the *tuning* (especially of pianos) and *repairing* of instruments. There is always a great need for and shortage of such experts.

For related occupations in this volume, *Artists and Artisans*, see the following:
 Clockmakers
 Furniture Makers
 Jewelers

For related occupations in other volumes of the series, see the following:
in *Manufacturers and Miners:*
 Metalsmiths
 Weapon Makers
in *Performers and Players*:
 Musicians
in *Scholars and Priests*:
 Monks and Nuns
 Priests
in *Scientists and Technologists*:
 Scientific Instrument Makers

Painters

The prestige of *painters* varied widely in the ancient world. In Egypt, painting was a craft having little status; *sculptors* found it useful only as a handy way of decorating or finishing relief wall carvings. For less demanding patrons, painting replaced carved reliefs as wall decoration, and sculptors sometimes painted a design's more complicated or repetitive elements.

The Greeks and Romans, on the other hand, accorded painting a high place. Painters competed in perfecting their skills, and the best could expect to be rewarded with fame and wealth. Surviving Classical Greek sculptures—in modern times, models of simplicity in white marble—were originally brightly painted by skilled Greek artists. Classical sculptors believed that the painting of their work was important. According to

the Roman writer Pliny, the eminent Greek sculptor Praxiteles once said that his best statues were those decorated by Nikias, a famous painter. "So much," said Pliny, "did he prize the color-work of that artist." Alexander the Great counted a painter, Apelles, as a close friend; no one else could paint the ruler's portrait. The legend of this friendship survived for 20 centuries, so that artists of Europe's Renaissance held up Apelles as their ideal.

In early Greece and Rome, most painting was paid for by the government. The painters received their commissions either directly from the government, or indirectly from sculptors doing public artworks. Public buildings had to be decorated, either with devotional scenes or heroic incidents from the past. When Pisistratus took over Athens in the sixth century B.C., he beautified the city by importing painters from neighboring cities. Later, a great opportunity for work came after the Greeks

These Greek painters of 2,500 years ago had considerable status, though less than sculptors, considered the great artists of the time. (From Museum of Antiquity, *by L. W. Yaggy and T. L. Haines, 1882)*

repelled an invasion by Persia at the beginning of the fifth century. Athens, which had led the alliance of Greek city-states, sought to commemorate its victory. Also, the Persian army had destroyed much of Athens; half the city was to be rebuilt.

The Greeks established the tradition of Classical painting, cultivating skills of great sophistication. Classical Greek painters followed the maxim of the painter Eupompus: "Let nature be your model, and no artist." We know that some of these painters made scientific studies of light and perspective: their paintings seemed to have three dimensions, a look that had never been seen before. *Scenery painters* in the theater were among the first to develop these effects.

Greek painters did not intend their work to be solely decorative; their paintings were meant to capture the complete attention of the viewer. For the unveiling of his panoramic battle scene, one artist stationed buglers out of sight; they sounded the charge when the curtain rose. Zeuxis, a famous master, inscribed beneath his portrait of the legendary Helen of Troy some lines from the *Iliad*: "Marvelously like is she to the immortal goddesses." He got away with the boast; most people thought it perfectly deserved.

In the first century B.C. Rome conquered the Greek city-states, which by then were in a period of decline. The Romans adopted much of the Greeks' rich tradition, importing Greek artisans, often as slaves, to their main cities. Private homes of wealthy Romans had *frescoes*—wall paintings on plaster—just as the Greek temples and other monuments had. Some fine Roman frescoes have been preserved at Pompeii by the volcanic debris that buried the city when Mt. Vesuvius erupted in 79 A.D.

We know more about the Classical painters' methods than their paintings. Over the centuries, Classical sculpture has reached us in fragments but few examples of Classical painting survive. Some Classical writers report that Greek painters worked only with red, yellow, white,

and blue-black. The Romans added pink, blue, and two additional shades of red. Painters executed wall frescoes in *encaustic*, *tempera*, and *mosaic*. Encaustic is a painting technique using wood and heated wax. In tempera, wood or stucco was covered with egg white, then paints were applied on top of that. When all the colors were in place, the painter polished the work. A mosaic was made by pasting thousands of colored chips along a wall, ceiling, or floor; teams arranged them to depict scenes or to form abstract patterns.

We also know of a kind of *portrait painting* that was practiced during the time of Rome's supremacy. The painter heated beeswax, transparent and without color, and then mixed it with paints, applying it directly to a wooden board, where the mixture set and hardened. The subject hung the portrait in his home; on his death, the portrait was placed over his face. Body and portrait stayed in a mummy case, left upright in the house; after a death in the next generation, they were carried off for burial, making room for the replacement.

As Roman painting reached its height, painting began to flourish in Asia. During the second century B.C., under King Asoka, Indian painting began to celebrate the Buddhist religion. Many painters trained as *priests*, learning their craft at an academy that took novitiates from all over the country. Later they served as the resident painters in various monasteries and temples. Frescoes like the 60-foot-high paintings in the Ajanta temple caves involved many painters working for a long time—no one knows how long. Indians took their painting seriously, publishing a library of art manuals and histories, biographies of painters, and treatises debating painting theory.

New activity among China's painters followed. Chinese Buddhists who made religious pilgrimages to India brought copies of Indian wall-paintings back with them to China. The Chinese adopted the subjects—scenes from the life of Buddha—but created their own style, establishing one of the premier art traditions of the

world. The Chinese treated their painters with special respect; a commoner with talent could rise to become a respected member of the imperial court. Over 1,500 years, the Chinese produced thousands of scholarly works on paintings and their makers.

Eastern painters practiced a sophisticated craft. They aimed to depict subtle physical movement, the effects of wind, clouds, water, and fire. A student trained with a master who tested his knowledge of sets of strokes; the pupil worked his way up from set to set as his eye and hand sharpened. When he had mastered the most complex series of strokes that his master knew, the student was thought ready to begin work as a painter. Eastern painters did not build up layers of color, as Westerners do; instead, they composed their painting from arrangements of these separate strokes.

Early Chinese painters had worked on plaster walls or lacquered wood. At some time during the second century A.D., they began to design scrolls intended to be rolled up, stored away and unrolled in private for the collector's enjoyment. But by the T'ang dynasty, lasting from the seventh to the tenth centuries A.D., painters were producing works for the home, decorating movable screens, as well as silk scrolls designed to hang on walls. The best screens and scrolls were autographed by their painter, and counted as very valuable items.

Chang Yen-yuan—a gentleman writing for fellow scroll collectors—wrote the first of many how-to manuals for mounting scrolls. The palace collection employed its own staff of high-born *scholars* to mount and catalog its store of scrolls, the best in China. Aristocrats of the Sung dynasty (lasting from 960 to 1280), not satisfied to be only collectors, became painters as well. Some dishonest collectors were known to forge the signatures of old masters; others, who worked as professional *mounters* and *art dealers*, deliberately substituted imitations for the originals given them to remount.

For centuries the art of Japan was closely modeled on that of its neighbor, China. In the eighth century,

Japanese painters strove to duplicate India's Ajanta frescoes, known to them through Chinese copies. Original Chinese paintings later crossed the water and were bought by the Japanese aristocracy. Korean artists worked in the same tradition, both in Korea and as immigrant painters in Japan.

Taking Chinese works as their models, Japanese painters learned the basic techniques of their art. But they soon found that their patrons did not value landscape painting. To paint what would entertain or exalt their masters, the feudal aristocracy, Japanese painters turned to portraying battle scenes on scrolls.

Japanese painters also depicted court social life, telling stories through a series of pictures—essentially comic strips for the nobility. The Japanese did not set up art galleries and, unlike the Chinese, collectors did not cover walls with displays of hanging scrolls. These paintings were designed only to decorate homes, so painters

focused on works that were easy to live with—quiet subjects painted in quiet tones, and small enough to be tucked away in a corner or specially built alcove.

Further west, where Asia met the Mediterranean, cultural traditions mixed with one another. The Arabs and their religion, Islam, had conquered the Near East in the seventh century. The Arabs had no tradition of painting, and, indeed, to them drawing images of anything God had made, anything in nature, was looked on as a violation of heavenly authority. But, though not officially tolerated, a wide variety of Islamic painting styles existed, especially in the later centuries. The relatively few painters certainly did not rank high in prestige, however. *Writers* were thought to take their inspiration from God; painters practiced a more humble trade, passing the job and its unchanging techniques from father to son. Under Islam, these middle-grade artisans were roughly on a level with *masons*. Islamic painters drew illustrations for scientific treatises, or, on a larger scale, painted palace frescoes that celebrated the easy life of the nobility.

Attitudes later changed, and the most powerful of the Moslems came to collect paintings and drawings as signs of their wealth and prestige. One painter became a favorite of Persia's king; this artist was rewarded with hand-polished paper and paints made from gold and lapis-lazuli, and was commanded to fashion the most luxurious artwork yet seen. Akbar, a Persian-influenced ruler of India in the 1500's, employed 100 Indian and Persian painters. They illustrated his memoirs and painted portraits, always in profile, of court notables. These painters worked for a small group of wealthy patrons drawing the same ministers and generals so often that the profiles became stereotypes, taught by master to apprentice.

Bordering on the Islamic nations, the Byzantine Empire was all that remained of the Roman Empire, which had fallen to Germanic tribes during the fifth century A.D. The Byzantines, who had officially adopted Christianity in the fourth century A.D., had religious

scruples about art similar to those of the Moslems, but they got around them in a very different way. Byzantium's Christian leaders issued a handbook with technical directions, visual themes, and physical descriptions of biblical subjects. They assumed that since all depiction of these subjects had been determined by God, in portraying religious matter, the painters were simply doing copywork. Every painting of the "emergence of Eve" represented the subject in exactly the same way—Eve emerging from Adam, "arms outstretched in the air"; the Eternal Father floated to one side; according to the official handbook, "He sustains her with His left hand and blesses her with the right." Painters did most of their work for the church, painting frescoes in cathedrals and monasteries. Because they painted the same subjects over and over in the same set style, they developed few new ideas or techniques.

Relatively backward and poor, Western European painters mimicked their Byzantine counterparts, copying those few art works that found their way to the West. For centuries, there were few painters in the West; many were essentially *draftsmen* who illuminated manuscripts—that is, decorated them with colored paints and often with silver and gold—in the church's monasteries. In early medieval times, texts were precious objects; a book was not only handwritten, but also colored and decorated with designs of great intricacy winding through its borders. The monasteries were secluded from the outside world. They could preserve manuscripts and nurture the skilled artists who decorated them. The *illuminators* compiled collections called *scriptoria*, storing the manuscripts in leather satchels.

Centuries passed as the monastic artists worked alone; few people outside the monasteries had the leisure to make or read such works. It was not until the 12th century that the cities of Europe became wealthy and cultured enough to support professional artists, most of them trained by *monks*. Painters were once again able to earn their livings through skilled work. These included

Self-portraits have been favored by painters for thousands of years. (Authors' archives)

illuminators, for a secular market for their productions was just edging into existence. Draftsmen were employed by *booksellers*, who gathered around the new universities.

As Europe became more prosperous, books became larger and richer. Their pages were bound so that they could be circulated more easily, and they were illustrated, rather than illuminated, with pictures that could fill an entire page. Unlike the painters of the day, *illustrators* drew pictures that attempted to depict the look of things in the real world, and they crowded the borders of their work with small, whimsical, often humorous touches.

The Catholic Church still commissioned mosaics and frescoes, done in the Byzantine manner, and many painters focused on the decoration of monuments. Medieval painting of this sort was a secondary art, enhancing larger architectural work. Painters decorated statues and completed devotional scenes for churches. These were often painted to fit in elaborately carved settings, such as altars, which left a set of panels empty for decoration; the paintings had to match the altars, not the other way around. Some frescoes were

bordered with rims painted to look like wall moldings, designed to match the architecture of the building.

Painters and draftsmen, like all craftspeople of the Middle Ages, worked simply as artisans. In 1283, the painters of London formed their first guild; it was an offshoot of the *saddlers'* guild, and four of its nine fundamental rules regulated the painting of saddles. Even a century later, a man who painted the favorite portraits of the Duke of Burgundy rounded out his living with high-priced craftswork, painting banners, draperies, and, at last, the Duke's hearse. In 1323, a book written in praise of Paris as a center for sophisticated living noted the city's large numbers of skilled workers. "We are not ashamed here to mention the makers of bread," or either "the . . . ingenious makers of all sorts of images, whether contrived in sculpture or in painting or in relief."

Draftsmen were few compared to other artisans, for books or paintings were luxury items. The Paris tax roll of 1292 listed 33 *painters*, 24 *image-makers*, and 13 *illuminators*—but more than 350 *cobblers*. Only one of all these artists is remembered by name; Master Honoré, who illuminated the manuscripts of the royal family, employed a servant, and was considered a success.

Few people, if any, took painting seriously enough to criticize it, or make a point of collecting it or protecting it from harm. The new rules for the Parisian painters' guild of 1391 held that a painter, before starting a project, should scrub the surface clean of any earlier work. In the 13th century, more cities began to commission paintings, but painters were not offered favored official posts; rather, they bid for the city's commissions, as modern contractors bid to lay town sewers. But the painter's trade was growing; the skills needed were becoming more sophisticated, and the painter was ready to rise in society.

With the onset of the Renaissance in the 14th century, the Italian cities and kingdoms, whose trade with the East was now producing great stores of wealth, began to regard painters as more than simple artisans. In Siena,

when a long-awaited altarpiece was due to be unveiled, church bells rang and crowds filled the streets for a public holiday.

In Naples Frederick II and his successors opened the court to favorite painters. One painter, Giotto, began his life as a peasant boy tending sheep in the fields; legend has it that a traveling nobleman saw the boy sketching upon a stone and knew at once that he was meant to be a painter. The story comes from Vasari, who wrote *Lives of the Artists* two centuries later, at a time when the best painters, backed by their literary allies, were arguing for a status beyond that of any other sort of artisan. But Giotto did not paint for critical acclaim or higher status. He painted as his talent led him, ignoring the dying Byzantine tradition for his own, more naturalistic manner; other painters followed suit. King Robert, successor to Frederick, was proud to have Giotto at court; stories told in later times describe Giotto as the king's companion, who made quick-witted remarks at Robert's expense, perhaps acting unofficially as as superior sort of *court jester*.

In Renaissance times, a painter reached a royal or princely court only by invitation from the ruler. The few official painters lived like other craftspeople—most had no duty at the court other than the assignments that came their way. There was no need for them to come to court or travel with the king's household; they could work much better in one place. But a talented painter, like Giotto, was likely to be intelligent and imaginative, good company. If a ruler wanted to keep a favorite painter at court he would sometimes have the painter fill an available court position, for there were often no set places for painters at court. That is why some painters appear on medieval court payrolls as armed *guards*. As late as the 15th century, Jan van Eyck, an impressive and polished man as well as a brilliant painter, served the Duke of Burgundy as much as a diplomat and advisor as a painter. But he was well rewarded for both jobs, with his own servants and prestige equal to a nobleman's. His

position was far superior to that of Giotto, and his painting, universally acclaimed, counted almost as much as his service to the state. In the century since Giotto's death, the prestige of painters had risen considerably.

This progress had been uneven, but the painter had become the most highly regarded of all artisans and would remain so for some time. In 1334, late in Giotto's career, when he was known throughout Italy, the city of Florence wanted to honor the famous painter. They decided to name him City Architect, for, the city fathers felt, the title of painter was not good enough for him and would be a dishonor. By the 1400's, painters were being knighted by the Holy Roman Empire. Cities began to create posts for official painters. Though these were still considered extravagances, they were a way for cities to display their wealth.

In the 14th century, painters' guilds sprang up in the merchant cities of Northern Europe, notably in the Netherlands and northern Germany. Most of them were dedicated to Luke, one of the four evangelists of the New Testament, who was considered the patron saint of the craft. The guilds could include *illustrators*, *illuminators*, *bookmakers*, *copyists*, and *booksellers*, in addition to painters. An apprentice worked for five to seven years in the studio of his master. At first he did menial work, sweeping floors, mixing paints, and preparing easels. Most painting at the time was done on oak boards; the apprentice would coat these with a mixture of glue and chalk plaster, to provide a proper painting surface. When judged ready, the apprentice would produce a trial work to show his skill. If his *master piece* was acceptable to his elders, he became a *journeyman*, a practitioner of the craft. It took years of experience, working as an assistant, before he could set up his own studio.

Members of these guilds now had much work to occupy them. Illuminators and, especially, illustrators prepared the books that nobles were buying for their libraries. Painters outside courts still took most of their commissions from the church, or more precisely, from the

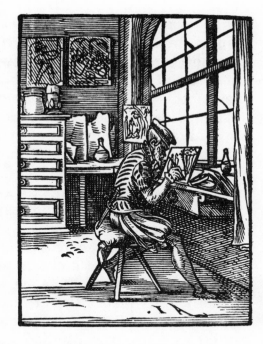

For much of history, most painters were decorative artists, like this glass painter. (By Jost Amman, from The Book of Trades, *late 16th century)*

carvers and *architects* who designed altarpieces. A painter would deliver a preliminary sketch to his patron; then the two of them would work out what the painter would do, and negotiated a fee and a deadline.

New buyers, still small in number, were also appearing. Nobles and affluent citizens sometimes wanted small paintings of their own, most often on religious themes. Because these were not meant for any particular architectural setting, a new trade developed; specialists began to make frames for the paintings. The frames were thought to be almost as important as the painting. *Framemakers* formed their own guilds, enforcing high standards in the carving of their work; the painter did the actual decoration of the frame.

The painters who belonged to one of St. Luke's guilds took pride in their occupation. As in all exclusive craft guilds, their rules decided what work was acceptable and what was not. The standards were demanding, and guild officials could enter any studio to check on materials, methods, and conditions. Guild members spent their lives together, even apart from work, gather-

ing in debate societies and shooting clubs. A traveling painter stayed with his foreign colleagues; the German Albrecht Dürer was treated like a celebrity when he appeared at Antwerp's guildhouse. An exchange of sketch books to trade ideas was customary.

The revival of talent and trade in the North followed new advances from Italy, still the center of the Renaissance. Most of Europe's finest craftworkers lived in Italy. In 1630, Charles I of England paid 10,000 pounds—$125,000 at today's rate—for a few paintings by Italian masters. Rome would stay for centuries the art center of Europe.

No longer dominated by Byzantine rules, the painters of Italy thought about and debated everything that had to do with their work. Florence, a merchant city where virtually every male citizen belonged to a guild, trained all its craftspeople to be Europe's best. Members of the Fraternity of St. Luke studied science and mathematics to produce paintings that would be closer to life than anyone had yet seen. Leonardo da Vinci began the practice of dissecting dead bodies to understand human anatomy. To master effects of light and shadow, painters

With the development of perspective, painters turned to a more realistic style. (By Jost Amman, from The Book of Trades, *late 16th century)*

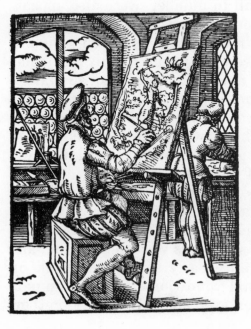

studied the relations of colors to each other, and used mathematical formulas for accurately laid out perspective. The best painters were as highly trained as today's surgeons.

Italy also built on the remains of Classical civilization. Almost all Greek and Roman paintings had long since worn away, but Classical sculpture had survived in fragments, some of which were dug up from Italian gardens. This was not simply a matter of one age enriching itself by copying the great work of another, however. Classical work served as an inspiration rather than a model. Discarding what they had been taught, Italian painters and sculptors were prompted by works like a newly unearthed Roman copy of a statue by Praxiteles to seek a new approach to their art. In this period, the history of the painter was closely tied to that of the sculptor.

Into this setting, the great artist Michelangelo was born in 1475. His father, a village official, did his best to keep the boy from becoming a painter, thinking it a demeaning trade. But Michelangelo followed his art and when he died, after decades as a painter, he had been famous most of his life, had accumulated considerable wealth, and had been treated as something of an equal by the most powerful men in Italy. Pope Leo X said that he thought of Michelangelo as a brother, but that he was still afraid of him. While the best painters before then had been recognized as supreme craftsmen, Michelangelo was the first to attain a status beyond this. Like the Moslem writers, Michelangelo was thought to be divinely inspired. His paintings and statues were so special he was allowed to behave in any way he liked—and he behaved terribly. Yet his patrons rewarded him with money and praise for whatever he chose to make. More than anyone else, he set the standard for other painters to follow. In the course of the next three centuries any painter with talent automatically came to be thought of as an artist. Today the words "painter" and "artist" are used almost as synonyms.

The best craftwork, and especially the best painting, was no longer required to fulfill any specific practical function. The patrons of art in Italy competed to own the finest works. Pope Nicholas V set aside tithes from the pilgrims who visited Rome, accumulating a lavish art fund for papal use. Lorenzo de' Medici, who became dictator of Florence in 1469, made his court a home for painters and scholars, supporting the city's intellectual life. The aristocracy came to commission more works than the church. The Italian painters now designed their own frames, intending the frame to match its painting, to provide a self-contained setting for the work, rather than to fit into the surrounding architecture.

Successful painters became the unofficial peers of the nobility. Some, like Jan van Eyck, provided services to governments, but some won their place by their art alone. It became the artist's professional tool to know how to move among the elite; the Italian Renaissance painters' premier biographer, Vasari, described Raphael as the first to "excell in art and in manners also." Raphael was so highly regarded that a cardinal once offered him a commission and the hand of his niece in marriage. In 1533, the Holy Roman Emperor made the painter Titian a Count Palatine and a Knight of the Golden Spur; the painter's children became nobles of the Empire, all due, according to the ennobling document, to his "felicity in art, and the skill he has displayed." A hundred years

Renaissance artists sometimes used grids—something like our modern graph paper—to help them draw more realistically and in proportion. (By Albrecht Dürer, early 16th century)

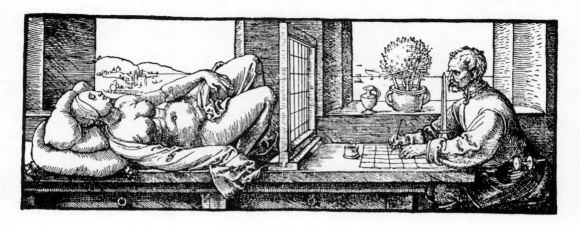

later, Philip IV of Spain, and all his brothers, practiced painting as part of their general education.

After the Renaissance, the best painters were welcome in the best society; they frequently invoked the precedent of Apelles, Alexander's favorite painter. With increasing prosperity in Europe, the painter's services were in great demand, not only by the gentry but also by the rising middle classes.

While court painters were the most privileged of the artists, even the relatively lowly illustrators were becoming fairly prosperous craftspeople. The book trade had burgeoned in the late 15th century, with Johann Gutenberg's development of the printing press. Illustrators found ways to reproduce their work in books, settling on woodcuts and the more sophisticated method of metal engraving. Pictures were carved from the surfaces of solid blocks, which were then covered with ink and stamped onto paper. The people who worked with woodcuts had little prestige and illustrated inexpensive religious works. The same pictures were used over and over again, without regard to accuracy. In one book, for example, the same city view represented both Rome and Jerusalem. Metal engraving ranked higher, for it took more skill—skill thought to have come from the *goldsmiths*, a well-respected body of artisans.

The painters' middle ranks found patrons of their own. An English visitor to the Netherlands in the 17th century wrote that *shoemakers* collected paintings: "He that hath not bread to eat hath a picture." Another man claimed that Dutch *farmers* routinely invested in paintings, checking which painters were most promising, buying their work, and then waiting as prices rose before selling at market fairs. Dutch citizen groups commissioned large paintings commemorating themselves, hanging them in clubs and meeting halls. Rembrandt's famous *Night Watch* was painted for a corps of citizen soldiers. One problem with these paintings was that every member of a group wanted to be in the foreground. Painters sometimes were paid according to how many heads and

hands were clearly in view—this could produce a rather curious arrangement of the figures.

The painters' concerns set them apart from other people. The best were famous for thinking of little besides their work; even the middle ranks of the profession devoted most of their time and energy to mastering the skill needed to stand out. The painters' desires to share with and learn from their fellows gave rise to the *academy*, an institution where artists could gather, displaying their works, exchanging ideas, and training the young.

The French formed their first academy in 1648. Its authority came from the state, with the throne supplying money and appointing officials. Membership was mandatory for any painter who accepted royal commissions. Louis XIV's ministers wanted to glorify French cultural life and the lavishness of its material wealth. The throne maintained a factory of the best workers in every craft; the factory's *cabinetmakers*, specialists in furniture, made the lavish frames for the painters' works. (Artists outside royal favor relied on framemaking specialists who belonged to a guild.)

The Academy drilled its students by strict methods; the aim was to ensure that the kind of art approved by the state and the Academy directors would continue to be made long into the future. The President of the Academy, Charles Le Brun, issued students a manual with instructions on what to paint and which techniques to choose. The Academy displayed its members' work in an annual exhibition. At first, only the nobility could attend, but in the 18th century the doors were opened to anyone with enough money to buy work. This is how the public first saw new works and where opinions about painters took form. Belonging to the Academy became essential for a painter who wanted to find patrons. By the end of the 18th century, artists from all over Europe were sending their work to be displayed by the French Academy. The British Royal Academy followed the French lead in 1768, and in the 19th century virtually

every nation in Europe supported one of its own, on however small a scale.

Any painter who made a stir at an Academy exhibition gained an entry into society. This helped an artist to get commissions to paint portraits, which were especially popular in these days before the development of photography. While most painters were men, some women occasionally established themselves as artists in the 17th and 18th centuries. One woman, Elizabeth Vigée Le Brun, became a member of the Academy; she had the great advantage of being the daughter of one of its past presidents and the protegée of Marie Antoinette. She made a great success as a society painter, showing respectable artistic skill and a sure understanding of human psychology. Le Brun wrote down for her niece a portrait painter's rules of the trade: "The sitter . . . is to be told she . . . has a fresh complexion . . . If the sitter is stupid, she is to be placed in an attitude of reverie."

A few years after it was founded, in the late 18th century, the British Academy could support itself by the sale of catalogs, required for admission, at its annual exhibition. Artists, including painters, had begun to work for something like a general public. The crowds visiting exhibitions indicated that aristocrats and the middle

This artist's workshop produced everything from wall-sized murals to miniatures. (From Diderot's Encyclopedia, *late 18th century)*

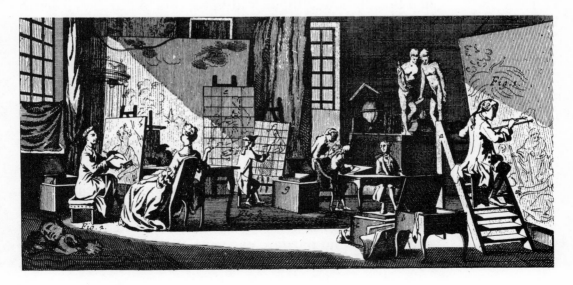

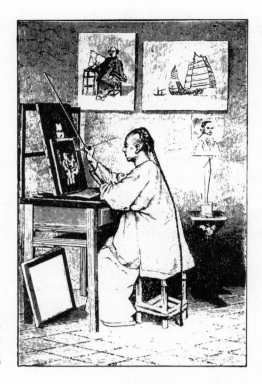

In modern times, Chinese artists began producing works in the Western style for sale abroad. (From The World: Its Cities and Peoples *by Edwin Hodder, et al)*

classes were willing to invest considerable amounts of money in art. This was a great change from earlier days, when a patron commissioned work. Instead of one customer, the painter had to take into account the wishes of a largely anonymous audience; this left artists freer to follow their own wishes, though many continued to produce work to order or to cater to the taste of a wider, and often less discriminating public.

The rediscovery of Pompeii in 1748 and of Herculaneum in 1709 and their subsequent excavation turned the Classical style into a powerful new fashion. People who considered themselves cultivated looked for art works from the days of ancient Greece and Rome—or for the new art that successfully imitated the old. This led to the development of several subsidiary professions dedicated to managing art. Experts traveled to Italy, on commission from the wealthy of Paris and London, to inspect ruins and bargain over antiques. *Art restorers* first appeared, using their scholarship to mend, not always

with the best results, damaged works from the past. *Art dealers*—still a handful—hired their own agents to buy up paintings and displayed their pickings in galleries, selling retail to the wealthy of Europe's northern capitals.

Journals, circulating among a small audience of elite readers, employed *reporters* to write about the new exhibitions being held all over Europe. Some told who had presented new paintings and what the paintings showed; others decided how well the painter had succeeded. These *art critics* presented a variety of opinions about what art should do, and praised painters who lived up to their views. In the early 19th century, art journalism was taken over by a battle between philosophies, when the *Romantics*, believers in expression of emotion and search for new experiences, rose against the more formal, cool, and controlled *Classicists*. Many painters had come to see the public as an audience that had to be won over to a way of thinking. Rebels, alone or with like-minded spirits, gave exhibitions of their own, inviting art-lovers to see what was being done outside the academies.

America's earliest painters operated outside these traditions. In the 18th century, the North American colonies were much poorer than Europe, and in the 19th century much of the country remained a frontier. Until after the 1776 Revolution, the painting done was competent but of little artistic interest. By the start of the 18th century, all thirteen Colonies had people who worked as painters. They decorated signs and glasswork; as we see from early newspaper advertisements some also offered lessons in drawing, singing, and dancing, too. The country's first painter with up-to-date training was a Scot who immigrated to North America in the 1720s. He gave lessons, and his pupils made up a small circle of society *portraitists*.

They worked for an equally small circle of patrons, for few people in America had money to spend on art. Art, including painting, was considered, as an American painter wrote regretfully, a "superfluous ornament." This

outlook remained characteristic of Americans well into the next century, so that the Frenchman Alexis de Tocqueville would write in 1835: "They [Americans] habitually put use before beauty, and they want beauty itself to be useful."

Talented American painters were likely to go abroad. One, Benjamin West, became president of the British Royal Academy. Those who remained at home found tastes little changed. America in the 19th century had entered a period of great prosperity, but its merchants, lawyers, doctors, and ministers who could afford to buy art still wanted painting to be "useful." They had no taste for the European grand historical tableaux. Patrons wanted to see themselves, and would pay only for portraits. The country supported some fine portraitists, but others had a hard time. Samuel F.B. Morse, an American artist who had received considerable attention in London, was forced to turn from historical works to portrait painting when he returned to America. Unable as a portraitist to duplicate his great success abroad, he turned from art to tinkering; in the end he found himself a hero in his native country—for perfecting the telegraph as a practical, working device.

Meanwhile the 19th century saw great changes in art and draftsmanship in Europe—changes almost as massive as those of the Renaissance. The machinery and the prosperity of the 19th century were beyond anything that the world had ever experienced. They transformed every craft; most became automated, with factories cranking out products. No machines could draw, but they did reproduce drawings. *Engravers*, *printmakers*, and book illustrators saw their work sold to audiences larger than they could have imagined a few decades before. Most of this widely disseminated work was not good, but some talented people were attracted to the field. Hablot Browne, under the name *Phiz*, became famous for the inspired drawings with which he illustrated the works of Charles Dickens. In the 1870s, Jules Cheret showed that the advertising poster could be

Only in modern times have artists taken to the open air with their easels. (From Harper's New Monthly Magazine)

used for displaying vivid and imaginative designs. He became a Paris celebrity. Many artists, most notably Toulouse-Lautrec, tried their hand at the work—setting the standard for the fine posters and advertising work still done today.

But there was a second and greater change, one that applied to painting itself. Some 19th-century artists continued working for customers, fashioning portraits and stereotypical works meant only to please the audience. A

minority of painters, however, decided to have nothing to do with this process. In preparing their exhibitions and manifestos, these painters meant to amaze the public, often boasting that they were about to launch a new epoch in the history of their art. While very few of the people who made this claim are remembered, some did succeed in bringing about the heralded revolution. As the 19th century neared its end, the art world came to be formed of competing "schools," informal alliances of painters bound together by common ideas, who worked in obscurity and then burst upon the public. They used exhibitions and journals to propagandize the uncommitted, with the fashion changing every few decades as new schools arose. The best known—and probably the most important—of these "schools" were the Impressionists. They believed that art should represent the world as it was experienced in the subjectivity of the individual painter's senses. People laughed when the first Impressionists' paintings were exhibited; but a few decades later, the grand old men of the movement were being courted by collectors and the press.

Over the centuries, the best artists had come to assume that the demands of the audience had nothing to do with the creation of art. In the first years of the 20th century, this became the general gospel, so that even the buyers and enjoyers of art came to accept it. The various movements passionately concerned with the complex intellectual issues that lie behind art were seen as the forces that rightfully decided what painters would paint. Since these movements were made up of painters and their intellectual allies, the artist could claim to exercise self-rule.

But in the 20th century the painter's audience has shrunk greatly. Many people care little about the issues that now concern painters, although art is still the subject of a good deal of curiosity and speculation. The subsidiary professions that surround the artist are needed to testify whether a painter has talent or not, since most people assume that it is impossible for the

average person to tell. Journals dedicated to art are published; the better general interest magazines have regular departments of art criticism.

Art historians scrutinize works from the past and the present, tracking the techniques and conventions characteristic of regions, periods, traditions, and individual painters. Some art historians teach at universities while carrying on their research. (So do many artists, especially at art training schools, which provide them with a regular income.) But one of today's art historians points out that the "techniques put to work [by art historians] . . . are the tools of the trade not merely for teachers but for art dealers, museum curators and a host of others whose living depends on their being right about questions of attribution, dating, authenticity and rarity." The museums that collect and preserve art compete with the universities for knowledgeable staff. The museums of the 19th century were run by amateur enthusiasts. Patrons, after donating great sums, might

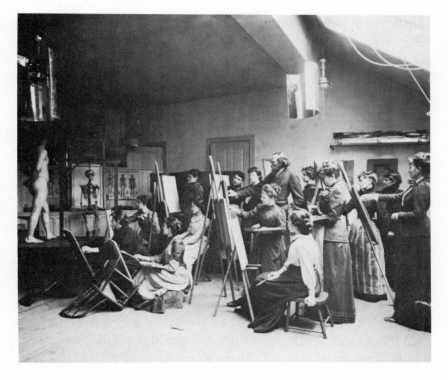

Some artists have always made part of their living teaching students, such as these daring late 19th-century ladies. (By Frances Benjamin Johnston, Library of Congress)

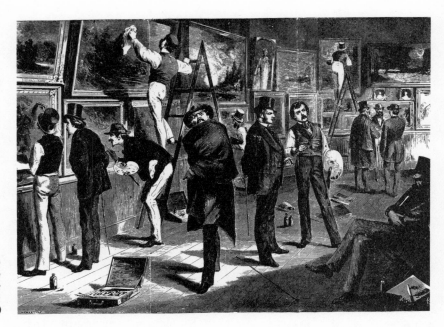

often direct how their money should be spent. Art museums today generally seek out art scholars, although they often cannot offer as much prestige or money as the colleges. The International Council of Museums resolved, at its 1965 general conference, that museum *curators* should be regarded as the equals of those specialists hired by the universities to teach. Sixteen years later, the Council's president acknowledged that this had not come to pass. In theory, curators should be trained in their profession—in how works should be cataloged, presented to the public, and so on—but this is not always the case. Many of the talented and ambitious can be expected to leave for university posts.

Galleries, devoted to displaying a changing array of new work, present painters to their audiences, giving them a chance at the critical reputations that bring sales. *Art dealers* or *gallery managers* are business people who operate showrooms where an artist's work can be displayed for sale. One manager wrote in 1976 that "art in America is now 'Big Business,'" pointing out that in 10 years the number of New York City's galleries had

doubled. Galleries have opened in many small cities, exhibiting work by local artists often priced below $1,500. But even this is a great deal of money for most people, and art works remain largely in the hands of the wealthy.

Other buyers of artworks include prosperous organizations, such as corporations, banks, and branches of government. Many painters find customers here. And some artists receive financial support without being expected to supply their sponsors with finished work in return. Cultural life is now considered so important by some members of society that its nurturing is held to be a duty. Most governments in the West set aside small parts of their budgets as endowments or grants to the arts. Rich private citizens fund foundations which select artists and projects deserving their funds.

Doing their part to preserve art are the museums. These grew up during the 19th century, and flourish in the 20th, drawing their money—like the artists

Modern artists are sometimes depicted as lazy creatures living on their fame and celebrity. (From Drawing and Design, *IV, August 1920)*

themselves—from a combination of government and private funds, with modest admission fees charged to the public. The directors and curators of these museums—the people who administer them as institutions, while hunting down, selecting, restoring, and presenting the artworks to be housed—can themselves become celebrities of the art world.

The largest and most famous museums, those in cities like New York and Paris, can attract large crowds. Masterpieces of the past that have entered popular legend bring in tourists; otherwise, an exhibition of works by a famous artist or school are the best draw. New works generally attract far less attention.

For related occupations in this volume, *Artists and Artisans*, see the following:
 Bookbinders
 Furniture Makers
 Glassblowers
 Illustrators
 Jewelers
 Photographers
 Potters
 Sculptors

For related occupations in other volumes of the series, see the following:
in *Builders:*
 Architects and Contractors
 Masons
 Plasterers and Other Finishing Workers
in *Clothiers*:
 Shoemakers and Other Leatherworkers
in *Communicators*:
 Journalists and Broadcasters
 Publishers and Booksellers
in *Scholars and Priests*:
 Curators
 Scholars

Photographers

In a little over a century and a half, photography has achieved the status of an important art form and a respected occupation having an impact on many fields. It has served as the basis for the development of motion pictures and television, the major new art forms of our time, and for very significant new industries as well.

The camera is one of the great inventions resulting from the Industrial and Scientific Revolutions. The principle of photography—that light entering a darkened enclosure will form an inverted image of the scene outside the enclosure—was understood by the artists of the Renaissance, and was described by Leonardo da Vinci, among others. But the image captured in the darkened enclosure vanished as soon as more light was allowed to enter. Even so the "camera" in

this limited form, became part of the standard equipment of many *artists* in the 16th, 17th, and 18th centuries.

Photography in the modern sense waited upon some means by which the image could be permanently captured—and that is what French inventor Joseph Nicéphore Niépce succeeded in doing in the years 1816-1826. The French painter Louis Jacques Daguerre had been doing somewhat parallel work during the 1820s and went into partnership with Niépce in 1829. Niépce died in 1833; but in 1837 Daguerre went on to produce the first truly successful photographs ever made. These photographs were called *daguerreotypes* in his honor.

The invention caused a sensation. By the early 1840s several early technical problems had been solved, and the occupation of *photographer* had been born. Many early photographers focused on landscapes, especially well-known scenes of beauty, romance, or history. Their pictures were published widely and soon people in practically every home in the Western world had, or had seen, a daguerreotype of some famous place. Many other early photographers primarily took portraits. The first portrait studio was set up in London in 1841; soon portrait photography studios were springing up in many major cities, catering to an eager public—by 1870, New York City alone had more than 300 photography studios. Once only *painters*, *miniaturists*, or *sculptors* could provide likenesses of people, their homes, and their favorite scenes; but now clients commissioned photographers to take pictures of people, places, and objects that interested them. Many of these early photographers also took pictures of the great events of the time, though it was not until late in the century that printing techniques allowed photographs to be included with ease in the newspapers, journals, and books.

The usual mode of training for photographers has been field work, although in modern times specialized training has been useful for some kinds of commercial work. Mastering photography has been a matter of long, painstaking apprenticeship, alone or with an experienced

photographer, a course not very different from that followed by photographers from Daguerre on. For example, the great American photographer Mathew Brady opened his first daguerreotype gallery in New York in 1844, when he was only 21 years old, and pursued his trade as a portraitist and business owner as he learned his art and craft. Seventeen years later, he became the pioneering photographer of the American Civil War, working right at the front during battles. Most professional photographers develop their own pictures, too, as almost all did in the early days of photography. Brady, for example, developed his photographic plates in the darkroom buggy he brought with him to the front.

Far from engaging in art for art's sake, many photographers have made a living photographing vacationers. (From Police Gazette)

Many other great pioneer photographers developed their art and craft as the field experienced quick technical development during the rest of the 19th century. These included the Englishmen Roger Fenton and James Robertson, who in 1855 photographed the Crimean War, much as Brady and others did the American Civil War; the French caricaturist-turned-photographer Gaspard Félix Tournachon, known as Nadar, the first person to take photographs from the air; Canadian Napoleon Sarony, the early theatrical photographer; the fine English artist-photographer Julia Margaret Cameron; the gifted amateur Charles Dodgson, known professionally as Lewis Carroll; and the great photographer of the American West, William Henry Jackson.

There were also the technical pioneers, such as George Washington Wilson, who in the 1850s began to produce excellent action photographs; Edward Muybridge, the English inventor-photographer who was the first to successfully photograph a galloping horse in a series of still photographs; and George Eastman, the Rochester, New York, inventor and founder of the Eastman Kodak Company. Eastman's handheld camera was the most effective of the many invented after the gelatin plate made it possible to develop negatives some time after a photograph had been taken, rather than immediately, as Mathew Brady had been forced to do on the battlefields of the Civil War.

In the latter 19th century, photographers disputed whether they should be regarded as artists or naturalists who add nothing to what they photographed. That dispute was largely settled by the emergence of a substantial body of great artist-photographers late in the 19th century, including Alfred Stieglitz, Gertrude Käsebier, and Edward Steichen, to be followed in the 20th century by such fine artists as Paul Strand, Edward Weston, and Ansel Adams. Since then, *pictorial photographers* have generally been regarded as artists by those around them and by society as a whole. Indeed, the artist's status was

and is one of the greatest rewards society has conferred upon the photographer.

While the pictorial photographers worked and developed their art, photography began to branch into the several modern forms which, while overlapping considerably, characterize its modern development. The art and craft of the *documentary photographer* began to develop in the latter half of the 19th century, with the work of such pioneers as the American social reformer Jacob Riis, whose powerful documentary photos began to expose the plight of poor immigrants in America in the late 1880s; Jean Eugène August Atget, whose thousands of photographs of Paris were unrecognized as a prime historical record until their rediscovery in the 1920s by photographer Berenice Abbot; and the American Lewis W. Hine, whose thousands of photographs of immigrant life and child labor in America remain today the best work of its kind ever produced. Their work has been continued and developed by such documentary photographers as Dorothea Lange, Walker Evans, and Margaret Bourke-White.

In time, technical developments expanded the use of the camera and the role of the photographer far beyond the dreams of photography's pioneers. The microscope has become a camera, the electron microscope a camera allowing scientists to capture on film and study that which as recently as 150 years ago was not even understood to matter. The telescope has become a camera, an extraordinary development in the modern history of astronomy. In 1895, Wilhelm Conrad Roentgen discovered X-rays, beginning a development that continues to revolutionize medicine, as diagnostic tools improve by quantum leaps through ever more sophisticated uses of *X-ray photography*.

In the 1880s, *newspaper photography* was greatly advanced with the invention of the halftone-plate, and photographers found a new area of specialization, as *news photographers*. Working hand-in-hand with *journalists*, these photographers provide unique and powerful

records of the great and small events of the day, sometimes—as when covering wars and revolutions—in situations of great danger.

Specialist photographers have emerged in other areas as well, such as sports, fashion, theater, and advertising. In time, they replaced many of the commercial artists who had illustrated newspapers and magazines before. They soon expanded their work beyond the newspaper world, being employed in advertising all kinds of products. Many commercial photographers are employed directly by the firms that require their services—whether that means photographing a model eating cereal for use on a box top, or a firm's home office building for its annual report—but many others do the same kind of work as free-lance photographers, on assignment.

In 1889, Thomas Alva Edison developed the *kinetograph*, the first motion picture camera, laying the basis for the art and industry of motion pictures and television. So the art and craft of the *cinematographer*

was born, as the specialist who shapes the "look" of a film. As movies and television developed into the major industries they are today, they developed much the same kinds of specialties as found in still photography. Some people work in teams with journalists covering news events; some make artistic films, short or long; some make commercial advertisements or industrial films; some focus on specific areas of expertise, such as sports or fashion. Many today have at least some special training; often they start in the trade doing essentially menial work, such as carrying camera equipment, then working their way up to be *camera operators* or *cinematographers*, perhaps even *directors* or *producers*.

Because photography has developed into such a massive industry, many people today work in photographic laboratories. Amateur photographers who delight in taking pictures, but lack the equipment or the special knowledge to develop them, send their film to laboratories for processing; so do many professionals who need multiple copies of their work for sale. While many of the *photographic laboratory technicians* employed in film laboratories primarily work on processing the film and producing the required number of copies, others work as *retouchers*, erasing defects or producing special effects for the firm's clients. Since photographic plates are the basic building block of the modern *offset press* printing process, which replaced Gutenberg's movable type, many of these technicians work in the printing industry.

In their short history, then, photographers have used new, more effective means to do what was attempted before, such as capturing permanently a view of a human figure or landscape, as well as things not previously thought possible, such as photographing the inside of a human body, a universe, or a microscopic particle.

For related occupations in this volume, *Artists and Artisans*, see the following:
Painters
Sculptors

For related occupations in other volumes of the series, see the following:

in *Communicators*:
 Journalists and Broadcasters
 Printers
 Publishers and Booksellers
in *Healers*:
 Nurses
 Pharmacists
 Physicians and Surgeons
in *Performers and Players*:
 Actors
in *Scientists and Technologists*:
 Astronomers
 Biologists
 Chemists
 Physicists

Potters

Potters have worked from the beginnings of civilization to the present day. Their craft is versatile; its products range from the crudest goods to the finest art objects. Through most of their history, potters have ranged from rural artisans to vendors of fine work to the rich.

It took a long while for prehistoric people to discover the special possibilities of clay. The first problem was that humans, for many thousands of years, lived nomadic lives, with no permanent home. Even if it had been possible to create the techniques of pottery, their products would have proved useless: People on the move have no use for containers that break.

The fertile river banks of the Middle East—the Nile and the linked Tigris and Euphrates—were the sites of early human settlements—and of the first appearance of

pottery. No one knows how people first discovered the usefulness of fired clay; perhaps they took their cue from seeing mud harden under the sun. But by 6000 B.C., clay vessels were being roasted in Mesopotamia along the Tigris and Euphrates (in what is now Iraq) and the coast of the eastern Mediterranean. Nearly 2,000 years later potters in Iran and Mesopotamia were using the *kiln,* an oven in which pottery could be baked without damage. They also developed various *glazes*, semi-liquid coatings that served to decorate work and also to make it more durable. The use of kilns and glazes spread to Egypt and became almost universal parts of the craft.

This pottery, called *earthenware*, was made from clay, often dug from riverbanks, ground to an even consistency, and then baked until hard. If it had been worked correctly, the clay became waterproof and watertight—an ideal container. But it was brittle and had to be treated gently.

Pottery was simple and useful; as a result, it soon became indispensable in the emerging civilizations. But those who benefited from the craft thought little of its practitioners. Potters dabbled in the earth and made objects that were practical but not valuable.

The first potters seem to have been women. They shaped the clay with their hands, making cups, beakers, and storage jars for their households. This changed with the invention of the *potter's wheel*, somewhere around 3500 B.C., possibly in Sumeria, in southern Mesopotamia. The wheel is a simple device. The potter "throws" the clay on a disc that is entered on a spoke. The disc whirls very rapidly. At first, the potter had to turn the wheel with one hand while working the clay with the other. Later wheels could be spun by foot, and at times an apprentice could keep the wheel going while the potter concentrated on the work.

Before the wheel, the potter had to turn the vessel to work on each of its sides. But with the wheel, every inch of the pot's surface was available almost simultaneously. A piece could be finished in a fraction of the time that it took

In the Near East potters like this one have worked their wheels for thousands of years. (From Picturesque Palestine)

before. A potter with skill also found that the material could be worked and manipulated in ways that had hitherto been impossible. The potter's wheel was one of those inventions that transform a craft. The wheel made it possible to produce more pottery and to show more skill in doing so. From a household task, pottery became a trade taken over by men.

Country after country adopted the new invention, and trade in pottery followed. One man, if he worked hard, could provide pottery for two hundred people. In those days of barter, pots became something like currency; there were so many available, and everyone found them useful.

An Egyptian wall painting, found in the ruins of Beni Hasân, shows the operation of a pottery workshop. The vessels are formed on the wheel, then heated on top of the kiln. The kiln has a tall rectangular shape, with an opening in its base where the fire is built. None of the workers, all male, is shown wearing any sort of protective clothing.

Clay was a cheap material and could be molded into many different shapes, so it was often used to copy items

otherwise made of more expensive materials. Potters even shaped copies of objects made of commonplace materials, such as leather goods and basketwork. Beginning with the vase painters of Mesopotamia and Iran, potters decorated their work in styles that other craftsmen had set.

The pottery of Mycenae, one of the early Greek cultures, became especially popular, and traders sold the beautiful wares widely. Potters made practical objects but their work also could reveal artistic interests. One expert noted that the earliest pottery to be baked in slip (a solution of clay in water) were handsome luxury goods, meant for display. Baking in slip not only brings out an extra sheen in pottery, but also seals any invisible cracks. It would have been a practical process to protect common household containers, but was actually first used for the look it gave.

Much pottery has survived from the cities of Classical Greece some five or so centuries B.C. Because so much of its art has disappeared, pottery has become important in our reconstruction of early Greek history. We know about the potters only through the signatures on their wares, some public inscriptions, and a very few mentions in written records. At the time, Greek potters were not a large body, and, if not despised, were not always respected. The successful owner of a large pottery workshop was given the deference that comes with wealth, and five such men are mentioned in inscriptions on the Acropolis in Athens. But the artisans who worked under such men were not considered solid citizens; indeed potters in Athens, during the fifth century, were considered aliens. Many wandered from job to job, like a *painter* named Oltos, who worked in establishments in six different cities.

By the standards of the time, pottery workshops were large; some employed 70 people. It is not known how the tasks were divided up, except that painting was regarded as a job for specialists. Some shops had only one or two painters; others had up to twenty. At first, vases

may have been sent for decoration to independent artists; but by the fifth century a workshop was more likely to hire its own painters, who became a type of potter.

It has been estimated that at no time were there more than 125 vase painters in Greece; add *shapers* and other workers, and the number of people who could be called potters is still well below 1,000. These people supplied all the pottery that Greece could use or export to its neighbors. They made not only vases but also tiles, architectual decorations, plaques, figurines, and large statuary, with some shops probably specializing in one or another of these. The potters had no network for marketing their goods. A citizen could walk into the shop to buy what he wanted, or a *merchant* might order a bulk lot for reselling.

By the first century B.C. and the rise of Rome, pottery in the Mediterranean had become something of an industry. Unlike many of Rome's other artisans, potters were not slaves but instead owned shops or worked in establishments similar to today's factories. The most successful of the independent potters gained as much respect as an artisan could. Workshops grew larger; much of the empire's pottery came from small settlements which specialized in pottery production—not just in Italy, but also in Asia Minor, Africa, and Spain. The most famous Roman pottery came from Arezzo, in Tuscany.

The progress of Western potters and their work halted in Roman times. Aside from minor touch-up jobs, little skill was called for in making these goods. Clay was pushed by hand into molds designed with decorations resembling stylish metalwork. When the clay dried, it would shrink and fall out. Then it was painted with gloss. Each piece was meant to look like the other. Workers exercised their skill primarily by smoothing away rough edges.

The collapse of the craft came with Rome's fall in the fifth century A.D. In the Middle Ages, potters struggled to make a comeback, sometimes pushing forward, sometimes falling back. In England, there were almost

no potters 400 years after the Romans left. The potters of Germany's Rhineland proved more successful. They continued working, sometimes even in factories similar to those of Roman times, though now smaller and less secure. By the 11th century these artisans had rediscovered colored glazes derived from lead silicate. By this point, the renewed prosperity of the craft had touched even Britain. Potters appeared in the towns, selling their wares to city customers. But the good fortune did not last. A hundred years later the trade had once again contracted, and English potters were retreating from the cities to a subsistence livelihood in the countryside. Like so many medieval crafts, pottery found its safest haven as one of the skills taught in the monasteries.

Potters had an unimportant, insecure position in Western society. But pottery was known to almost every settled society on earth, and when it dwindled in one part of the world it could still revive and grow in another. In East Asia, the potters of China and its neighbors continued to work, and they made such strides that the craft's strongest traditions and most distinctive work come from the East.

The Chinese were especially inventive when it came to the technology of pottery. They first developed *ceramics* (the art of making pottery) sometime in the sixth century B.C. Their early work was not very interesting to look at, for the Chinese potters at that time did not have the West's mastery of colored glazes. Many of the pieces dug out from early Chinese tombs are imitations of ceremonial bronze vessels.

Ancient Chinese potters invented *stoneware*, a mixture of different clays fired at temperatures higher than those used for simple earthenware; the result was a hard and handsome grayish pottery. A second transformation came during the reign of the T'ang dynasty, beginning in the seventh century. While many trades prospered in this time of expansion and relative security, pottery advanced to the front rank of crafts. Some anonymous in-

ventor found that kaolin clay combined with feldspar made a pottery unlike any seen before—*porcelain*. In looks, durability, and method of creation, porcelain represented an advance over stoneware, as stoneware had been over earthenware. Porcelain vessels were a shining white. The material was harder than stoneware but also closer-grained, and could be stretched to an unprecedented thinness. This was the first material for pottery that became valuable in its own right, and porcelain work soon became a highly desired ornament for noble homes.

The production of porcelain flourished under the Sung dynasty, between 960 and 1279. Chinese writers listed 16 varieties of porcelain. The most coveted was *celadon*, which, through trade with the Moslems, reached first the Middle East and then, in smaller amounts, Europe.

Porcelain workshops could be found all over China. The potters, like their counterparts in Rome, gave little thought to expressing themselves; in most cases they simply made what their many customers would buy. The potters generally followed tradition in the styles they chose, assuming that what people had wanted before, they would continue to want. Some, though not all, of the pottery came from molds. One vase was made by many

Eastern potters, like these Tokyo porcelain makers, have long been famed. (From House and Home*)*

hands; up to nine workers might take it through its successive stages of shaping, baking, glazing, and decoration. Of these, the potter who might stand out enough to win popular recognition was the one in charge of mixing the clay and tending the furnaces, the technician of the enterprise.

Other countries were touched by China's progress. The Islamic nations imported Chinese work, using it as a standard of quality. The Moslem potters were the finest of the Mediterranean. The practice of their craft took considerable skill, and some won personal notice—at least, decorated pottery in Persia and Egypt includes the maker's name, something unusual in the history of the trade. The Moslems were inspired by the Chinese and tried to follow their lead by creating a quasi-porcelain called *frit*. Another invention, which would profoundly influence subsequent European work, was the development of the first glaze derived from tin and decorated with bright enamel colors. Trade in Islamic luxury pottery rivaled that of the Chinese.

The pottery of Islam and China reached Europe through trade and, more forcibly, by the Moslem conquest of Spain in the eighth century. Granada, stronghold of the Arab kingdom in Europe, produced vibrantly decorative work. Even as the Arab boundaries in Spain receded, its potters grew greater in influence. Merchants of the Christian countries to the north and east did their best to lure Granada's potters. In 1362, the papal Palace of Avignon, in southern France, was decorated with painted tiles made by Islamic workers.

The European tradition of sophisticated pottery had long since died out. As Europe was regaining both the prosperity and the confidence it had lost with the fall of Rome, it responded to these new traditions from the East. The blossoming of cultural activity during the Renaissance revitalized nearly every craft. The village potter soon met competition from new artisans, workers who were inspired by the beautiful and advanced wares from the East.

Italy in the 16th century led the European revival, influenced by Arab potters from Spain. The new artist-potters considered themselves equal to *goldsmiths* in skill and ambition. The work these potters turned out was for display, and their patrons expected them to be imaginative. It became a custom among the nobility to exchange decorative plates on special occasions, painted with a scene of the birth or marriage being celebrated.

Meanwhile other potters continued to make simple goods, selling them in large quantities. Monasteries and pharmacies bought storage jars, and the *pharmacists* also used ceramic mortars and pestles. Different factories worked for different markets. Potters in Orvieto, Viterbo, and Ravenna in Italy made useful everyday wares. Other pottery workshops were owned and sometimes run by aristocratic patrons. A workshop of potters was founded by Pier Francesco de' Medici at the Castle of Confagglio. Another, in Gubbio, was begun near the end of the 15th century by Giorgio Andreoli, a craftsman. The rulers of the time recognized him as a man performing a useful service. He was excused from paying taxes, first by the duke of Urbino and then by Pope Leo X, for the "honor" and "revenue" his pottery brought to the state.

The Italians called their product *majolica*; it featured the Islamic style of decoration, with enamel colors on tin glaze. Two kinds of workers shaped the pottery. The *turner* made round vessels on the wheel. The *former* made everything else, using molds. To create more elaborate works, separate pieces were joined together with a thin, clear clay similar to glue. The work was sent on to the *glazier* and then heated in the kiln. The *painter* decorated it, using an array of brushes he had fashioned himself with delicate hairs drawn from the ears of a cow. After a second firing, the vessel emerged from the kiln a finished work.

Italian majolica had buyers all over Europe, and many Italian potters migrated to their markets. They settled first in France and Spain (which had lost many of its finest artisans with the expulsion of the Moslems and

Jews), then in Portugal and, further north, in Holland and England.

Learning from the Italians, the French developed their own stoneware style called *faience*, making use of a shiny but transparent glaze. The Netherlands was the home of especially profitable Italian factories near Delft. The workshops of emigrant Italians sometimes had patrons, sometimes not. Most often, protection from a monarch would take the form of allowing the Italians to have a brief monopoly to defray the initial expense of setting up a new industry. The Italians were assured of buyers, at least for their practical wares, but success in an unknown country still required a good business head.

The craft continued to travel, though by fits and starts. Expert artisans were attracted to Switzerland and Germany, but some potters who penetrated the more distant, backward regions of Eastern Europe and Russia were pushed eastward. Anabaptist potters, members of a widely persecuted sect, fled from Italy and Switzerland to Bohemia (the western knob of present-day Czechoslovakia). These *Habaner* became the kingdom's first makers of luxury pottery. This was an ironic turn of events, for Anabaptists believed all wealth and ostentation to be a sign of irreverence toward God. These refugees supported themselves by making expensive

Country potters are much the same the world over. Here one drinks beer while the other works. (By W. H. Pyne, from Picturesque Views of Rural Occupations In Early Nineteenth-Century England.*)*

items for the noble patrons, but for their own use made only the simplest and roughest vessels in keeping with their disapproval of ostentation. Small teams of eight or nine typically staffed a workshop but its pottery was not a group effort; each artisan began and finished his own work. The little that these shops produced was enough to fill the needs of their Bohemian patrons. Separation from the rest of the populace lasted through the 17th century; only as Central Europe's prosperity increased did the Habaner find themselves growing in wealth and acceptance, finally entering the life of their adopted country.

European pottery had developed and prospered with the Continent's renaissance in art, technology, and trade. But in modern times there was a new development, as European and Chinese traditions became linked. Chinese porcelain had been owned by European kings since the 14th century, when it was treated as a rare prize. But as European merchants traveled around the world, they brought back porcelain in ever greater amounts, selling it to the nobility. Soon the countries of East Asia began making porcelain for European tastes, while the European potters accepted the lead of their Chinese colleagues and tried hard to master the foreign secrets of technology and style.

Under the first ruler of the Ming dynasty in the late 14th century, China's kilns had all been moved to the city of Ching-te Chen, south of the eastern Yangtze River. Potters attracted from all over the country were organized in factories directed by an overseer known as the Secretary of the Board of Works, who reported to the emperor. Ching-te Chen was a vast complex of connected workshops; a census listed the city's population at 1 million. Each worker had his specific task. Molds were still used more than the wheel. The Emperor Wan-li, who ruled from 1573 to 1620, is said to have ordered an average of 34,200 pieces from the city for every year of his reign. This represented the city's greatest output. Work for foreigners was less distinguished, but by the 17th

century it made up a very large part of the country's trade. Potters produced the styles that brought European money, and the Chinese factories even adopted some Japanese patterns when these proved popular.

Potters working elsewhere in Asia drew on China's traditions. From the sixth century A.D., Japanese culture had been significantly influenced by China. Until then the country had long been politically divided, and technologically backward; the potter's wheel was unknown there until the first century A.D., although cord-patterned pottery dated at about 2000 B.C. has been found in Japan. The Japanese potters had done what they could to imitate the Chinese, but the collapse of central authority in 12th-century Japan made cultural exchanges impossible. The provinces found themselves separated from each other and from China. Many potters fled from civil war to the Mino district, where the ruling clan protected them. The so-called Six Ancient Kilns were all that remained of the industry.

The potters that remained were rural artisans. Most villages had a pottery shop, a family affair with its kiln dug into the hillside. These potters knew very little of life beyond their homes and farms. Their jars, beakers, and cups were entirely Japanese, showing no sign of outside influence. These vessels were meant to be solid and leak-proof, and nothing else.

Later, when new rulers asserted their control over Japan, the fate of artisans improved with more secure times. During the 1570s about 100,000 pieces of pottery were made every year in one province, Tamba. Little, if any, of this work was sold outside regional boundaries, however. The potters still worked just for their neighbors, but these neighbors could now afford more than ever before.

The aristocrats' potters also prospered, developing into dynasties of craftspeople. The first of the *Raku* potters was born in 1515; the thirteenth in the line died in 1944. China's secret of making porcelain reached Japan via Korean potters brought back as captives from the inva-

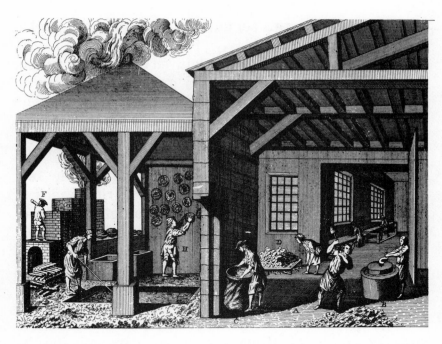

The kiln is the heart of any pottery operation. (From Diderot's Encyclopedia, *late 18th century)*

sion of their country. The first man to make porcelain in Japan was a Korean potter named Ri Sampei, who is thought to have had his first success in 1616. He discovered kaolin, the type of clay needed to make porcelain, in a deposit near a village called Arita. Ri Sampei set up work there, and over the next few decades Arita became a small city with forty kilns in operation.

Even in the days of national unity, each province of Japan had a local family of well-born warriors who kept order. These families provided the money and protection for the new pottery workshops, competing against one another for excellence and for profits from popular exports. The Nabeshima family, who controlled the region of Arita, set rules for pottery operations, appointing an overseer for the porcelain works and instructing inspectors on what would qualify as quality work. The clan also did what it could to ensure that the kaolin clay deposit would not be soon depleted. They also worked to keep the method for making porcelain a secret. Reasoning that loyal workers could be induced to keep the secret, the Nabeshimas introduced a system of wages

that rose steeply with seniority, a concept that startled Japan's other employers.

The rise of competitors was delayed but not prevented. Porcelain workshops gradually multiplied, allowing Japan, like China, to export pottery to the West. The Japanese did not adapt themselves as thoroughly to foreign tastes as the Chinese did, but what they liked, others often learned to enjoy. The pottery that the Japanese made for their tea ceremony was left deliberately rough, so as to embody a spiritual lack of ostentation known as *wabi*. This notion often puzzled contemporary Westerners. But much other Japanese work looked bright, colorful, and imaginative. Sakaida Kakiyemon was the first Japanese potter to decorate porcelain with enamels. It was such valuable knowledge that he disinherited his two younger sons rather than divulge it to them. The Chinese had also experimented with decoration, creating layers of color by painting the white body of the porcelain, applying glaze, and then painting atop the glaze.

In 1664, the records of a single Dutch ship list that it carried 44,943 pieces of Japanese porcelain. In the 18th century, China's porcelain city, Ching-te Chen, earned more from exports than almost any other city in the world. Europe's potters did what they could to imitate Kakiyemon and the Chinese. Eventually they succeeded, and as they mastered the technical secrets of pottery they came to overwhelm their foreign competitors. Western technology pushed Japan's luxury potters into a decline that lasted through the 19th century. China also suffered, and Ching-te Chen was wrecked by the Taiping Rebellion of the mid-19th century. A German visitor of the time described the city as being in ruins.

First European technicians raced to discover how to make porcelain; this remained the premier product of the luxury potters. Experimentation was carried on through the 17th century, with the first real porcelain in Europe made in 1690 by Ehrenfried von Tschin, who set up a laboratory with alchemist Johann Böttger, their

activities funded by Saxony's Augustus the Strong. In 1720, they founded a royal porcelain factory in the city of Meissen near Dresden, in what is now East Germany.

Luxury potters competed for information rather than for workers. The Europeans could be as secretive as Sakaido Kakiyemon and the Nabeshimas. The Meissen potters swore oaths of silence, but some workers—early industrial spies—made a living by stealing these secrets and then wandering among the royal courts to find buyers. The most valuable man in the trade was the *arcanist*, who understood the material and equipment needed for highgrade pottery. One arcanist, Joseph Jakob Ringler, courted the daughter of a Viennese factory owner in order to gain information on kiln design. Ringler carried his secrets in a notebook, which was copied out by spies one night when some friends got him drunk. In such ways the technical knowledge of the pottery trade was spread.

Most of the workshops involved in the production of luxury goods, both those that made porcelain and those that made faience, were started by businesspeople who wanted to make a profit for themselves. Some enterprises remained within the family; many of the faience factories of 18th-century Marseilles were run by the capable widows of middle-class tradesmen. But many other factories were taken over by royal and noble patrons. Like the Japanese warlords, the monarchs of Europe followed a mercantilist policy, stimulating industries to win revenue for the state. If an enterprise took a king's fancy, he granted it a monopoly; then he might decide to run it himself. The possibility of revenue from pottery was great, and so was royal interest. The French porcelain factory at Sèvres was protected by monopoly and tariffs. In 1753, Louis XV bought up all shares and appointed a director with a board of experts to advise him. An array of German rulers, as well as the kings of Denmark and Naples, took similar measures. Some nobles were intrigued enough to found workshops on their estates. The Lord of Sinceny, a French aristocrat, began one in 1734,

and devoted it to turning out *chinoiseries,* imitations of Chinese porcelain. Other firms might rise and fall with the market, but a nobleman's could last as long as its patron's interest held steady.

At first, most of Europe's fine pottery was sold to aristocrats. The aristocrats of 18th-century Europe were cosmopolitan. They formed their own community, one that was quick to conduct new fashions from country to country. Faience, at first known only to France, was soon made throughout Europe because the nobility demanded it. Some factories made their work according to designs that the aristocrats gave them. The others followed the fashions these factories set. Because these potters worked for customers whose tastes were always changing, the craft did not follow traditional patterns from year to year, but changed to meet demand. The nobility used porcelain to furnish their very large and lavish tables. There developed a lasting vogue for complete table sets running from vast serving bowls to rows of tea cups. All these were complementary in design and decoration, with a flamboyant serving tray as the centerpiece of the ensemble.

A good deal of work went into preparing materials before potters could begin making porcelain. (From Diderot's Encyclopedia, *late 18th century)*

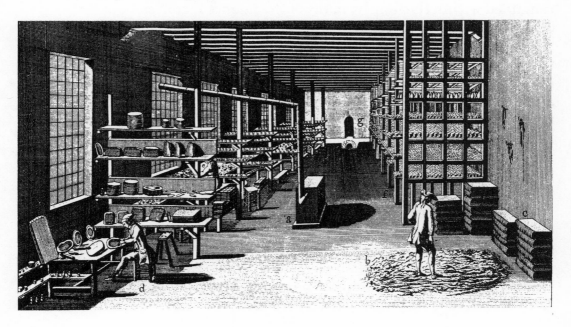

As in China, European pottery works became factories very similar to those of today. A *manager* inspected all functions, coordinating everything. Each unit employed a small number of true craftspeople; what they made was reproduced by dozens of relatively unskilled laborers. Craft went into carving the mold that produced a limitless number of pieces. The work was decorated with small, repetitive designs. One painter set the motif, and a staff of others filled in its details. Finally, among the chief workers, there was the arcanist, the technical expert, accustomed to a special salary and other privileges.

The degree of division of labor can be judged by the number of people who worked on an important commission, a dinner service for Catherine the Great, Empress of Russia. The job lasted from 1775 to 1777. One worker made the mold for the plate, another coated the plate with glaze, a third ground it, a fourth painted in the flowers for its decoration, a fifth painted some cameos, a sixth gilded the work, and the seventh man burnished it. At the end of the 18th century, European potters were the most successful in the world.

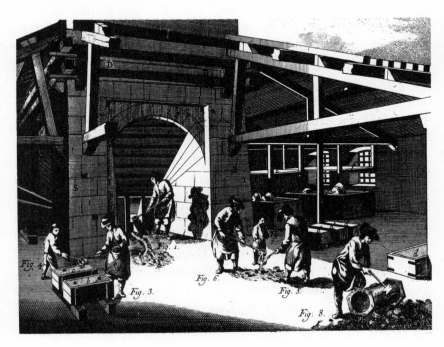

With the expansion of trade in modern times, pottery became big business. (From Diderot's Encyclopedia, late 18th century)

Skilled glazers decorated pottery, passing it over the flame (as at right) to set their work. (From Diderot's Encyclopedia, *late 18th century)*

The early American Colonies were not very hospitable to most crafts. The colonists could not do without pottery, but the trade remained small and its output simple. The first pottery made in the Colonies was done in 16th-century Virginia. The tradesmen did a good business in functional vessels and tableware, but for centuries American pottery remained a rare commodity. In 1697, an English visitor to Philadelphia noted that: "Potters have 16 pence for an earthern pot which may be bought in England for four pence."

Luxury potters were few and far between. Instead, much of the work was done by village craftspeople—present in almost every country and much alike whether their home was Tamba or New England. In Vermont, the potters made earthenware from common red clay. Each village had its *farmer* or *fisher* who could earn money by making pots. Keeping the workshop in a barn, such a potter worked with the seasons: Clay was dug in the fall, dried in the winter, fired and worked during the spring and summer. No more than four people

were found in one shop. The chief used the wheel, and the others looked after the kiln. One family could continue making the same-style pots for its village for a hundred years.

Some American potters attempted to develop a trade in advanced stoneware, but failed. In 1769, some Philadelphia entrepreneurs decided to set up their own porcelain works. An ad in the newspaper announced that they would take only a few apprentices for each department—"throwing, turning, modelling, moulding, pressing, and painting." A year later, they petitioned the Pennsylvania government for aid. Next they ran a lottery to raise money, and then took a second ad, telling the poor of chances to better themselves through apprenticeship in porcelain work. Apparently, what the factory made was good enough to be sought after in England. But transportation across the Atlantic meant high prices, and there were too few buyers at home. The factory failed after two years.

In 1757, Madame du Bois, a wealthy woman in New York state, used her porcelain service for the first time; it is recorded that "curious housewives from the country round came journeying thither to gaze with interest on this unwonted piece of luxury." In some parts of America, any kind of pottery was scarce, the populace generally using wooden plates and bowls. The craft was still struggling in the 19th century. Factories sprang up near the clay deposits of the Ohio River Valley, but their owners relied on English immigrant labor and the pottery produced was always poor. In 1874, the United States exported only $6,592,360 worth of pottery, with no porcelain among it. Until 1918, table sets good enough for use in the White House had to be commissioned in Europe.

By the beginning of the industrial age, England had the lion's share of the world market for pottery. In methods and output the craft had long been close to modern-day factory work. In the late 18th century British capitalists worked to transform it into a true industry.

On the northern fringe of Europe, England's pottery had remained for some time untouched by the revival on the Continent. In the 1670s the Company of Glass-Sellers, petitioning Parliament to allow more pottery imports, charged that English potters made nothing worth having, and that they were too small in number to be worth notice. "They are but six or seven of the said Pot-Makers in England who may employ fifty families or thereabouts."

But ambitious Britons in the next century opened up many trades, one of them being pottery. Prime among the businessmen who took advantage of Britain's prosperity was Josiah Wedgwood, who made Britain's pottery trade the most successful in the world and contributed much to the beginning of the Industrial Revolution.

Wedgwood worked endlessly with the materials and equipment of the craft, recording his discoveries in his "experiment book." He produced a new array of pottery from various mixtures of clay. He also experimented with labor, organizing the lives of his workers in his combination of factory and planned village; a lover of Classical times, he named this factory and company town Etruria, after an ancient region of Italy.

Most important, Wedgwood found ways to replace workers with machines. The decoration of all European pottery in the 18th century was stereotypical. Every factory's staff of painters had a collection of engravings from which to copy. Wedgwood brought this practice to its logical and efficient extreme with the introduction of transfer printing, which allowed the same picture to be stamped on surface after surface. This process eliminated all but the original artist, made possible a vast output, and soon became the standard way of decorating pottery.

For cut-glass decoration, Wedgwood introduced an automatic lathe. In 1782, Etruria was the first factory of any sort to install steam engines, which easily outstripped the human rate of production.

Wedgwood began his enterprise at a time when aristocrats were still the largest consumers of luxury pottery. He went to great lengths to ensure that products made at Etruria would find patrons among the aristocracy. He cultivated noble acquaintances and, to spread word of his work among people abroad, made it a habit to give a departing British ambassador an especially lavish serving tray or piece of statuary.

But new people were acquiring money and with it a taste for what the aristocrats had long enjoyed. The prospering middle classes discovered that they enjoyed hot drinks like cocoa, tea, and coffee, and used stoneware cups to drink them in. In 1764, one English factory found that its most popular product was a line of statuettes representing popular actors and actresses. Instead of being reserved for special display, porcelain was soon being used indiscriminately, as a decorative touch to almost anything. There were porcelain flowers, curiosities, cane handles, pipe bowls, and dentures.

Wedgwood's factory sold goods to both traditional and new customers. Commissioned by Russia's Catherine II to make a table set, Wedgwood's firm took seven years to complete the 952 pieces. However, Wedgwood also issued a line of "Queen's Ware," dedicated to the British royal family but available for purchase by people who could not aspire to social eminence. It has been selling ever since. Wedgwood pottery became the favorite of all classes throughout Europe.

Because of Wedgwood and his competitors, pottery in the 19th century became an industry. The business increased with the invention of ceramic sanitary piping in 1843. One Philadelphia factory manufactured ceramic industrial vaults able to hold 500 gallons. A factory in Weston, Massachusetts, turned out garden vases, cuspidors, umbrella stands, and other furnishings, using molds that imitated styles from Greece, Rome, Classical Etruria, Phoenicia, and ancient Cyprus.

Throughout the 19th century, the new factories coexisted with rural potters; these dwindled steadily for

decades without quite disappearing. The craftspeople, using hand and wheel, held out longest in Central Europe's Austro-Hungarian Empire. The village potters were proud of their independence, celebrating it in a cycle of drinking songs, but they had to work hard to survive, and finally found themselves blotted out by the industrial competition that penetrated the Continent.

Individually, potters could no longer make a living, but the craft found new practitioners among upper-class artist-potters. When machines replaced handwork the craft was preserved by people with the leisure and interest to practice it for its own sake. Even so, pottery might not have been expected to become the favorite that it did, for its reputation was not high. But in the 19th century Sir Herbert Read would write: "The art of pottery is of all arts the one that fuses together in indestructible unity earth and heaven, matter and spirit." This was a unique claim for a craft.

In late 19th-century England, the leading potter was not a workman but an affluent and admired idealist named William De Morgan, a close friend of William Morris, leader of the arts and crafts movement. In the United States, the craft was taken up by some of the country's many industrial heiresses. There the movement began with a group of women in Cincinnati, Ohio, who exhibited their work at the 1876 Philadelphia Exhibition.

English potters came to the fore in modern times; these potteries are in Lambeth, near London. (By Gustave Doré, from London: A Pilgrimage, *1872)*

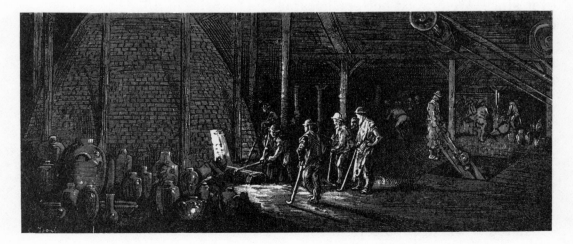

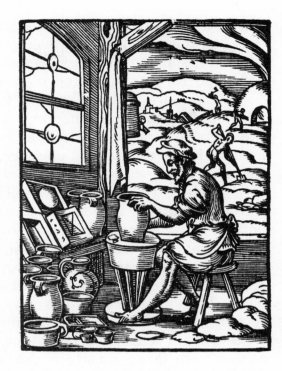

While others tilled their fields, the potter worked quietly in his shop. (By Jost Amman, from The Book of Trades, *late 16th century)*

Their leader, Maria Longworth Nichols, founded a workshop on her estate, naming it Rookwood, to echo Wedgwood. Her talent defeated her artistic aims, however; the work sold, she hired laborers and machinery, and soon discovered that she was operating a small but profitable factory.

These new practitioners of pottery declared themselves to be following a tradition of individual expression that they thought had stemmed from the Middle Ages. Being wealthy enough to own a workshop meant that expression was most often limited to one's own individuality. William De Morgan once scolded a worker who had finished decorating a vase without waiting for De Morgan's design: "Please understand I don't pay you to think! If you think again, you must go elsewhere!"

The reasons for pottery's continuing popularity are hard to define. The most important may be the experience of working at the potter's wheel, an answer hinted at by Sir Herbert Read's declaration about pottery's ability to unite "earth and heaven, matter and spirit." Wealthy, in-

dependent potters saw no reason to use molds. Instead they had the satisfaction of feeling and seeing clay take form as it spun on the wheel beneath their fingers. The artist-potters complained of being cut off from a "simpler," more "natural" way of life that had once existed but was now gone; shaping a vase seemed a perfect way to recapture the feel of that existence. Many have found this a very powerful pleasure, one that calls upon the mind along with the senses.

In modern times, Japan rivals America and the European nations not only in its output of industrial pottery, but also in the skill of its artist-potters. Englishman Bernard Leach, one of the best-known Western potters in the 20th century, studied with Japanese masters and looks on that country as a spiritual home. The village potters are gone, but they have been replaced by an international community of individuals looking for a sense of personal expression and artistic achievement through pottery making.

For related occupations in this volume, *Artists and Artisans*, see the following:
Painters
Sculptors

For related occupations in other volumes of the series, see the following:
in *Financiers and Traders*:
Stewards and Supervisors
in *Harvesters*:
Farmers
Fishers
in *Healers*:
Pharmacists
in *Manufacturers and Miners*:
Factory Workers

Sculptors

Sculpture has been one of the most widely practiced crafts and often one of the most honored. In the past 500 years it, along with painting, has become an art: work practiced chiefly to meet its maker's aesthetic requirements, the sense of what is beautiful or expressive.

Each of the earliest civilizations had its *sculptors*. Sculpture dating from 2500 B.C. has been found on the Indian subcontinent. Evidence of the practice in China dates from the Shang dynasty, around 1500 B.C. The sculptors of East Asia worked on modest clay figures, little tokens used to consecrate tombs.

Egypt was the home of a much more developed craft. Its sculptors built monoliths (works carved from a single stone) and great monuments as well as a wide array of figurines, freestanding statues, and wall-carvings in

relief, in which the sculpture projected from a flat surface. Early sculptors, who worked with clay, modeled ambitious, life-sized statues. Because the statues were made of clay, they had to be of a very stable design or they would topple. That is one reason why figures generally were represented seated on wide-based thrones or, if standing, balanced with one foot firmly planted forward. The Egyptian sculptors seem to have been very conservative, for these postures continued for a thousand years, even in later statues chiseled from granite.

In the pharaoh's workshops the hardest stone went to the best sculptors. Granite was a prize. Limestone could be cut into shape by almost anyone, and every sculptor made use of it at one time or another. Wood could also be used. It qualified as a semi-precious material, for not many trees grew in Egypt; the finer woods, cedar and cypress, for example, came from abroad. An adolescent boy underwent many years of instruction by a master before he could practice the craft.

Sculptors, as slaves owned by the pharaoh or a noble, were held in little regard, but their work was respected—though not in the manner sculpture is today. Egyptians did not think a statue was worth attention simply because it was beautiful. It served a need and contributed to something more important than itself. Egyptian sculpture, both wall-relief and free-standing statuary, was meant to decorate architecture, to embellish and fill out palaces, temples, and tombs. The work was made only as part of a building. Tombs housed most sculpture; the dead person and his or her household goods were reproduced in stone, so they could continue untouched into the afterlife. In this, the sculptor was producing not art in the modern sense, but a form of spiritual insurance.

In culture after culture for thousands of years, sculpture was thought of in this way. That is why the work of the ancient Greeks is so astonishing. Like the Egyptians, the Greek sculptors carved reliefs and made many

statues for temples and tombs. But they also set the Western standard for sculpture. Unlike the Egyptians, the Greeks wanted their statues to have the vividness of life, with anatomy accurately represented and the figures caught standing, bending, or turning. They even introduced a new subject matter. The figures were often arranged in scenes, portraying religious ceremonies or mythological acts of heroism.

The first Greek sculptors found work, as those of other nations did, glorifying the state and honoring the dead. Greek stone sculpture began in the seventh century B.C., after vast marble deposits were quarried. The artisans who worked this marble took commissions from the state, to commemorate a variety of occasions, and from wealthy citizens, who most often wanted to mark a relative's tomb.

For a long while, Greek sculptors made statues that looked very human and naturalistic, but which seemed to have all been drawn from the same small group of humans. Either because commissions followed set patterns or because the sculptors were creating ideal forms, features and expressions changed not from project to project but from decade to decade. Still, Greek sculptors considered themselves important as individual creators, and this opened the way to change. The sculptor's work, even when it adorned a grave, was meant to stand on its own merit, not to play some part in an afterworld. People were meant to look at and admire it. A statue, in itself, became something worthy of respect, and people commissioned them as marks of honor. Many Greek sculptors made a healthy income from cities that wanted to celebrate a native athlete.

The sculptor generally inscribed his name on the pedestal of the work and might add (on behalf of the statue) some praise for his work. Greek sculptors formed their own community, keeping an eye on each other's work, comparing their progress, and exchanging ideas. In the fourth century B.C., they began to speculate about how their work should be practiced and what it was meant to do; some of them wrote down their ideas for

easier circulation. Polyclitus of Argus wrote his *Kanon* (Rules) listing the aesthetically proper proportions for the body of a male adolescent, for example.

Cities and temples proclaimed open contests for commissions, and sculptors competed against each other. Sculptors had opinions not only about what their fellows made, but also about how they worked and their relative prestige in the eyes of the world. One was nicknamed "the man who enfeebles his art" for his fruitless labor over details.

Sculptors seem to have thought that what they did was one of the most important and interesting tasks on earth. Other people were not so sure. The Greek historian Plutarch wrote that the sculptor made admirable things, but that no one of spirit would have demeaned himself with the labor needed to produce them. Other scholars, however, chronicled the lives of great sculptors. In Athens, the best sculptors could become citizens, a status not permitted other manual workers. The great sculptor

In the old Greek tale, the sculptor Pygmalion produces a statue of Galatea and then brings her to life. (From Advertising Woodcuts From the Nineteenth-Century Stage, *by Stanley Appelbaum, Dover, 1977)*

Phidias was even a friend and political ally of Pericles, the Athenian leader. For a set of three statues, done in a year, a sculptor received roughly seven times the average workman's annual pay.

The first Greek sculptors to work in marble did not practice by first sculpting their work in another material. They drew many sketches, fixing an idea of what they wanted, and then attacked the stone with a *mallet* and an array of *chisels*. Each line and curve had to be correct the first time it was tried. With pointed chisel, the sculptor knocked away stone to establish the statue's outline, then used a claw chisel to peel off further layers, as proportion and round forms appeared. For detail work, the sculptor used the more delicate gouge chisel. Once the statue stood free, its sculptor used files and stones to smooth the surface. Finally, the work would be colorfully decorated by a *painter*—surprising as it may seem to modern admirers, Greek sculpture was never meant to be seen as bare marble.

From the third century B.C., the Greek sculptors tried new ways of working that would have been strange to their predecessors. By this time, Phidias and Praxiteles had done their work and won fame; books had been written, by sculptors and others, about the craft.

Sculptors now looked upon themselves much as we look upon artists generally today. Ambitious sculptors thought their skills and ideas unique; they wanted each statue they carved to steal all eyes away from their competitors' work. The serene compositions of earlier times were replaced by figures leaping or twisting about one another. New sculptors did their planning in clay, as sketches could no longer work out all the complications to be found in a design.

The same century saw the beginning of the Hellenistic Age. Macedonian Prince Alexander the Great conquered the Greek cities and went on to annex the Persian Empire. With political decline at home in Greece, patrons lost money, and sculpture became stagnant. Many sculptors earned their keep by restoring older works, still assured

of finding buyers. But abroad everything was different. Alexander's victories left a constellation of quasi-Greek societies spread across the Middle East. Greek sculptors—who had long been recognized as masters of the art—went abroad, where their prestige brought wealth. They won commissions, taught respectful foreign apprentices, and were employed by the many kings who arose after Alexander's death. The Greek style of sculpture became the dominant style throughout the Mediterranean. With some modifications, this remained the case for many centuries, through the rise and fall of Rome and up to the sixth century A.D. and the beginning of the Dark Ages.

Surprisingly, Greek influence even extended far into Asia. In the wake of Alexander's conquest in Central Asia, Greek art became fused with the Buddhist religion, producing a distinctive Greco-Buddhist religious art that spread through India and across the vast Asian continent to China. Even at the famous Jade Gate, in the early Great Wall of China, some buildings sported Doric columns with Greco-Buddhist decorative carving. The most distinctive works made by the Central Asian sculptors were massive statues, some 80 to 100 feet high, found wherever Buddhism spread—in deserts, on mountain tops, or in jungles. But though the work still remains and delights modern admirers, we know little of the sculptors themselves, for written records of the region do not tell us about them, either personally or professionally.

In early India, at least, sculptors were likely to have been slaves. The work there was monumental: huge statues or immense palaces and temples decorated with wall reliefs. The golden age for Indian sculptors began in the third century B.C., when a king named Asoka embraced the Buddhist religion, and Buddha became a standard subject for Indian sculptors. This golden age lasted until the sixth century A.D.; by then the Buddhist influence had traveled to India's neighbors in Central Asia and East Asia.

The small kingdoms along Asia's southeast coast built on Indian traditions—both Buddhist and Hindu—were making changes of their own. Sculptors worked all through the first thousand years A.D. In the ninth century they built the most famous work of Southeast Asia: the city of Angkor Wat, founded by Cambodia's Khmer dynasty. Cambodia's kings had a tradition of building monuments to themselves, crowning the hills around their cities with temples and statues. These grew more extravagant as each generation tried to outdo the one before. At last, Suryarvarman built Angkor Wat, a city for himself, along with a ridge of artificial mountains to be covered by new temples. The complex is considered the height of Indo-Chinese building and relief sculpture. Sadly, a good deal of the site was lost as a result of American air raids in the early 1970s.

Many people in China were also influenced by the Indian religious art; their adoption of Buddhism gave new impetus to the craft of sculpture. Under the earlier Han dynasty, the Chinese had carved some reliefs to decorate tombs. But by the fifth century A.D. China had developed a class of sculptors, artisans who devoted themselves to making images out of metal and stone. Statues, religious and secular, could be found in every city in China. Their makers were ignored, however. Chinese *scholars* loved to debate the arts, but sculpture was one of the disciplines that, mysteriously, they ignored. If a sculptor is mentioned in Chinese writing, it is generally because he also practiced some other craft held in greater esteem. One such person was Tai Ku'ei, who was also a painter. He was so highly regarded that even the Chinese emperor wanted to meet him (although Tai Ku'ei declined to travel to the capital).

Tai Ku'ei is credited with significant advances in Buddhist statuary. Previous Chinese sculptors had worked by traditional and unadventurous methods, and their statues were rigid and formal. Tai Ku'ei, however, developed new techniques. He worked on one statue for three years, displaying it periodically to a critical

audience. From their comments, he could test how well each of his methods worked. At every stage he went back to redo his earlier work, and in the end emerged with an image more vivid and accomplished then any Chinese sculptor had managed before.

The Chinese continued the craft for several centuries until 845 A.D. when the imperial court ordered a purge of the Buddhists. By the time the Buddhists were allowed to return to their religion, the wealth and influence of the faith had been lost. With the loss of religious patronage, sculpture soon declined. The craft had traveled, along with Buddhism, to Japan, where it lingered on into the 14th century. The Japanese sculptors, influenced by Chinese forms, erected giant bronze Buddhas and carved smaller versions in native wood. But when Buddhism declined there too, this time more gradually, Japanese sculpture declined with it.

The status of sculpture in the East rose and fell; in Europe the craft virtually disappeared for a time when the Roman Empire fell. But the sculptors of Africa practiced their craft steadily over the centuries.

Most of the sculptors worked in Africa's many villages. Wood was everywhere, and everyone—not only *priests* and aristocrats—wanted sculpture. Families and village leaders commissioned work. Sculptors made everything from plates and bowls to the masks needed for religious ceremonies. Carving in wood, village sculptors relied on a variety of chisels and axes to give shape to their work, and knives to carve detail. The finished work was polished with rough-surfaced leaves. Sculptors used little surface decoration. They colored their work black with charcoal and white from ground-up kaolin clay. Occasionally red or yellow ochre might be used. The works of the best sculptors are unique and always imaginatively detailed. These artisans worked devotedly. Apparently, the African sculptors' devotion to their work has changed little over the centuries. One book quotes a modern-day girl in Africa as calling *carvers* "likable fellows," but not worthwhile for marrying. "Months go

by, and they don't seem interested in anything but their blocks of wood," she complains.

African sculptors practiced their craft as artists, but they did not do their work simply to make things of beauty. The most advanced sculptures the villagers wanted, masks and statuettes, were endowed with religious significance. Each carving represented one of the spirits thought to occupy the natural world. Wearing the mask or owning the statuette was thought to give people some amount of control over the spirits that ruled their world. As a result, each tribe set rules about the making of these totems. Only certain woods could be used for certain spirits. In some villages, the spirits also claimed the iron tools with which their statues were made; only the person who fashioned the tools could use them to carve out the images. This is why, in African villages where the tradition survived into modern times, the *blacksmith* was also the sculptor.

African carvers worked with their own artistic goals in mind; the best artisans spent their lives in trying to reach them. But the religious nature of the carvers' work placed them apart from the other villagers. Their status depended not so much on how the villagers felt about the work, as on how they felt about the spirit world. As a dealer with spirits, the sculptor was either revered or shunned.

Apart from the sculpture traditions of the tribal villages there were also remarkable sculptors in some cities in West Africa, notably between the Niger and Congo Rivers. The reason for the sudden appearance of this craft there is unknown, although some Byzantine works seem to have filtered westward from Egypt, perhaps contributing to the development of the fine African work. In any case, the Yoruba people—who lived in what is now Nigeria—in the 12th century began to produce striking sculpture. The sculptors of the Yoruba cities carved portrait busts of the royal family, and the habit of making lifelike representations was also taken up in the provinces. When, during the 14th century, the

neighboring Benin people invaded the Yoruba lands, they continued the practice of sculpture. The kings of the Benin wanted to be portrayed in brass and ivory; the lesser chiefs had to settle for wood with brass plating.

Sculptors in any African capital conducted themselves as a very special group. They had many rules and many rankings to measure mastery. The sculptors' guild allowed for no hereditary places; every candidate had to go through years of training, and at the end faced the strong possibility of being turned down. Once accepted into a guild, however, a member could expect considerable prestige and wealth; certainly no one treated sculpture as a casual commodity. Work was assigned by some guilds, according to each sculptor's inclinations and special skills. Under the Benin, work made of bronze could belong only to members of the royal family. The sculptors' work might belong to the monarch, but they were highly valued for their skills.

The appearance of this fine sculpture in West Africa is all the more striking because the Moslem cultures north across the Sahara, with whom the West African peoples had the most contact, had no sculptural tradition of their own. Their religion forbade the creation of sculptural images, and the few sculptors who continued to work in the lands taken over by Islam had little support or patronage.

In Europe, the sculptor had little place in the Dark Ages. After the fall of Rome, the nomadic tribes occupying Europe largely destroyed what was left of the old Mediterranean civilization. European life centered around campfires more than cities. *Jewelers*, *woodworkers*, and primitive *masons* did their work simply and on a small scale, often unknown to each other even if they were separated by merely a few dozen miles. Only gradually did the crafts of sculpture and painting—whose histories would run together into modern times—revive.

Once again, religion supported art. The Catholic Church gradually developed a network of cathedrals

and monasteries across Western Europe. The tradition of pilgrimages began to encourage new building, for bands of people traveled to religious shrines, and the church wanted places for them to rest and worship along their routes.

At the beginning of this revival, cathedrals and monasteries often operated their own masonry workshops. Although the clergy preserved and practiced many other crafts, they never became carvers, so that even during the Dark Ages, the *monks* had a body of professional stoneworkers whom they could hire to carry on the modest building of the period. Carving in this period was practiced by masons: First they piled the stones in place; then they cut in decoration for the appropriate spots. From the 10th to the 11th centuries, what art historians call Europe's *Romanesque* period, carving, either relief or statuary, simply filled in blank architectural spaces. As in India and Egypt, the carvers worked just to embellish buildings. This embellishment was rather timid, almost an afterthought. Getting a cathedral to stand, after years of slow building, was enough of an accomplishment.

Each of the workers on a masonry team had some area of specialization, broad by today's standards. Carving marble and alabaster, sculptors made figures to decorate cathedrals and tombs. Afterwards, someone else painted the work in bold colors.

People have long believed that the medieval carver was a simple laborer, someone who worked to specification. Some scholars now dispute this, but it is true that few statues before the 13th century bear any name or mark. The carvers may not have designed their own work. English sculpture, like all arts of the time, copied the designs with which the clergy illustrated their manuscripts. Cathedral statues came in a series, organized by an "iconographic plan," that is, a system of symbolic images, that illustrated some religious truth from the Bible. Since most masons could not read, the biblical message seems most likely to have come from the

priests, with the masons following orders. Whether or not they took their cues from the priesthood, the masons seem not to have considered themselves unique creators. Their statues looked very much alike. Faces had little or no expression, figures no personalized identity, and even the folds of the clothing were carved in set, unvarying ridges. These were stylized emblems of the biblical figures represented.

Prosperity and practice eventually brought more freedom to the craft. This growing sense of freedom can be seen in the carvers' work. Artisans who decorated the cathedrals became more far-ranging and ambitious, until the patterns they chiseled began to reflect and elaborate upon the architecture. Signs of life began to appear in their images, as carvers now tried to bring to their work something of the world around them. These changes can first be seen in works dating from the middle of the 12th century. The result was the *Gothic* style characteristic of medieval art roughly from the mid-12th century to the 14th century.

During this time the masons, who seem to have been independent artisans, moved away from the church. Their workshops were transferred from cathedrals to quarries; carving stone where it was dug, they cut down on the weight of the stone to be transported. The masons also found customers outside the church. As they began to define their craft, the work was divided into specialties. Some of the new specialists—a group that made statues and considered itself something of an elite—were called *imaginators* or *imagers*. An Englishman named John of St. Albans was the first, according to tradition, and he became the King's Imager in 1268.

Such a person was among the finest of the profession, but the others still wrestled with stone and hacked it into shape in the old way. As late as 1612, the same mason carved statues for Wadham College and then built a storage vault for its kitchen. Some carvers were paid according to how many feet of stone they had worked but

compared to other artisans, they were paid well. An imaginator earned twice as much as a *rough-mason*. Carvers at court, working for the royal family, had the best chance to prosper and join the middle class. Other carvers were kept hard at work in the quarry workshops, which were run with tighter efficiency than had been seen before. They turned out statues, both on commission and on speculation. Work made on speculation was stored as stock for future customers.

The profession of sculptor became fully established in this Gothic period. The sculptors were workers, belonging to guilds, most often those for *wood-* or *stonecarvers*. Workshops employed teams of sculptors, all of them working anonymously to finish the same projects. Young apprentices were increasingly drawn into the quarry workshops to be trained in the skills of carving.

Some workshops remained in one family from generation to generation; it took an able businessman, as well as a fine craftsman, to start his own workshop and keep it going. The master of a shop was its mind. He represented the shop in its legal and financial dealings, and made every decision about its operation. The master accepted projects from patrons, approved or created designs, and

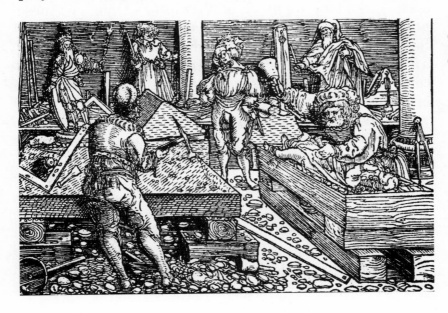

Sculptors' workshops, their floors covered with rubble, produced all manner of statuary. (Authors' archives)

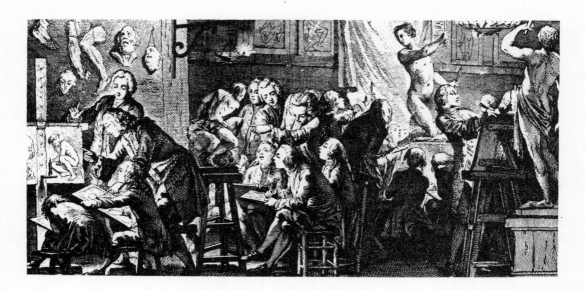

In art schools, sculptors and painters drew life models and copied great works of art for practice. (From Diderot's Encyclopedia, *late 18th century)*

then assigned the workers to their jobs. As the project progressed, he supervised the team, making sure each member executed his task correctly.

Through the 15th century, sculpture workshops conducted most of their business with organizations. The church, of course, was still the main customer, but secular groups, especially guilds, also wanted to erect monuments in their meeting halls and clubs. Producing such works took up much of a sculptor's time. For these projects, the sculptor's artistic sense was not important, for customers simply wanted something imposing, affordable, and large. Wealthy individuals also commissioned works from the workshops. These often brought substantial income, while some additional profit was made by selling terra-cotta replicas of these works, often on a smaller scale, to the less prosperous but emerging middle-class customers, who frequented retail shops in the cities.

Feeling themselves to belong to a profession, sculptors drew together, studying and learning new skills, no longer simply repeating what had already been done. The revival of the craft gathered speed in the last decades of the 14th century. At the same time, the standards of those who commissioned work rose. The

church began to stage competitions; just as in ancient Greece, sculptors tested what they had learned against one another.

This intellectual revival meant sculptors had to set new goals. They no longer worked just to carve a simple figure and take their pay in return; there were new satisfactions. Sculptors, or at least the more ambitious among them, worked so as to produce something that pleased their own sense of beauty and creativity. Most chose the same aim as the artists of Greece: accurate representation of the natural world.

One of the first sculpture competitions, held in 1401, selected the designer of a bronze door for a church in Florence; the proclamation invited "skilled masters of all the lands of Italy to participate." A few decades later, Florence would be inhabited by sculptors not only from "all the lands of Italy," but from all of Western Europe. Before the end of the century, fine relief carving was being done in Paris and Prague as well. The best sculptors had begun to form an international community of craftspeople trained in the same demanding discipline.

In this period—the Renaissance—the stature of the sculptor was rising sharply; sculptors and painters increasingly came to be considered premier among craftspeople. Sculptors of the Renaissance were still most often called upon to decorate buildings, provide statues for niches, and carve patterns into wall moldings. The church was still one of their largest patrons. But the sculptors' skill attracted other customers as well: aristocrats who were interested in glorifying themselves in marble. Theirs was not strictly an artistic interest, but many of the noble patrons, Lorenzo de' Medici being the most famous example, did develop an informed appreciation of sculpture, accompanied by strong ideas about what they wanted.

The archaeological remains of ancient Greek and Roman civilization, now being dug up by Classical enthusiasts, showed that art did not have to be created

solely for the pleasure of the church. Heroic statuary of the past demonstrated how ordinary people, not just saints, could be celebrated. The young Michelangelo's education was much enhanced when he was allowed to roam through the Medici private gardens, inspecting unearthed Roman copies of the work of ancient Greek sculptors Phidias and Praxiteles. In 1496 he carved the first full-scale non-religious statue Europe had seen for perhaps 1,000 years; it depicted the Roman god of wine, Bacchus, and had been commissioned for a nobleman's courtyard.

Michelangelo also revived the Classical portrait bust, seeking to capture a subject's personality in the set of the face. Michelangelo accomplished this with his bust of *Brutus*, a figure from Roman history. Others soon tried their hands at busts of great men of the day. The *equestrian statue* (the figure is on horseback) had been a familiar monument in the ancient world; now Michelangelo gave it back to modern Europe. He restored a statue—lost for centuries—of Marcus Aurelius, one of Rome's great emperors. Dictators and kings wanted themselves preserved for the ages on horseback, looming above other men. The style lived on for three more centuries, so that even American generals have been represented in this fashion in town squares, their images cast in bronze along with those of their mounts.

Church, state, and the nobility all flooded sculptors with commissions for monuments. Sculptors' works soared in quality and in price. Sculptors became different sorts of workers than they had been before. The statue of Marcus Aurelius had originally been intended to top a Roman triumphal arch—to supply the peak to an imposing monument. When Michelangelo restored the statue however, he placed it on a low base, close to the ground and the spectators' eyes, so the statue could be seen and studied. Michelangelo wanted the sculptor's work to be admired in itself, and his colleagues—though much more slowly—came to adopt the same stance.

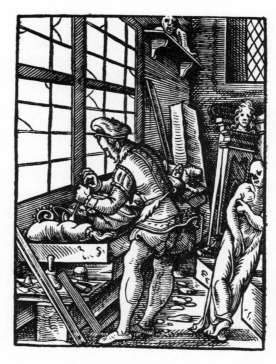

Those who sculpted the statues decorating the great religious and public buildings were always given high status. (By Jost Amman, from The Book of Trades, *late 16th century)*

But change came slowly. Michelangelo, considered by all to be an unequaled genius, could quarrel with popes and produce whatever works appealed to him. In the next centuries, only a handful followed—or were able to follow—his example. Even two centuries later artists counted as supreme craftspeople—but still craftspeople. All but a few of the best sculptors produced their work for their patrons, whom they had to please.

Sculptors could be considered artisans more easily than could painters. Sculptors worked with their hands, hewing hard rock and, as one painter observed, covering themselves with dust. During the 15th century, when painters first discovered that they could be artists, some of their theorists suggested that sculptors might be too earth-bound to qualify: To carve a statue required more from the arms than it did from the mind, they thought. In the 17th century, some sculpture was still being done by masons. These masons received special training and good pay, but they still labored in workshop teams next to the rock quarries.

The nobility of the 17th century poured out their wealth in patronage; it was a boom time for the artistic professions. Patrons expected a level of skill that a century before would have belonged to only a few and the finest of craftspeople. But the statues of this time tended to be gaudy dramatic scenes with figures wearing marble gowns carved so that they seemed to stream in the wind. Ambitious sculptors wanted to make their mark, showing that they had mastered every one of the new skills.

Meanwhile the exploration of techniques and ideas begun in the 15th century continued. The craft became ever more exacting to practice and, for those suited to it, rewarding. The creative quality of sculpture exerted its own pull, away from patrons and their demands, into a zone that only a few people could enter.

No longer part of the old artisans' guilds, sculptors wanted to exchange ideas with one another, to understand their work more deeply, and to train newcomers to the craft. They joined with painters in founding *academies* for the study of their arts. The first such academy was in France, mandated by the throne, during

Along with busts and Classic torsos, this sculptors' workshop also features a bas-relief in process. (From Diderot's Encyclopedia, late 18th century)

the 17th century. England's Royal Academy followed in 1768, and by the 19th century every nation in Europe had a state-sanctioned academy and often one or two groups that had organized in opposition to the academy. The fact that painters and sculptors joined in the same institutions shows how close their different jobs had become. No other crafts were as prestigious.

But though the same people bought the work of sculptors and painters, it was not always for the same reasons. For many buyers, sculpture had an edge over painting, simply because it was three-dimensional. Not everyone is so concerned about the aesthetic properties locked up in a piece of canvas; buying something solid was often more satisfying. In the 18th century, as prosperity grew, affluent members of the middle class bought an increasingly large share of artwork. Merchants and professionals wanted the interiors of their homes to match those of the aristocracy. Many people made profits by selling them replicas or models of the artwork owned by the nobility; England's Josiah Wedgwood, for example, ran a factory that mass-produced pottery and sculpture. This was the sort of market that many artists now worked for.

In England's North American colonies there was little carving done in the 18th century. Americans did not have the money that Europeans did, or the interest in expensive decoration required to support sculptors. Americans made do with village artisans such as headstone carvers or people who worked in eccentric novelty trades. Only a few of these carvers supported themselves solely by this work. An American widow, Patience Lowell Wright, turned to a genteel trade to support her family in 1769. She modeled small portrait busts and animal figurines in wax, both on commission and to exhibit, for an entrance fee, in her home. She was good at what she did, and eventually her success carried her to England. There, she became a society favorite; even the royal family sat for her. Like any portraitist, one of her most valuable skills was knowing how to get on

with her subjects. But she was a rarity, both as an American and as a woman sculptor.

Changes came to America only after the Colonies had won independence from England. The new country had more money; its merchants and professionals were willing to pay for the type of heroic statuary found in Europe. Foreign sculptors came across the Atlantic, looking for easy pay and a less discriminating audience. A former court sculptor to the recently deposed king of Poland advertised in 1795 his skill in "portraits of the most illustrious persons of ancient, and modern times . . . chimney pieces . . . animals for garden use." These immigrant artisans did not do so well against native competition. America's masons and woodcarvers had bred young and ambitious craftspeople, trained in artisanal work but eager to set about proving their worthiness for higher things. The biographer of one American sculptor described him as an "artistically-inclined stone-cutter." One woodcarver, William Rush, became famous in both London and Bombay; he carved prow figureheads for ships that created a stir wherever docked. Rush at last turned from trade and declared himself an artist, still carving his statues in wood. He created a scandal when for one work, *Nymph*, he employed a young woman for his model.

Many Americans appreciated talent, but many others distrusted the arts and saw no reason to pretend otherwise. Many artists believed they could find a better life in Europe. Much good work was done in America, but new ideas were formed in Europe. The sculptor Horatio Greenough studied at Harvard (sculpture was now an acceptable occupation for a gentleman) and on graduation left for Rome. He had discovered his vocation when, years before, his father had bought a replica of Classical statuary for the family garden. While pursuing a successful career in Rome, Greenough was commissioned by the U.S. Congress to carve a statue of George Washington. In 1841, he shipped across the Atlantic his *Washington*, done in the Classical heroic manner still

fashionable, the father of America sitting on a throne, wearing sandals and a toga. Greenough had meant to suggest Jupiter, king of the gods. But the crowds that saw *Washington* unveiled in the Capitol rotunda were horrified. They had never seen such a thing! Washington had always worn a shirt in life; why was he bare-chested here? (Some months later a prankster placed a cigar between Washington's lips.) The gap between artist and public was clear.

The response to sculpture was better in Europe, where statuary had won public favor. Large and imposing statues made better monuments than paintings could. As always, people wanted art to commemorate some event or person they considered important. Sculpture still served a purpose apart from the purely aesthetic. From 1812 to 1814, through most of its battle with Napoleon Bonaparte, the British Parliament voted a sum roughly equivalent to one million dollars for statues to honor military heroes. In 1812, the painter Benjamin Robert Haydon complained to the British public in his autobiography:

> You load your churches, your halls and your public
> buildings with masses of unwieldy stone, and allow
> not one side or one inch of your room for pictures.
> Is this fair? is it just? is it liberal?

England's Parliament had become the greatest patron of sculpture in that country. After the French Revolution, Europe's nobility no longer built monuments to themselves. The Catholic Church was encountering a great deal of criticism from people who accused it of worldliness and extravagance. Some of the new millionaire entrepreneurs still paid for celebrations of themselves, but few others were interested. This left government as the sculptor's main support. The officials who commissioned sculpture held themselves accountable to the tastes of the citizens. Accordingly, throughout the century, figures were sculpted in a stiff

The fancy-dressed figure in the foreground is presumably the sculptor, overseeing the casting of a bronze equestrian statue. (From Diderot's Encyclopedia, *late 18th century)*

neo-Classical manner; though meant to be straightforward and realistic, they had little individual style. The pedestals, which were frequently embellished with troops of subsidiary figures, became more grandiose with the size of the builder's budget. The Albert Memorial in London, erected in memory of Queen Victoria's husband, is a famous example of this sculptural style.

In earlier times, good artists and poor artists had tried to achieve the same things. The imaginative artist succeeded and won fame; the others were relegated to copying. But in the 19th century, we begin to hear of artists rejected by the public, not because their work is not good but because it is not understood. Winning the

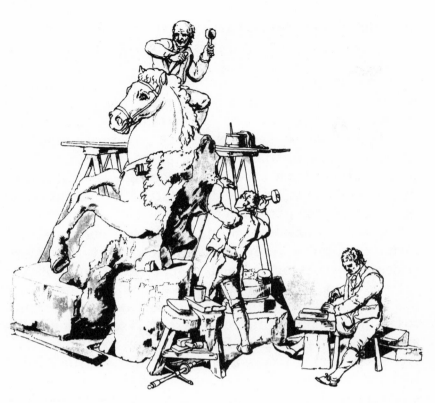

Apart from artistic talent, sculptors needed technical skill with the hammer and chisel to produce marble monuments. (By W. H. Pyne, from Picturesque Views of Rural Occupations In Early Nineteenth-Century England)

honors is a new type of artist who works to please the general public, not a particular patron. Some sculptors, it is true, followed the lead of painters: They worked to meet their own standards, with little thought of any audience beyond a small circle of peers. But sculpture is not produced inexpensively. Someone has to pay for the masses of material that are used, and governments had the money. Just as the artist had grown from the craftsperson, now a kind of craftsperson began to split off from the artist. What he made was prized by its audience because it carried the prestige of art; but unlike his predecessors, this new kind of sculptor took little interest in trying anything that his colleagues had not. In modern parlance, we would simply call these sculptors "hacks." Their public monuments were seen as art because they were grandiose, done in the exaggerated heroic mode of the time, and so had the characteristics of what the uneducated public considered art. The French

poet Baudelaire called this type of sculptor a *pompier*, someone who pumps things up many times their natural size.

In the 20th century, the demand for public statues declined. Art in general was no longer considered public; it had fallen into the most private hands—those of the artists themselves. People who took an interest in art expected artists to make whatever they thought best; people who did not take an interest ignored the whole matter and no longer waited for statues of their heroes to be set up by the government.

For today's serious sculptor, only the creator's self-formulated rules apply. He—or, more often in modern times, *she*—uses any methods or materials that ignite the artistic fancy. Some sculptors make mobiles; some pile up steel in expressive heaps. The sculptor is a familiar figure to the modern public and, as an artist, is seen in much the same way as a painter; in fact, very often the two are one. Artists in earlier times often mastered the skills needed for both disciplines. Now sculpture and painting are more often called "mediums" for an artist than disciplines. The emphasis is not on the skills themselves, but on the work as outlet for the artist's creativity. The work is most often abstract and intellectual, investigating ideas important to people who are interested in the formal values of art. But there lies the rub. Artist-sculptors enjoy considerable prestige, but they work for a very small audience. The rich support them, either directly or through grants.

Governments continue to fund art projects, however, if only to support native artists. Cities in Europe and the United States sometimes commission work. The result is often a work of welded steel weighing several tons. But the gap between the artist's private vision and the public's expectations is still wide. Even a work by Pablo Picasso, perhaps the most famous artist of the 20th century, was met with derision when it was delivered to the city of Chicago. The larger cities of Europe even maintain vaults where they can store unsuccessful public art out of sight.

American sculptors at Mount Rushmore combined mountaineering with carving. (Library of Congress)

In recent decades, the pendulum has swung westward in the art world. The United States, an immensely rich nation with a great fund of talent, now has an artistic life equal to Europe's. Where once artists chose to settle, at least for a time, in the artistic centers of France and Italy, many now choose to base themselves in cities like New York, whose galleries and museums have made it one of the capitals of the international art world.

For related occupations in this volume, *Artists and Artisans*, see the following:
 Painters
 Potters

For related occupations in other volumes of the series, see the following:
in *Builders:*
 Architects and Contractors
 Masons
 Plasterers and Other Finishing Workers
in *Scholars and Priests*:
 Monks and Nuns
 Priests

Suggestions for Further Reading

For further information about the occupations in this family, you may wish to consult the books below.

General

Brewster, Ethel. *Roman Craftsmen and Tradesmen.* (Menasha, Wisconsin: George Banta Publishing, 1917). A dissertation on portrayal of workers by the Roman satirists; has no index, and the contents page is in Latin.

Cowell, F.R. *Everyday Life in Ancient Rome.* (New York: G.P. Putnam, 1961). A survey of daily habits and common trades.

Hauser, Arnold. *The Social History of Art*, in four vols. (New York: Vintage, n.d.; reprint of 1951 Knopf two-volume edition). A standard, very useful general work.

Lucie-Smith, Edward. *The Story of Craft*. (Ithaca, New York: Cornell University Press, 1981). A helpful text, with beautiful, well chosen plates.

National Geographic Society. *The Craftsman in America*. (Washington, D.C: 1975). An anthology of essays on different crafts and periods.

Sullivan, Michael. *A Short History of Chinese Art*. (Berkeley and Los Angeles: University of California, 1967). A standard work.

Clockmakers

Ullgett, Kenneth. *Clocks and Watches*. (London: Hamlyn, 1971). A brief and well-informed survey that touches on all aspects of the craft's history.

Welch, Kenneth. *The History of Clocks and Watches*. (New York: Drake, 1972). Especially informative on technology.

Furniture Makers

Charlish, Anne, ed. *The History of Furniture*. (New York: William Morrow, 1976.) A large coffee-table book; concentrates on Europe since the Renaissance.

Cottrell, Leonard. *Life Under the Pharaohs*. (London: Evans Bros., 1955). Contains several pages on the tools and techniques of cabinetmakers in ancient Egypt.

Mercer, Eric. *Furniture 700-1700*. (New York: Meredith Press, 1969). A social history of furniture's use, rather than its production, in Europe.

Reeves, David. *Furniture: An Explanatory History*. (London: Faber & Faber, 1947). On use and manufacture of European furniture since the Middle Ages; contains a very good chapter on the sort of artisans who became furniture makers.

Thornton, Peter. *Seventeenth-Century Interior Decoration in England, France and Holland*. (New Haven: Yale University Press, 1978). A historical record of the trade's birth and its manner of operation.

Glassblowers

Arnold, Hugh. *Stained Glass of the Middle Ages in England and France*. (London: Adam and Charles Black, 1939).

Diamond, Freda. *The Story of Glass*. (New York: Harcourt, Brace and World, 1953). A survey of glass's history and technology, with an emphasis on colorful details.

Northend, Mary Harrod. *American Glass*. (New York: Tudor Publishing, 1926). A guide to different styles, with a summary chapter on glassblowing technique.

Pepper, Adeline. *The Glass Gaffers of New Jersey*. (New York: Scribner's 1971). Informative on glassblowers' lives.

Polak, Ada. *Glass: Its Tradition and Its Makers*. (New York: Putnam, 1975). First-rate information about glass history, technique, and technology, from the Renaissance onward.

Wymer, Norman. *English Town Crafts* (New York: B. T. Batsford, 1949). Includes several pages on the techniques of stained-glass artists, both modern and medieval.

Jewelers

Bedinger, Margery. *Indian Silver: Navajo and Pueblo Indians*. (Albuquerque, New Mexico: University of New Mexico Press, 1973). A scholar's work on the silverwork of the Navajos and the Pueblos.

Black, J. Anderson. *The Story of Jewelry*. (New York: William Morrow, 1974). Includes excellent plates, diagrams to describe technique, and analysis of changing styles.

Churchill, Sidney. *The Goldsmiths of Italy*. (London: Martin Hopkinson, Ltd., 1926). Cyril Bunt, ed. On the work and lives of goldsmiths and silversmiths throughout Renaissance Italy; includes a chapter on the Roman guild's regulations.

Honour, Hugh. *Goldsmiths and Silversmiths*. (New York: Putnam, 1971). Concise, informative biographies.

Jackson, Charles. *English Goldsmiths and Their Marks*. (New York: Dover, 1964). A catalog of guild hallmarks, with useful chapters on the history of guilds throughout the British Isles.

Kauffman, Henry. *The Colonial Silversmiths*. (Camden, New Jersey: Thomas Nelson, 1969). Exhaustively details products and techniques.

Marx, Jenifer. *The Magic of Gold*. (Garden City, New York: Doubleday, 1978). A comprehensive work on gold, with a good index.

Piers, Harry. *Master Goldsmiths and Silversmiths of Nova Scotia and Their Marks*. (Halifax, Nova Scotia: The Antiquarian Club, 1948). Brief biographies of the region's smiths.

Plass, Margaret Webster. *African Miniatures: Goldweights of the Ashanti*. (New York: Praeger, 1967). A catalog of plates, with some short chapters on Ashanti history and life.

Rosenthal, Renate. *Jewellery in Ancient Times*. (London: Cassell, 1973). A chronological review of the ancient Mediterranean's jewelry, with attention to political circumstances.

Locksmiths

Butter, Francis, J. *Locks and Lockmaking*. (London: Pitman, 1926).

Hennessy, Thomas. *Early Locks and Lockmakers of America*. (Des Plaines, Illinois: Nickerson & Collins Publishing, Locksmith Ledger Division, n.d.). Capsule histories of many firms.

Musical Instrument Makers

Bragard, Roger, and Ferdinand J. De Heu. *Musical Instruments in Art and History*. (New York: Viking Press, 1967). A very colorful, thorough history of musical instruments and their makers, with many pictures.

Taylor, Charles. *Sounds of Music*. (New York: Scribner's, 1976). Chapter 4 on "Craftsmanship and Techniques" nicely explicates the art of making musical instruments.

Painters

Heydenryk, Henry. *The Art and History of Frames*. (New York: James H. Heineman, 1963). Covers European styles from the late Middle Ages on.

Holt, Elizabeth, ed. *The Triumph of Art for the Public*. (Garden City, New York: Anchor, 1979). A compilation of contemporary reports on art exhibitions, running from 1785 to 1848, with historical background and commentary.

Martindale, Andrew. *The Rise of the Artist in the Middle Ages and Early Renaissance*. (New York: McGraw-Hill, 1972). A social history survey.

McLanathan, Richard. *Art in America: A Brief History*. (Goldborne, Lancashire, Great Britain: Harcourt Brace Jovanovich, 1973). On painting since the Pilgrims, with some attention to social background.

Roskill, Mark. *What is Art History?* (New York: Harper & Row, 1976). What the art historian looks for, and why.

Short, Ernest. *The Painter in History*. (London: Philip Allan, 1929). A very useful history of the painter's progress.

van Gulik, R.H. *Chinese Pictorial Art as Viewed by the Connoisseur*. (Rome: Istituto Italiano per Il Medio ed Estremo Oriente, 1958). Irreplaceable scholarship; a limited edition.

Zelermyer, Rebecca. *Gallery Management*. (Syracuse, New York: Syracuse University Press, 1976). A how-to book.

Photographers

Coe, Brian. *The Birth of Photography: The Story of the Formative Years, 1800-1900.* (New York: Taplinger, 1976). A slim, but useful book on photography's early days.

Freund, Gisele. *Photography and Society.* (Boston: David R. Godine, 1980). Useful essays stressing European developments.

Jeffrey, Ian. *Photography: A Concise History.* (New York: Oxford, 1981). A useful review, focusing on the great documentary and art photographers.

Jenkins, Reese. *Images and Enterprises: Technology and the American Photographic Industry, 1839-1925.* (Baltimore: Johns Hopkins University Press, 1975). A unique work on the business and technical aspects of photography's history.

Newhall, Beaumont. *The History of Photography from 1839 to the Present Day. Revised and enlarged edition.* (New York: Museum of Modern Art, 1964). A classic in the field.

Pollack, Peter. *The Picture History of Photography from the Earliest Beginnings to the Present Day.* (New York: Abrams, 1969). A large, heavily illustrated review.

Rosenblum, Naomi. *A World History of Photography.* (New York: Abbeville, 1984). A beautifully illustrated work with a wider view.

Sandler, Martin W. *The Story of American Photography: An Illustrated History for Young People.* (Boston: Little, Brown, 1979). A readable, well-illustrated work.

Potters

Barber, Edwin Atlee. *The Pottery and Porcelain of the United States*. (New York: J. & J. Publishing, 1976). A reissue of a classic work from the 19th century.

Caiger-Smith, Alan. *Tin-Glaze Pottery in Europe and the Islamic World*. (London: Faber & Faber, 1973). On styles, as well as the making and use of pottery.

Cook, R.M. *Greek Painted Pottery*. (London: Methuen, 1972). Follows changes in the styles of ancient Greek pottery and its decoration; a scholar's work, with a short but useful chapter on the industry's operation.

Hillier, Bevis. *Pottery and Porcelain 1700-1914*. (New York: Meredith Press, 1968). A social overview with much detail on who made pottery and who used it.

Koyana, Fujio. *The Heritage of Japanese Ceramics*. (New York: Weatherhill/Tankosha, 1973). Translated by John Figgess. Includes beautiful color plates with commentary, and some historical information.

Rhodes, Daniel. *Stoneware and Porcelain: The Art of High-Fired Pottery*. (Radnor, Pennsylvania: Chilton, 1974). Very informative on technology.

——————. *Tamba Pottery*. (New York: Kodansha, 1974). On methods and social position of potters in a Japanese province.

Rollo, Charles. *Continental Porcelain of the 18th Century*. (London: Ernest Benn, University of Toronto Press, 1964). On styles and history, with attention to individual factories.

Watkins, Laura Woodside. *Early New England Potters and Their Wares*. (Cambridge, Massachusetts: Harvard University Press, 1950). Introduction tells how the potters lived.

Sculptors

Ashton, Leigh. *An Introduction to the Study of Chinese Sculpture*. (London: Ernest Benn, 1924).

Craven, Wayne. *Sculpture in America*. (New York: Thomas Y. Crowell, 1968). On general styles and individual careers from the 18th century to today.

Devanbez, Pierre. *Great Sculpture of Ancient Greece*. (New York: William Morrow, 1978). Translated by Hakua Tynikowska. Color plates, with information on stylistic periods and the Greek outlook.

Keutner, Herbert. *Sculpture: Renaissance to Rococo*. (Greenwich, Connecticut: New York Graphic Society, 1969). On cultural and artistic developments from the 16th century to the 18th; chiefly plates, but with detailed introduction.

Laude, Jean. *The Arts of Black Africa*. (Berkeley and Los Angeles: University of California Press, 1971). Translated by Jean Decock. The styles of African sculpture in social and historical context.

Licht, Fred. *Sculpture: 19th and 20th Centuries*. (Greenwich, Connecticut: New York Graphic Society, 1967). Contains many plates; introduction describes sculpture's many aesthetic changes, and speculates on social causes for them.

Richter, Gisela. *The Sculpture and Sculptors of the Greeks*. (New Haven: Yale University Press, 1950). Contains a detailed chapter on the Greek sculptors' methods and materials.

Seymour, Charles Jr. *Sculpture in Italy: 1400 to 1500*. (Harmondsworth, Middlesex, U.K.: Penguin, 1966). Contains a chapter on patronage, workshop organization, and the influence of geography.

Stone, Lawrence. *Sculpture in Britain: The Middle Ages*. (Harmondsworth, Middlesex, U.K.: Penguin, 1955). A detailed history of styles; introduction tells of sculptors' status, pay, and influences.

Whinney, Margaret. *Sculpture in Britain: 1530 to 1830*. (Harmondsworth, Middlesex, U.K.: Penguin, 1964). Provides much information on the lives and work of British sculptors; includes a detailed chapter on Europe's neo-classical style in vogue in the 18th century.

Index

of Renaissance, 34-35
of reproduction styles, 48
and upholsterers, 40, 45
Furniture sellers, 43

Gallé, Emile, 64
Gemcutters, 87, 96-97
Gentleman and Cabinet-Maker's Director (Chippendale), 44
George III, king of England, 22
Gerla, Hans, 109
Giotto (Italian painter), 125, 126
Glassblowers, viii, 51-67
 American, 62-64
 as artists, 64
 in East, 55
 English, 61-62
 operation of glasshouse, 59-60, 61
 revival of art, 67
 Roman, 53-55
 spread of craft, 60-61
 techniques of, 52-53
 Venetian, 57-60
 windows of, 64-65
Glassmaking
 factory production in, 63-64, 65
 of optical glass, 65-67
 of stained glass, 56-57
 techniques of, 51-52
 See also Glassblowers
Glazes, pottery, 152, 156
Gobelins workshop, 36-37, 38
Goddard, Luther, 23
Gold
 coins, 77-78, 80
 jewelry, 75-77, 88
 supply of, 78, 87-88, 92-93
 tooling, 1, 2-3
Goldsmiths. *See* Jewelers
Gole, Cornelius, 41
Gothic style, 186
Grandfather clock, 18
Greenough, Horatio, 194-95
Guibert, Philip, 41
Guitar makers, 113
Gutenberg, Johann, 95, 131

Hallet, William, 42
Harland, Thomas, 23
Harun al-Rashid, 80
Haydon, Benjamin Robert, 195
Hemicycle, 12-13
Henlein, Peter, 16
Henry III, king of England, 83
Henry IV, king of France, 110
Heusz, Jorg, 101
Hine, Lewis W., 147, 148
Hoppert, Bartholomew, 102
Hotteterre, Jacques, 112

Hourglass, 12, 15
Huygens, Christian, 18

Ihara, Saikaku, 14
Illuminators, 69-71, 122-23, 126
Illustrators, x, 71-74, 123, 126, 136-37
 block printing of, 71-72, 131
 employment of, 74
 lithographers as, 73
 metal engraving of, 73, 131
Imaginators, 186-87
Import merchants, 90
Impressionism, 138
Inca jewelry, 88
Incunabula, 8
Ingersoll, R.H., 27
Ingold, Pierre Frederick, 25-26
Instrument makers. *See* Musical instrument makers
Interior decorators, 38-40, 48, 49

Jackson, William Henry, 146
Jala-yantra, 12
Jensen, Gerreit, 41
Jerome, Chauncey, 25, 26
Jerome, Noble, 25
Jewelers, ix, 75-98, 108, 184
 American, 89-90
 Ashanti, 88-89
 of Byzantium, 80-81
 cloisonne objects of, 97
 Egyptian, 75-77
 firms of, 93-95
 gold supply for, 76, 78, 87-88, 92-93
 and goods for stepped buffet, 84
 Greco-Roman, 77-80
 guilds of, 83, 85-86
 Indian, 88
 Islamic, 80
 and mechanization, 93
 monks as, 82-83
 of Native American civilizations, 88
 of Renaissance, 86-87
 silversmiths, 90-92
 specialists, 95-97
 status of, 85
 trade in personal jewelry, 84-85
 use of precious stones, 80, 81, 84-87, 95-97
Jewelry designers, 95
John of St. Albans, 186
Joiners, 34, 42, 47
Jousse, Mathurin, 102
Junghans family, 26

Käsebier, Gertrude, 146
Kiln, 152
Kinetograph, 148
Knibb, John, 22
Koran, calligraphy of, 8, 10
Kwabi, Fusu, 89

Lalique, René, 64
Lange, Dorothea, 147
Lapidaries, 95-96
Lathe, 33
Lead glass, 62
Le Brun, Charles, 36, 39, 132
Le Brun, Elizabeth Vigée, 133
Legrain, Pierre, 4
Leo X, pope, 129, 159
Letterpress illustration, 72-73
Lewis, John C., 103
Lithographers, 73
Littleton, Harvey, 64
Locksmiths, ix-x, 95, 99-106
 American factories of, 103-4
 of ancient peoples, 99-101
 blacksmith as, 102
 clockmaker as, 16, 101-2
 English, 102-3
 as security specialist, 105-6
 standards for, 104-5
Louis XIV, king of France, 39, 40
 furniture workshop of, 36-37
Louis XV, king of France, 165
Louis XVI, king of France, 22, 48
Lute maker (luthier), 109, 110
Luther, Martin, 3

Machinists, 104
Majolica pottery, 159-60
Mantel clocks, 18
Mantius, Aldus, 2
Marot, Daniel, 39
Marquetrer, 35, 37
Masons, 13, 121, 184-86
Medici, Lorenzo de', 130, 189
Medici, Pier Francesco de', 159
Medici Galleries, Florence, 35, 36
Meissen porcelain, 164-65
Metal engraving, 73, 131
Metalsmiths, 95, 107
Michelangelo (Italian painter and sculptor), 129, 190-91
Miniature painting, 70
Mirror makers, 65
Monks
 as bookbinders, 1
 carpentry shops of, 32
 as goldsmiths, 82-83

as illuminators, 69-71,
 122-23
masonry workshops of, 184-
 85
Morris, William, 46
Morse, Samuel F.B., 136
Museums, 139-40, 141-42
Musical instrument makers,
 ix, 107-14
 in ancient cultures, 107-8
 of Baroque period, 111-12
 of classical period, 112-
 13
 guilds of, 110, 111-12
 piano, 113
 of Renaissance, 108-10
 tuning and repairing by,
 113
 in twentieth century, 113
 violin, 111
Music box, 22, 113
Muybridge, Edward, 146

Nabeshima porcelain works,
 163-64
Navajo silversmiths, 91-92
Nicholas V, pope, 130
Nichols, Maria Longworth, 173
Niépce, Joseph Nicéphore, 144
Night Watch, 131-32
Norton, William, 62
Noyon, Claude, 16

Ophthalmic laboratory
 technicians, 66
Ophthalmologists, 66
Optical glass, 65-67
Opticians, 66
Optometrists, 66

Pacificus, Archdeacon of
 Verona, 13
Padlock, 100
Painters, vii-viii, 71, 86,
 115-42, 179
 academy of, 132-34
 American, 135-36
 in Byzantine manner, 121-
 22
 Chinese, 118-19, 134
 Classical, 115-18, 134
 Classicists *vs* Romantics,
 135
 commissions from Church,
 122, 123, 126-27
 guilds of, 124, 126-28
 Indian, 118
 Islamic, 121
 Japanese, 119-21
 of miniatures, 70
 patrons of, 131-32
 portraitists, 118, 133,
 135
 of Renaissance, 124-31
 scenery, 117
 schools of, 138
 twentieth-century audience
 of, 138-42
Paneling, 34
Payne, Roger, 3

Pericles (Athenian
 statesman), 179
Petronius (Roman satirist),
 79
Pewterers, 84
Pharmacists, 159
Phidias (Greek sculptor),
 179, 190
Philip IV, king of Spain, 131
Philip the Fair, king of
 France, 83
Philip the Good, king of
 France, 84
Photographers, x, 74, 143-50
 documentary, 147
 motion picture/television,
 148-49
 news, 147-48
 pictorial, 146-47
 pioneer, 144-46
 specialist, 147-48
Photographic laboratory
 technicians, 149
Photography, development of,
 143-44
Phyfe, Duncan, 44
Piano makers, 113
Picture researchers, 74
Pin-tumbler lock, 104
Pisistratus (Greek
 statesman), 116
Plato (Greek philosopher), 31
Pleyel, Ignace, 113
Pliny (Roman statesman), 79,
 116
Plutarch (Greek essayist and
 biographer), 178
Poitevin, John, 41
Polyclitus of Argus, 178
Polyphonies, 109
Porcelain makers
 Chinese, 157-58, 161, 164
 English, 171
 European, 164-67
 Japanese, 162-64
Portland vase, 54
Potters, viii, 151-74
 American, 168-69
 Anabaptist, 160-61
 -artist, 172-74
 Chinese, 156-58, 161-62
 of earthenware, 152
 English, 155-56, 170-72
 French, 160, 165
 Greek, 154-55
 and invention of potter's
 wheel, 152-53
 Islamic, 158
 Italian, 159-60
 Japanese, 162-64
 and mechanization, 170,
 171
 of prehistoric people,
 151-52
 Roman, 155
 of stoneware, 156
 workshops of, 153-55, 159
 See also Porcelain makers
Poulsen, Niels, 3
Praxiteles (Greek sculptor),

116, 129, 179, 190
Priests
 inventions of, 13
 See also Catholic Church;
 Monks
Printers and printing, 2, 3,
 9, 95
 block, 71-72
 metal engraving, 73, 131
 offset, 149

Raku potters, 162
Raphael (Italian painter),
 130
Ray, Man, 95
Read, Herbert, 172, 173
Rembrandt (Dutch painter),
 131
Retouchers, 149
Revere, Paul, 90
Richard, Daniel Jean, 24
Riis, Jacob, 147
Ringler, Joseph Jakob, 165
Robert, king of Naples, 125
Robertson, James, 146
Roentgen, Wilhelm Conrad, 147
Romanesque period, 185
Rubricators, 71
Rush, William, 194

St. George, 13
St. Luke's guilds, 126-28
Sakaida, Kakiyemon, 164
Salo, Casparo da, 111
Sambin, Hugues, 34
Sampei, Ri, 163
Sandglass, 12
Sandwich glass factory, 63
Sargent, James, 104
Sarony, Napoleon, 146
Schlick, Arnold, 109
Scribes, 7-8, 69-70
Scrittorii, 8
Sculptors, vii-viii, 86, 175-
 99
 academy of, 192-93
 African carvers, 182-84
 American, 193-95
 -artist, 198
 Buddhist influence on,
 180-81
 of cathedral statuary,
 184-86
 Chinese, 175, 181-82
 Egyptian, 175-76
 in Gothic style, 186
 Greek, 115-16, 129, 176-79
 and Greek style, 179-80
 imaginators, 186-87
 patronage of, 188, 192,
 195, 198
 of public monuments, 194-
 98
 of Renaissance, 188-91
 of Romanesque period, 185
 workshops of, 187-88
Seals, carving of, 96
Seddons furniture company,
 41-43
Seiko of Japan, 28